ROBERT POLIDORI'S METROPOLIS

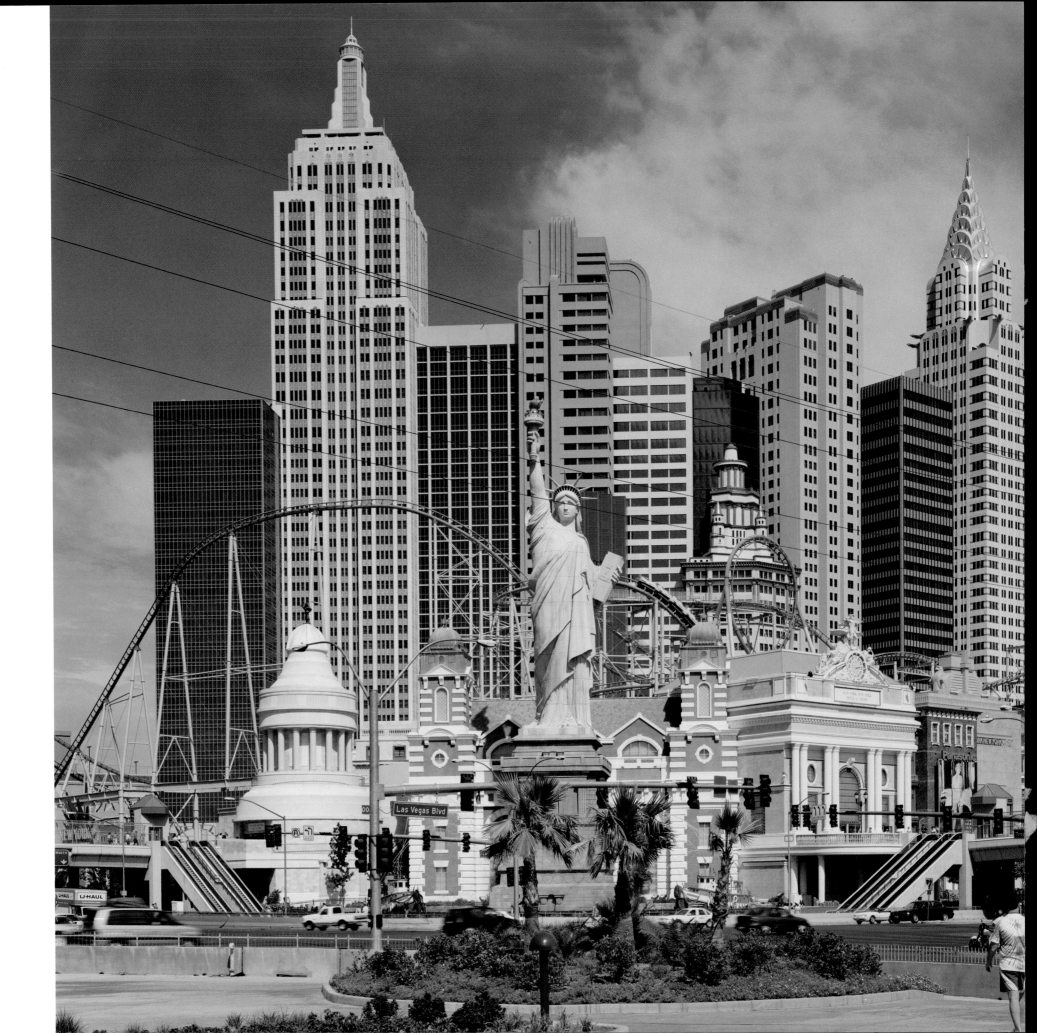

ROBERT POLIDORI'S METROPOLIS

with MARTIN C. PEDERSEN
and CRISWELL LAPPIN

METROPOLIS BOOKS

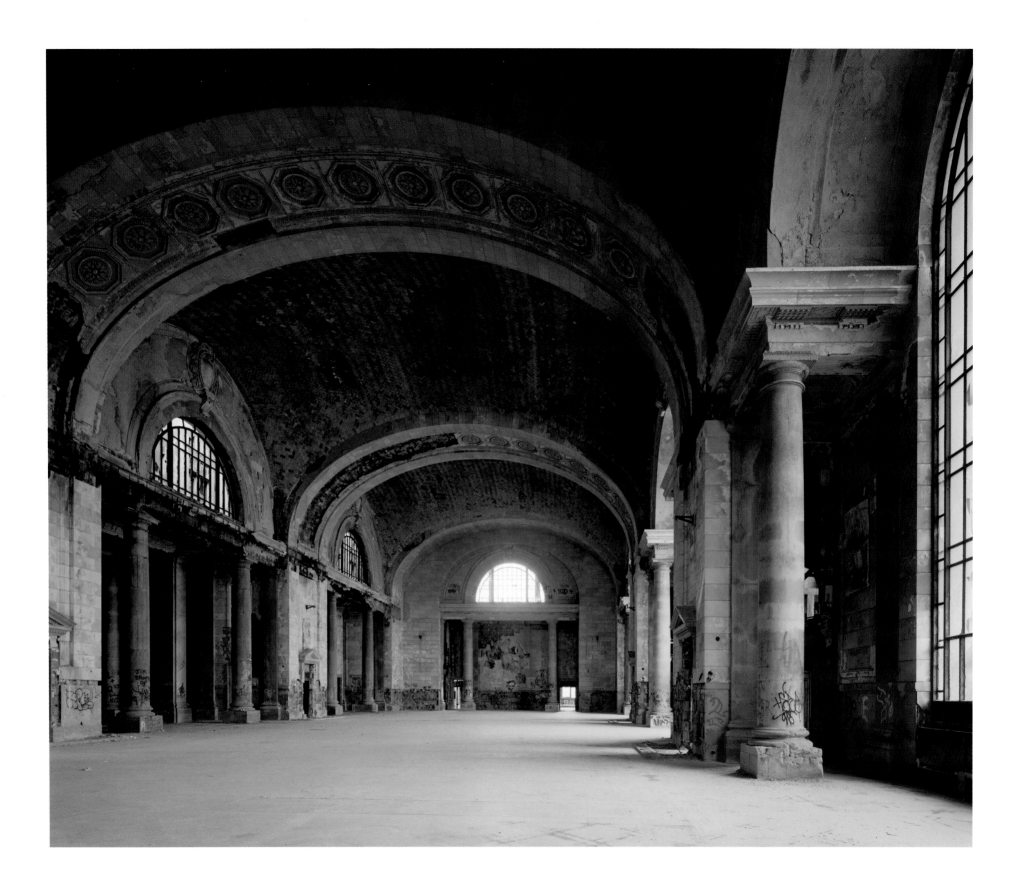

ON ROBERT POLIDORI'S METROPOLIS

Martin C. Pedersen

The idea for this book began to take shape about two and a half years ago, when Robert Polidori first visited the *Metropolis* offices. We had heard through mutual contacts that he wondered why we had never called him and instead kept using his work as "pick-up art." Robert told us he had always wanted to shoot Detroit's Michigan Central Station, an eighteen-story office building and terminal that had been abandoned since the 1980s. We commissioned the shoot on the spot. It is the quintessential urban ruin; we featured it in our May 2002 issue.

During the course of that first discussion, it became apparent to me that beneath the Polidori bluster was a keen observer of the built world, a man who could talk astutely about contemporary architecture and urbanism, the meaning of images, the art and craft of photography, its philosophical implications, and much more. It was also clear that a project combining his images and his insight would make a compelling book.

When Robert agreed to do the book, *Metropolis*'s art director, Criswell Lappin, started by spending several afternoons looking through the Polidori archive. It is a massive collection, and the New York portion represents only a part of it. Dozens of images were selected: cities, buildings, contemporary architecture, ancient ruins. Later I interviewed Robert about each image and from these talks created preliminary text; he also selected additional photographs. The resulting publication is a mix that uncannily mirrors Robert's work. His photos are hard to categorize because they are often several things at once: architecture photography, fine art, photojournalism, sociology, anthropology. Similarly, the text in this book straddles numerous genres: anecdote, polemic, architecture criticism, urban analysis, creative manifesto, even photographic how-to. The sum total of these first-person "riffs" comprises a fascinating portrait of Polidori the artist, one that goes deeper than a monograph. Robert has a point of view about the world he shoots, and in those rare instances when he doesn't—when the situation confounds him—he's the first one to cop to his confusion and use it as part of his relentless quest for answers.

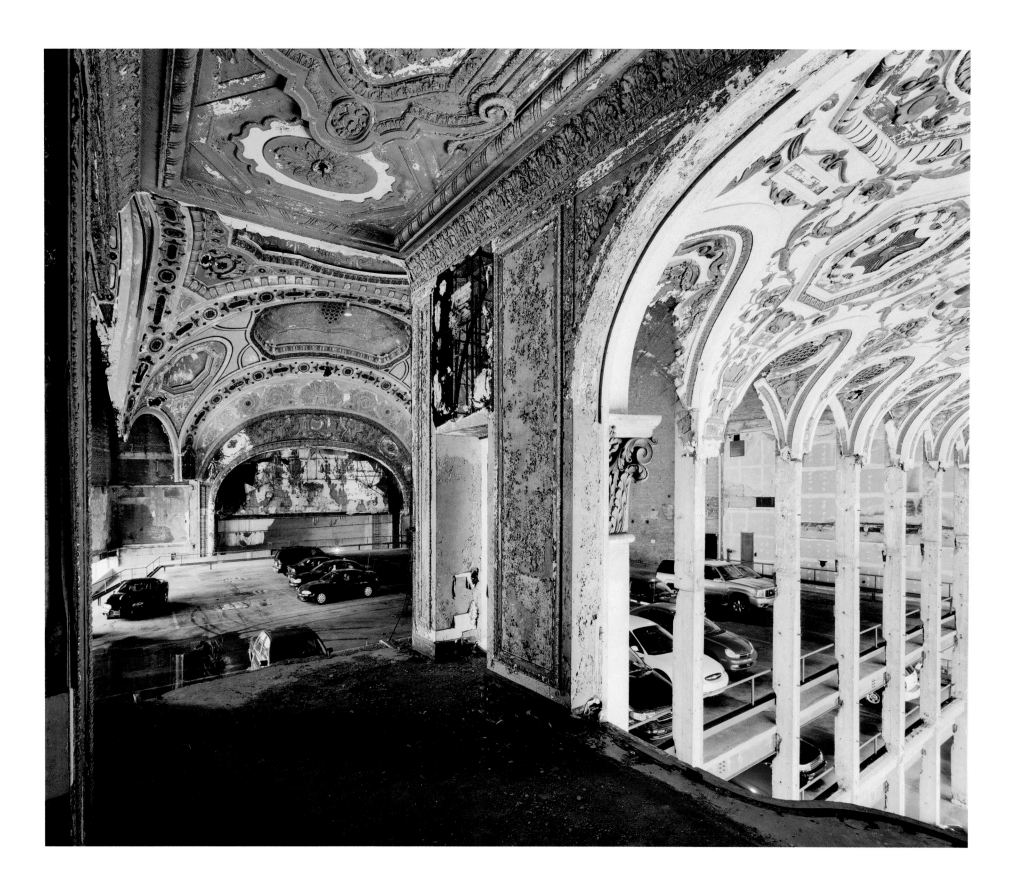

ON PHOTOGRAPHY

Like everyone, I was born naive and not knowing anything. Somehow, early on, I came to the notion that cameras were instrumental in a sort of oracular process. It was a simple concept: where you point the camera is the question, and the picture you get is the answer. I noticed that if you take the time to examine and sift through an image, you might see something you initially missed when you were taking the photo. This yield is like a knowledge dividend. I remember in the 1970s being flabbergasted by a passage in a book describing in detail how the priestess at Delphi sat on top of a tripod placed over a deep well inside a cavern. I got excited and thought, yeah, this is it, this is what photography is about. I should be taking photographs that require a tripod. This idea of knowledge acquisition was probably the central motivation in my early development as a photographer. Photography can be used to illustrate a concept, much like writing an essay, starting from a core idea and fleshing out the details in a kind of mise-en-scène. At the same time, this approach seemed useless to me, like putting the cart before the horse. If you already know what you want to say, it's going to be easy to fabricate your statement. What I knew was what I wanted to know more about. I knew I wanted the physical world to reveal itself to me and tell me what the answers are.

Robert Polidori

ON PETRA

I always loved the fantasy that dwellings
could be sculpted out rather than built.
Cut right out of stone or earth, or even
cast in metal. That would really be materi-
al integrity, now wouldn't it? Practicality
doesn't give this much of a chance to
happen. So Petra is an anomaly. These
structures are homologous to examples
of Phoenician, Palmyrene, and Roman
architecture, but they weren't really built—
they actually were sculpted from rock
walls. This illusion of building is what
the planners intended—it's trompe l'oeil
in the third dimension. This urbanism, truly
integrated into its environment, is a sub-
lime attempt at the perfect integration of
form and content.

8

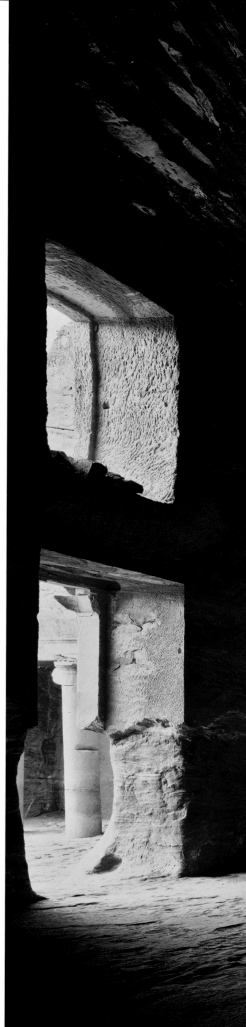

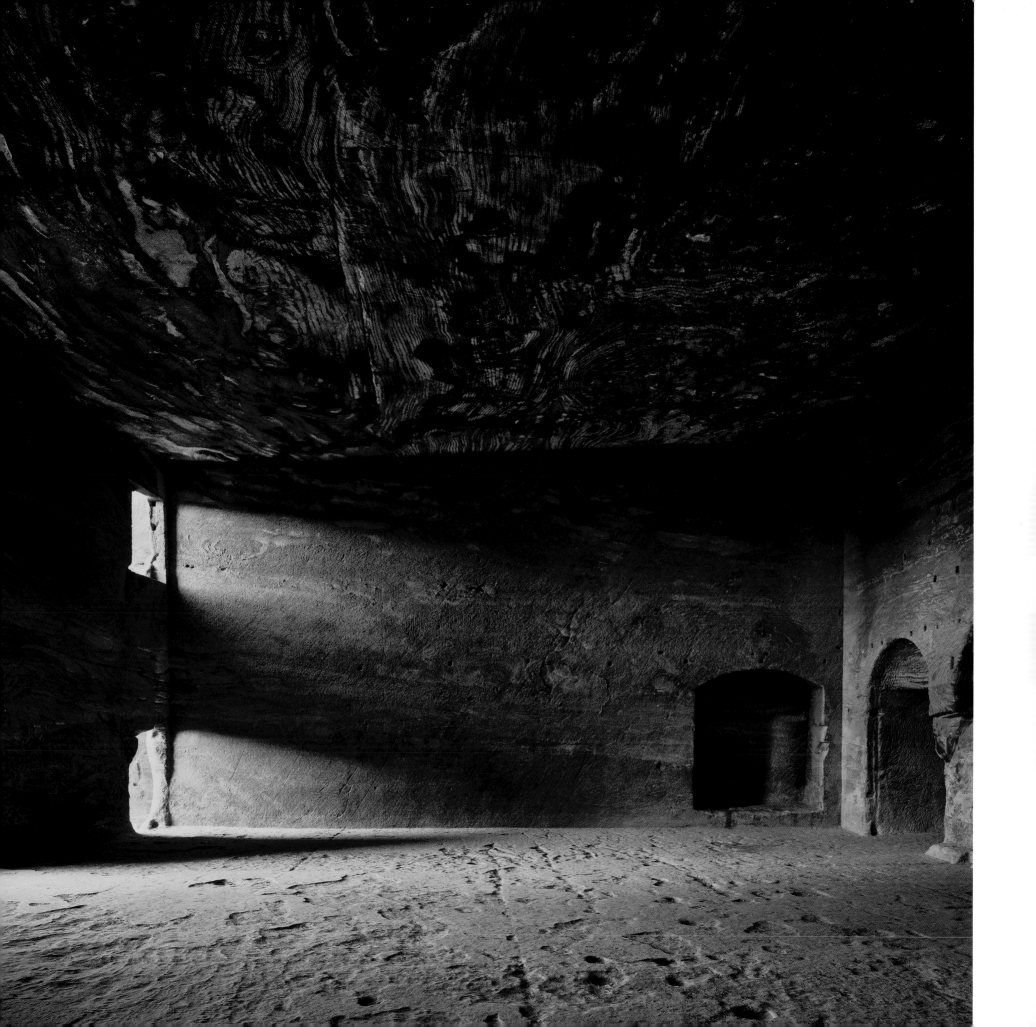

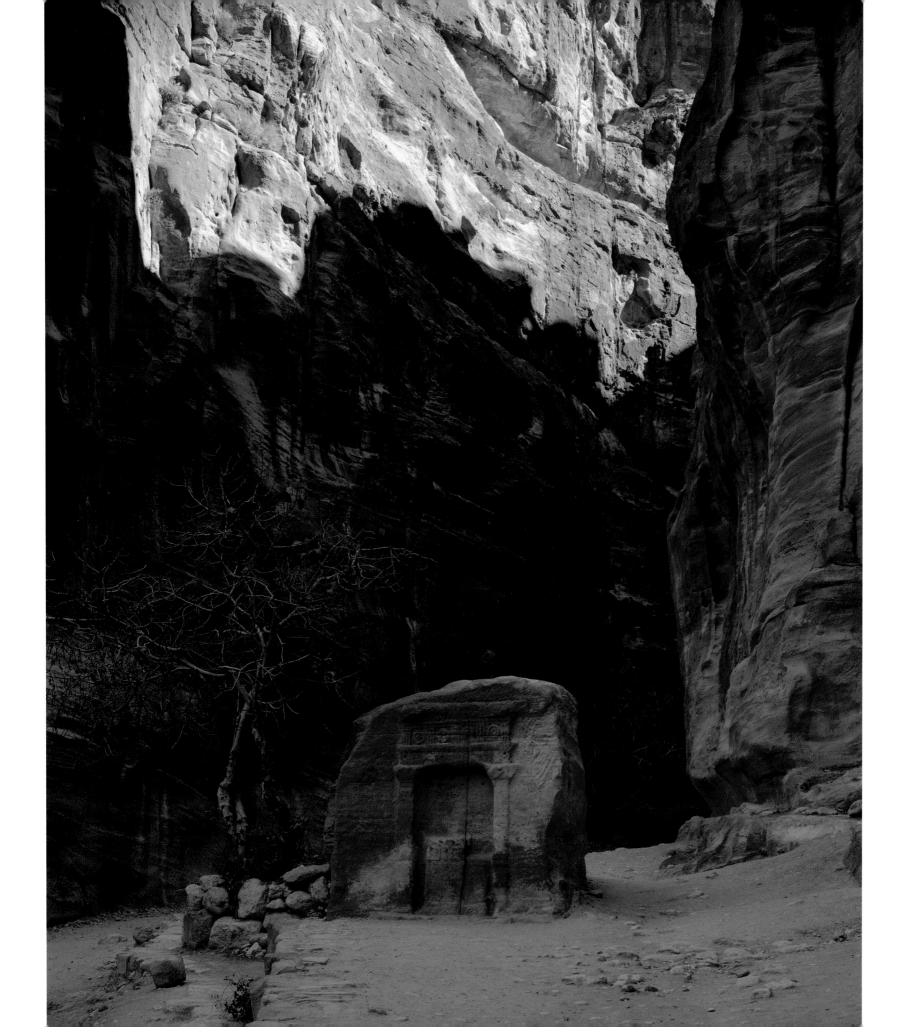

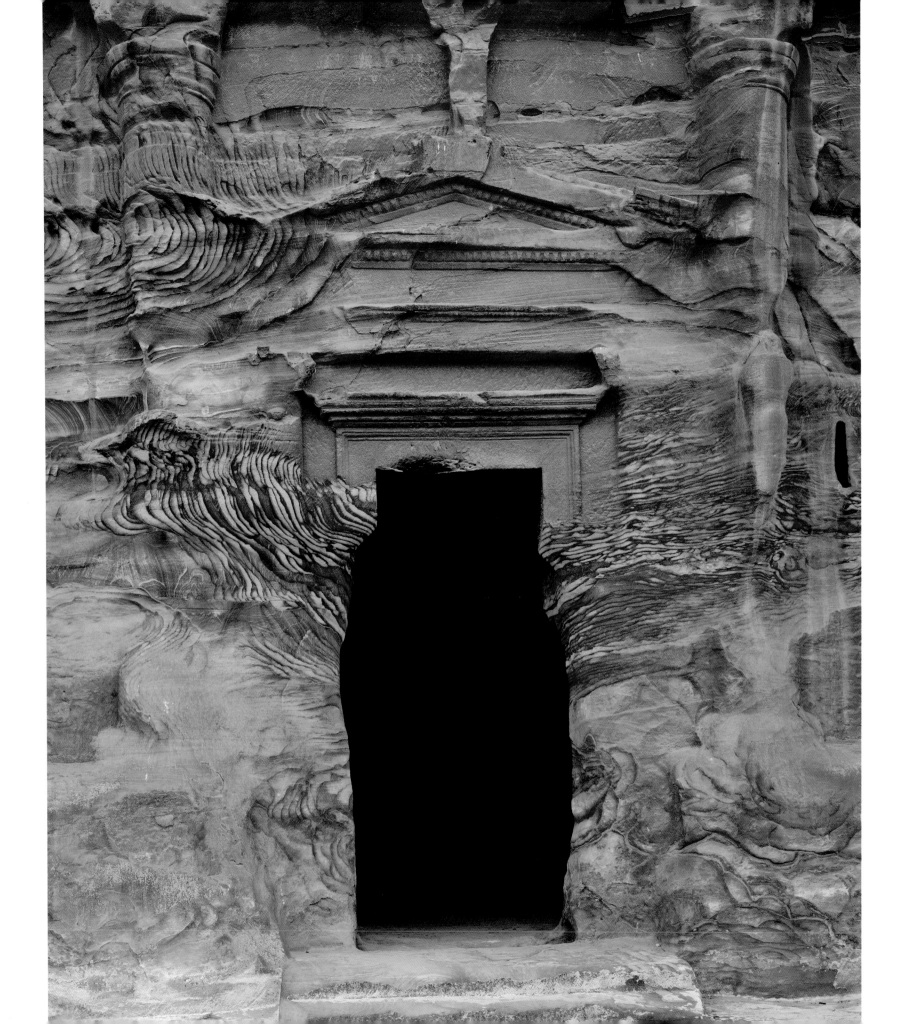

ON LEPTIS MAGNA

One of the most incredible places on earth is a Roman ruin in Libya called Leptis Magna. I remember arriving there for the first time. Giuma Anag, my Libyan escort, brought me to the site at sunset and asked me to close my eyes as he walked me into position. He wanted to see the look on my face when I saw the Severan Forum for the first time. He told me that he did this with every new visitor he accompanied. Perhaps it is some sort of psychological test he uses.

When I opened my eyes, I was transfixed. It was the most amazingly beautiful place I had ever seen. I was lucky—because of my reaction, Giuma and I really bonded, and he became a dedicated companion during the seven weeks I stayed there.

As a photographer, when you're fortunate enough to look at a place for longer than a glance—which is all maga-zine work affords you—you can draw out some of its secrets. The more I studied Leptis, the more respect I gained for the

Romans, not only as master builders—that's obvious—but as great urban planners. Architects and planners today should look back to the Romans, who were so good at mixing the monumental and the intimate. Since visiting Leptis I've had a secret fantasy that someday an eccentric billionaire or even a wealthy government will spend all its money build-ing a functioning imperial Roman city, complete with electricity and plumbing.

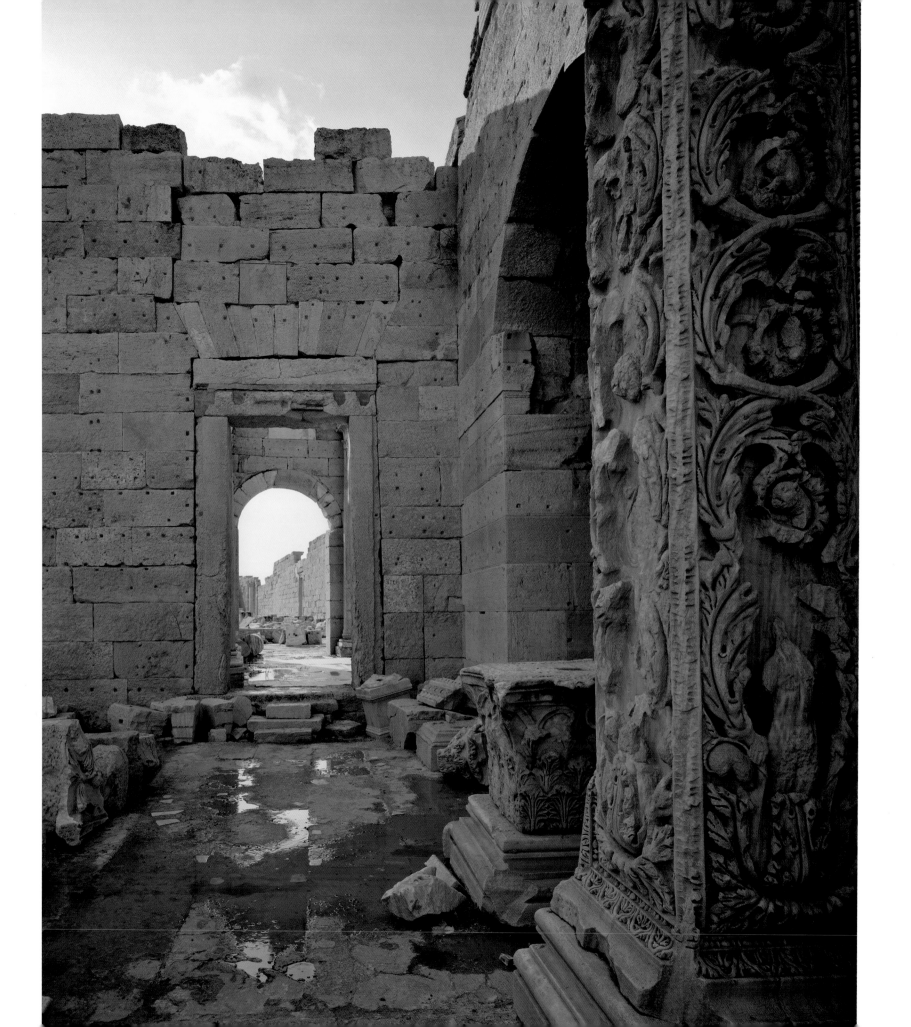

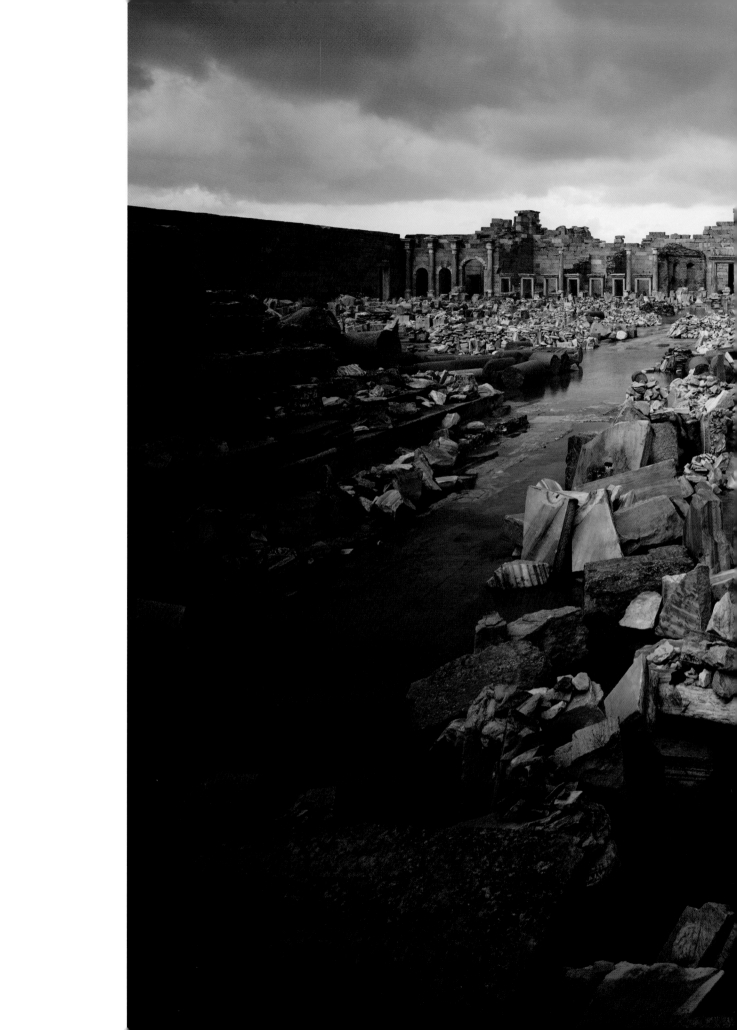

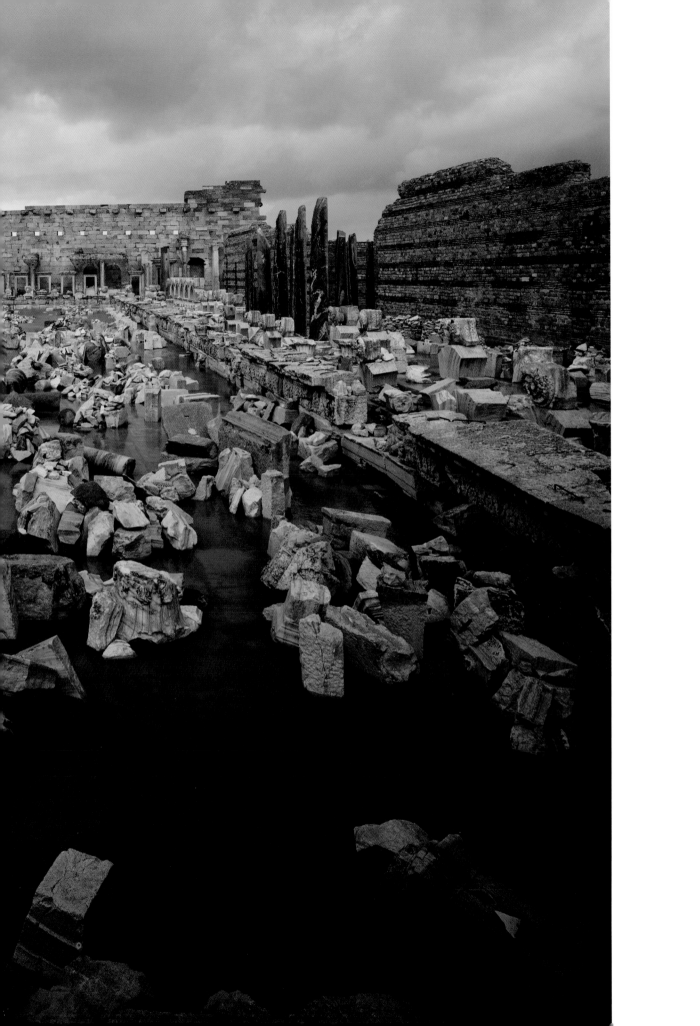

ON SHANGHAI

It seems like everyone in the world now
accepts this as fact: China will be the
world's next dominant superpower. Given
the size of the country's population and its
determination, this prediction is probably
true, but what amazes me is how few
countries dare to challenge or even con-
test this assertion. It's like a given—people
say it's just the inevitable. Why is this?
The world seems to be staring in a passive
hypnotized trance before the spectacle
of the dragon emerging from its cocoon
in a new skin. And as you can see in
these images of Shanghai, it is obvious
that many Chinese cities are undergoing
a serious metamorphosis.

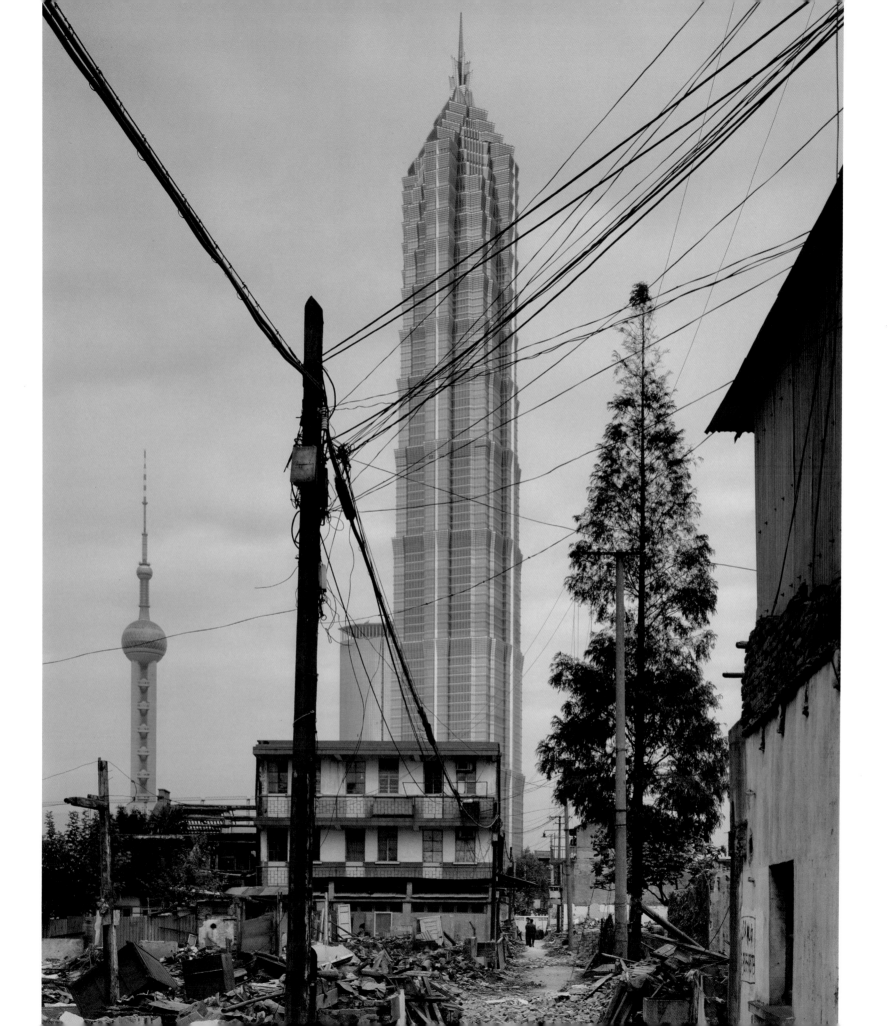

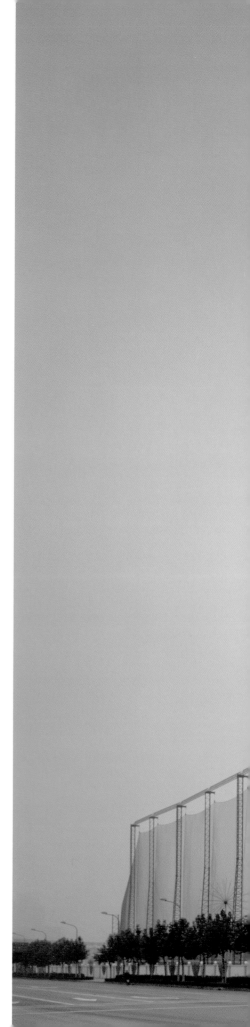

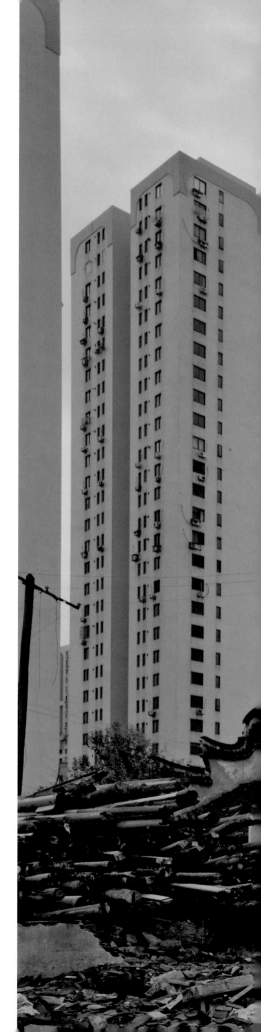

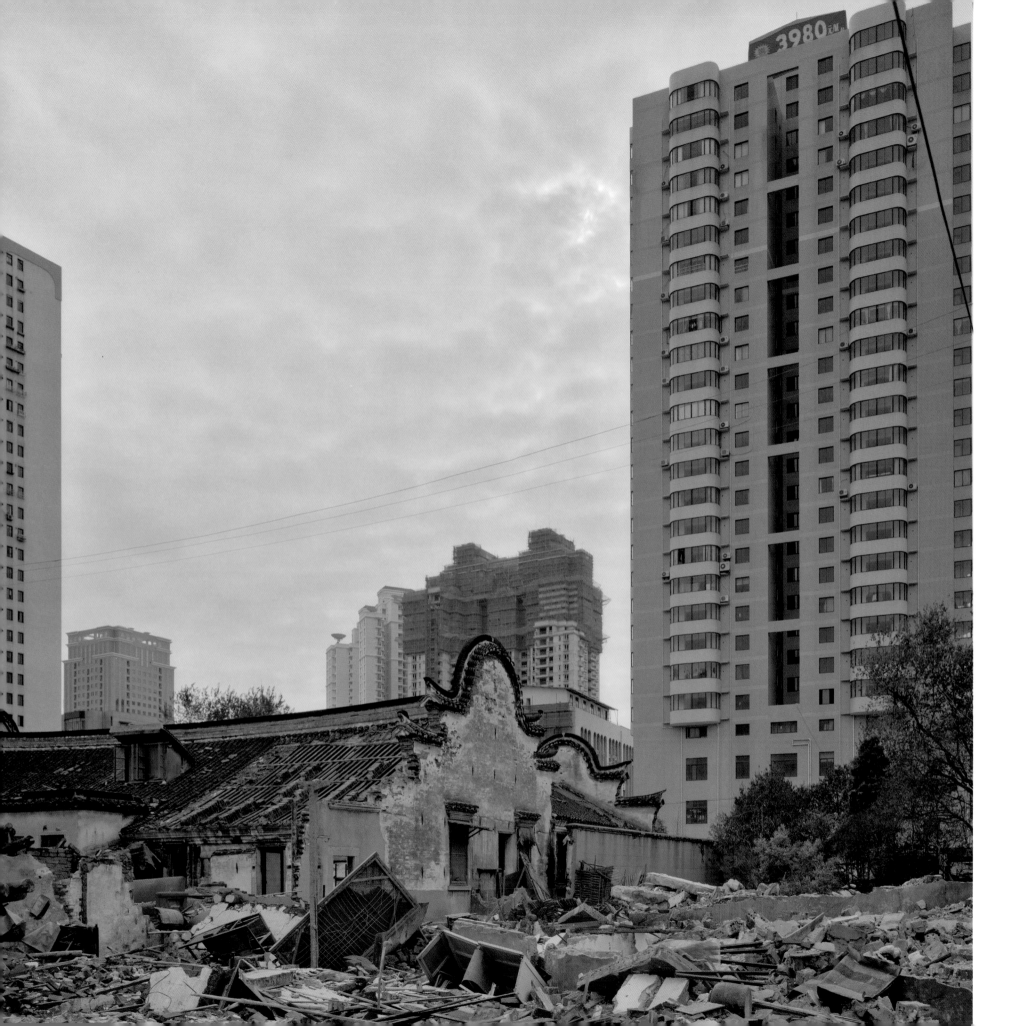

I saw this scene outside my hotel window on my first day in Shanghai: peasants sifting through the demolition rubble of the old city, stacking bricks and lumber for reuse. And I thought: I have to get this closer up. But I was afraid that since it was a Communist country it was going to be a hassle to get authorizations. I thought I'd need several days to negotiate them. Certain images that I had shot of Las Vegas that couldn't remotely be construed as derogatory had met with resistance—the officials there were impossible. So I knew this image of Shanghai could be problematic. As it turned out, it was super-easy to photograph there. You just do it right in front of the cops— they don't care. The Chinese don't think they have anything to be ashamed about. They're proud of the demolition. They're moving forward toward their new world and don't doubt it for a second.

22

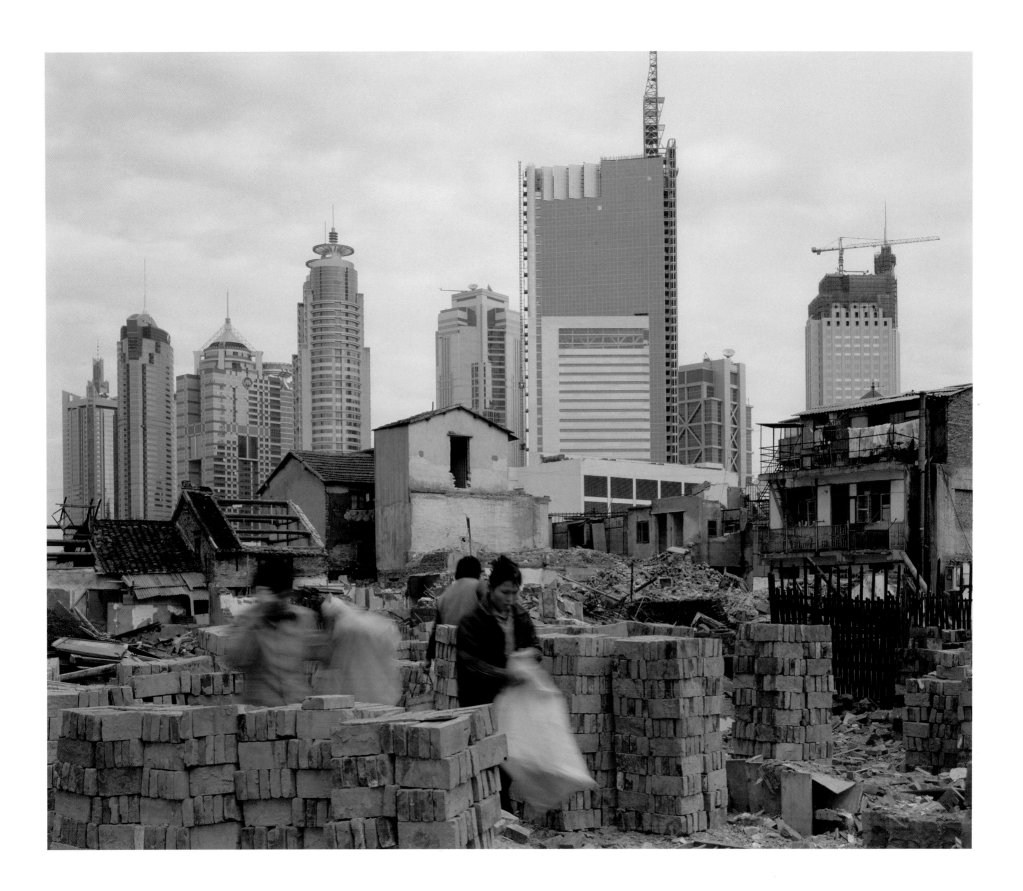

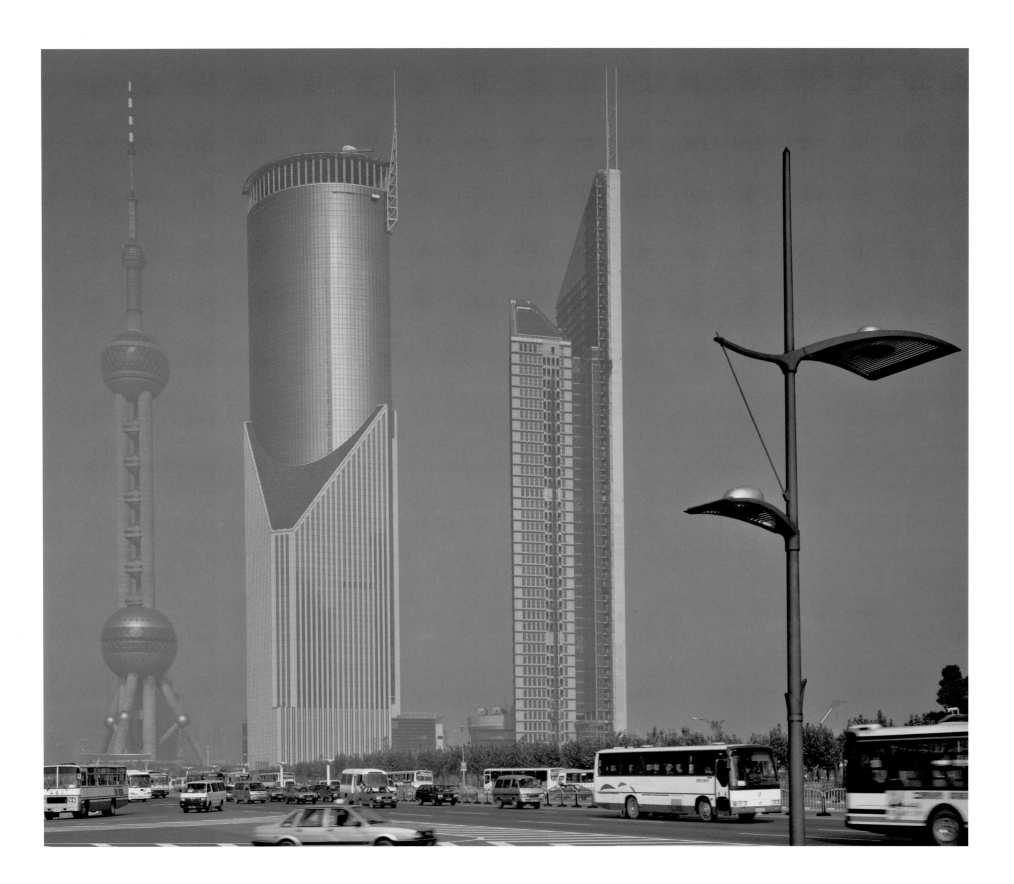

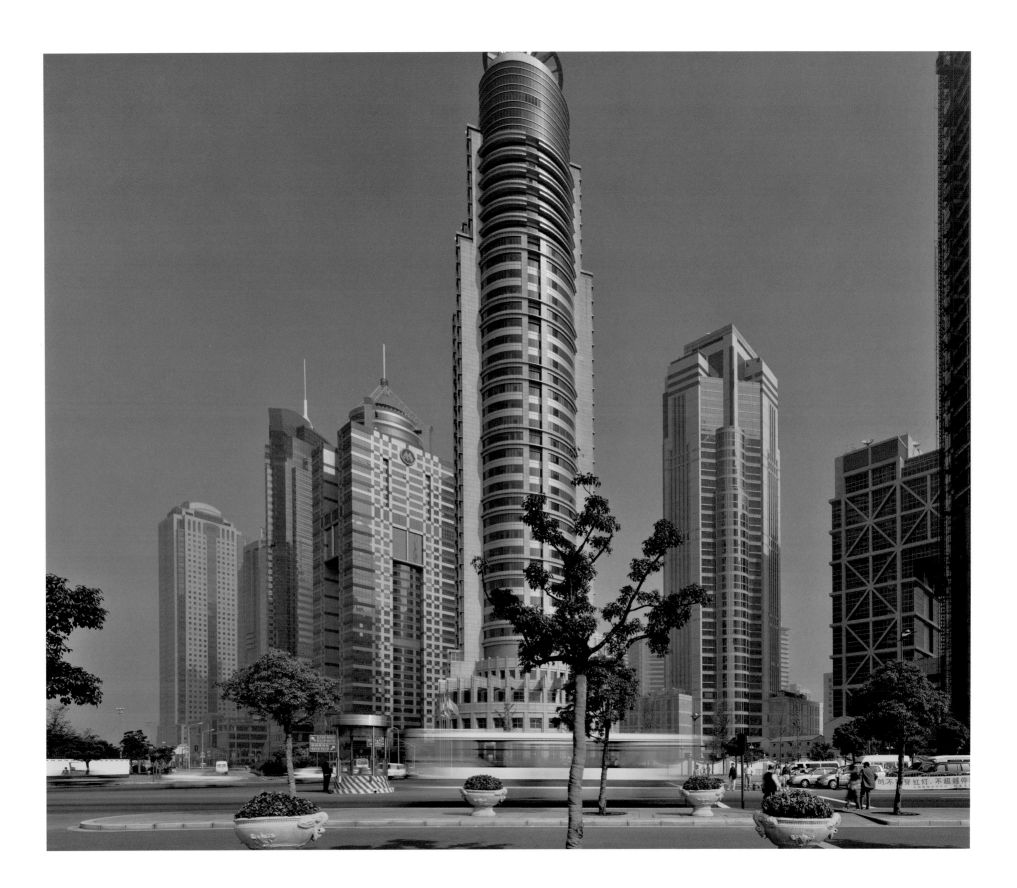

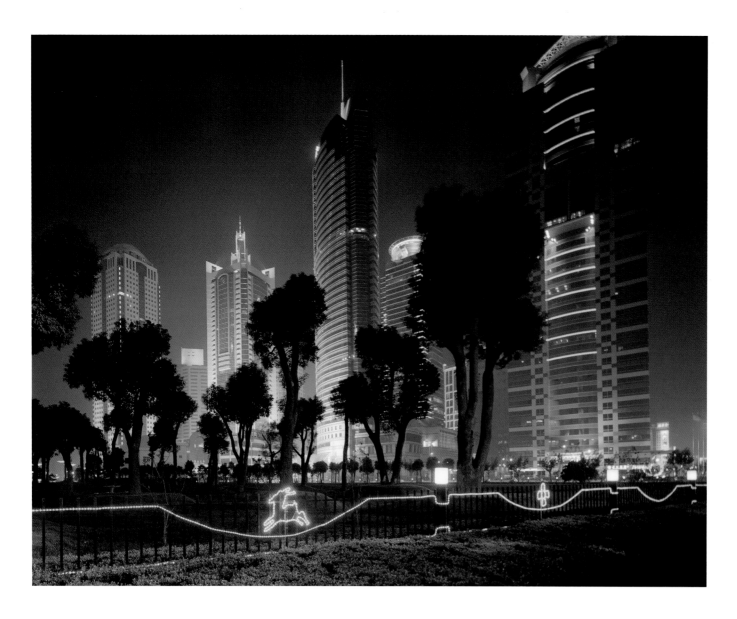

Some Chinese cities look drab during the day, but at night they're almost psychedelic. Here you get a real sense of Shanghai as a huge stage set. It almost looks like Disneyland, but it doesn't belabor the effect by pretending to be a kind of self-conscious kitsch theme park. It really is what it is, and the Chinese are sincere about it. It does have a theme, however: the twenty-first century as a new starting point of history. It's a Futureland built on a past that's being erased. I often wonder, though, how long the Chinese and their natural ecology will be able to withstand it. I mean, if you cut off a plant's roots, how long will it live?

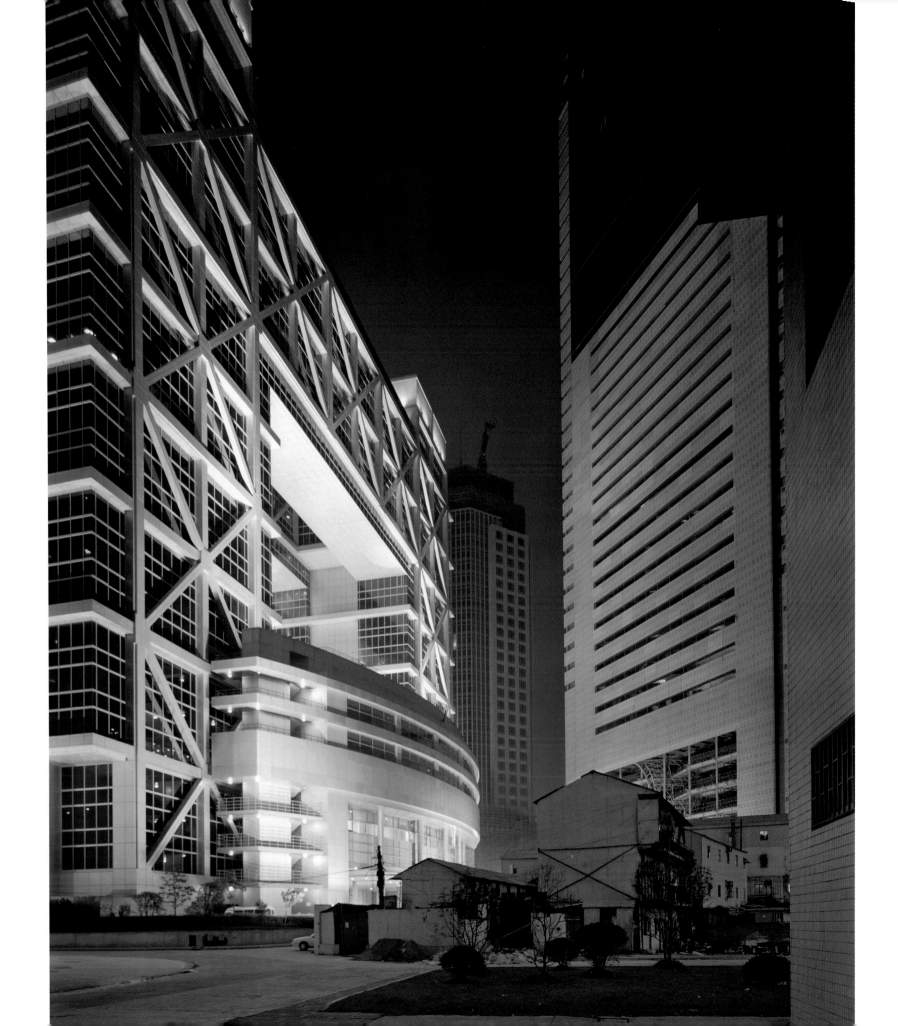

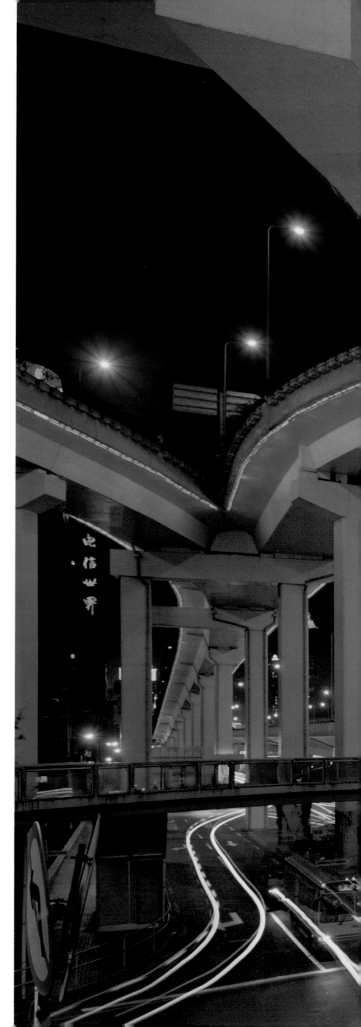

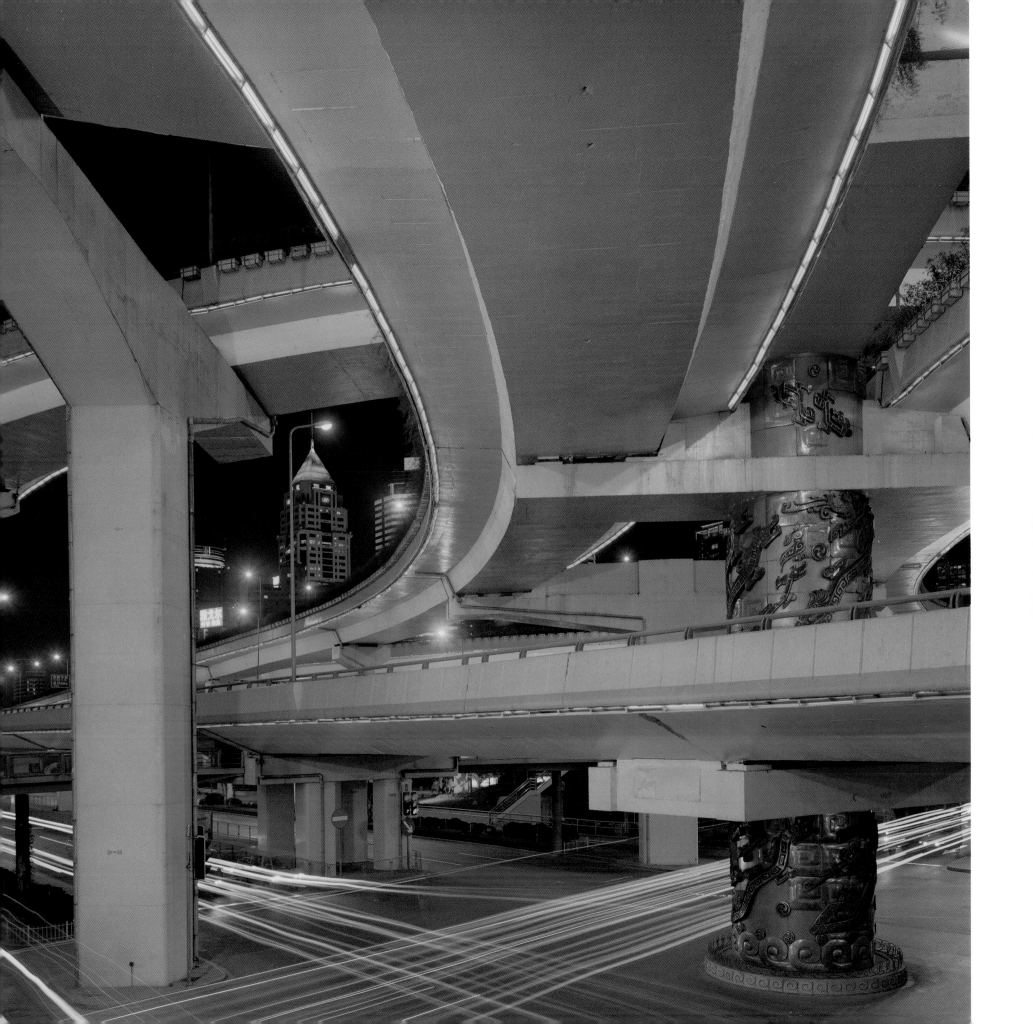

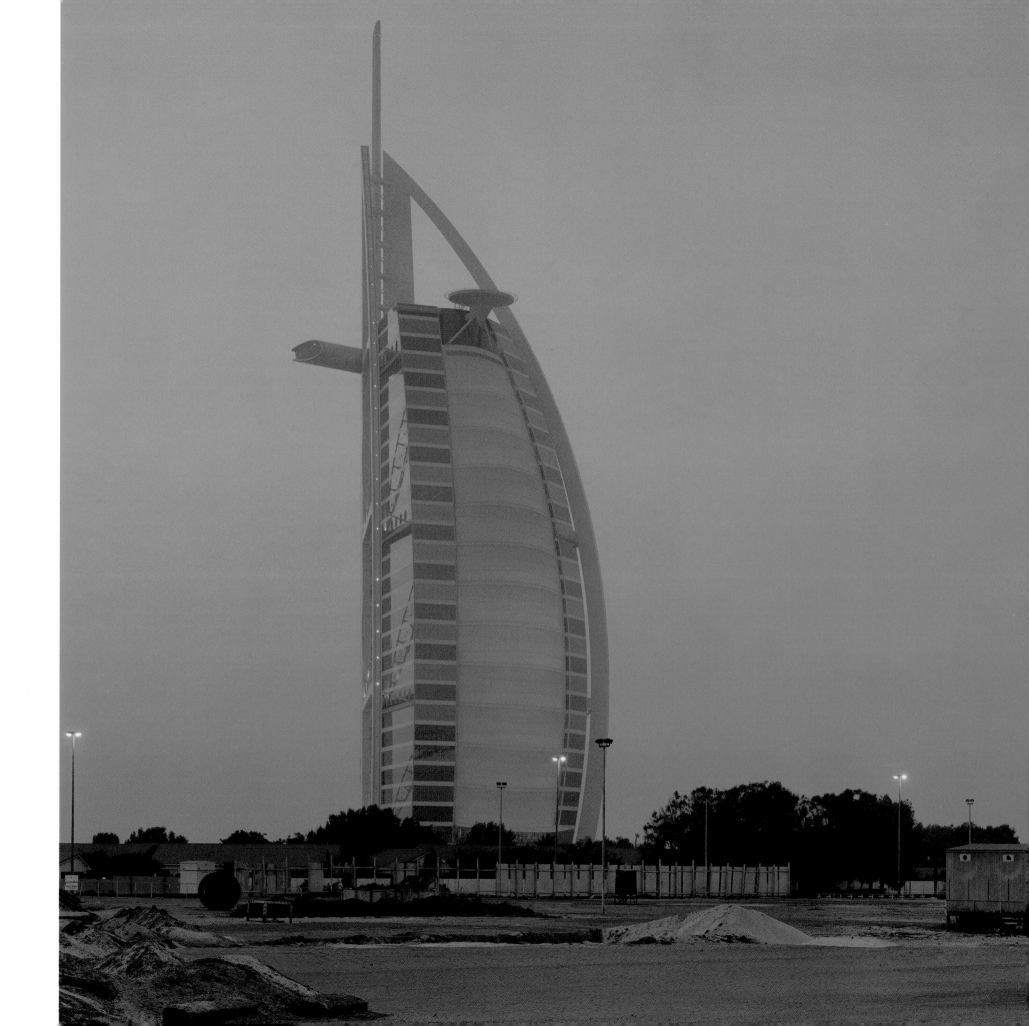

ON THE BURJ AL ARAB, DUBAI

I first spotted this view from my taxi on a highway access road coming in from the airport late at night. I saw the temporary offices and housing for the construction staff of one of the first seven-star hotels and knew I wanted that image. Even though it looked so promising and my appetite for it was way up, it was one of the last shots I took because I knew the magazine I was shooting for wouldn't run it. Why? Most architectural photographs are product shots. This is not a product shot; this is a sociology shot. The architects and editors want you to see the hotel as some sort of jewel-fantasy, which in fact is what guests staying there want to believe, too. Nobody wants a backstage shot. Nobody wants to pay for lessons in the possible class upheavals occurring around luxury projects.

31

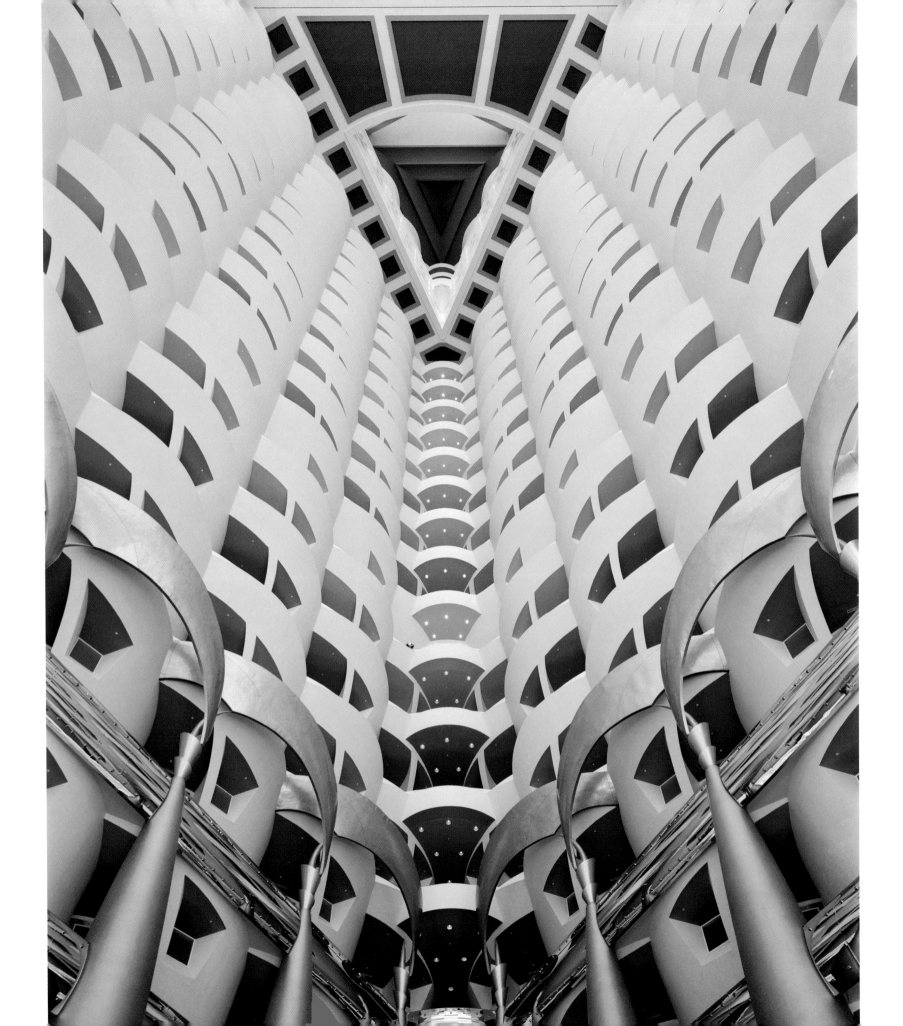

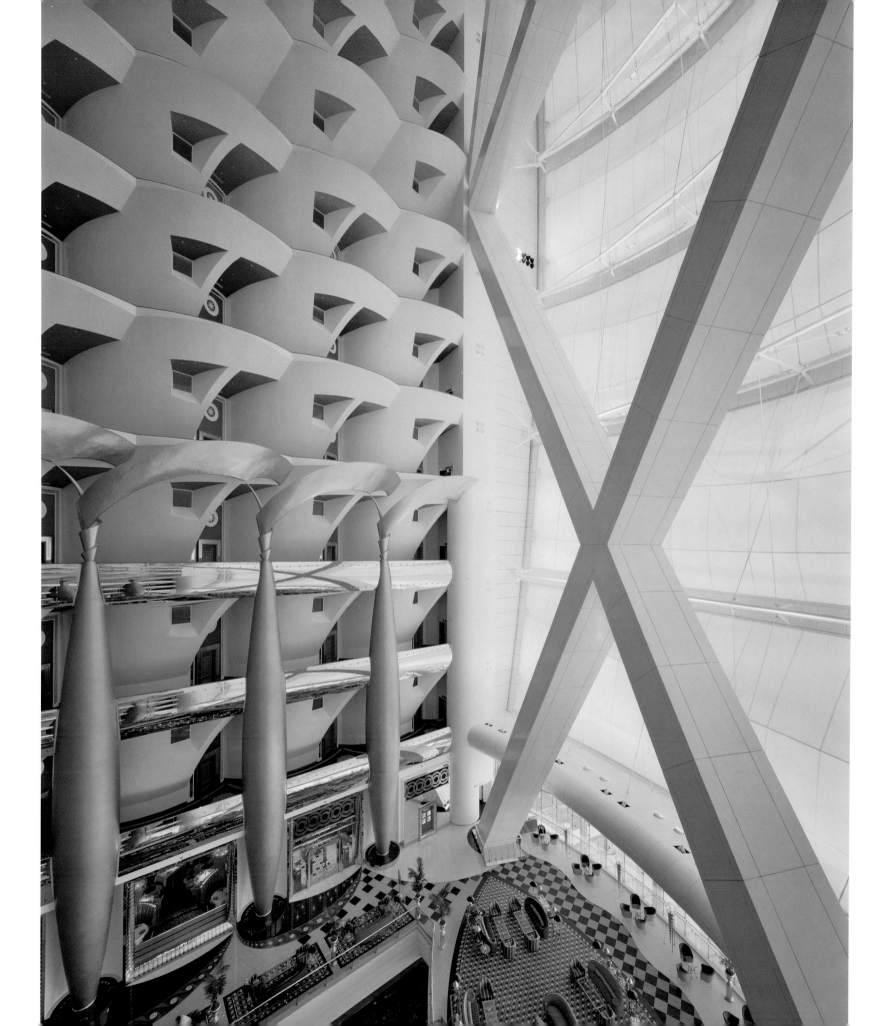

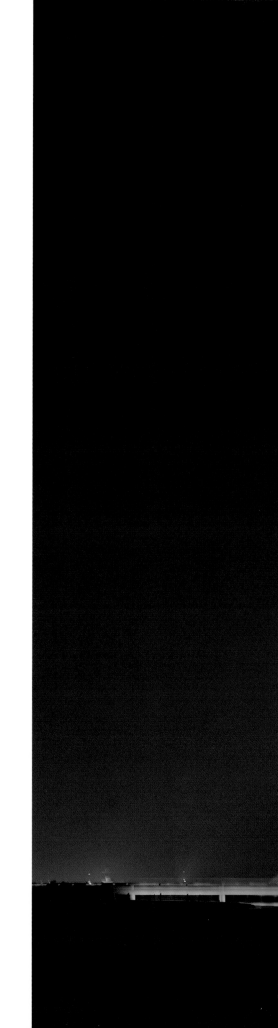

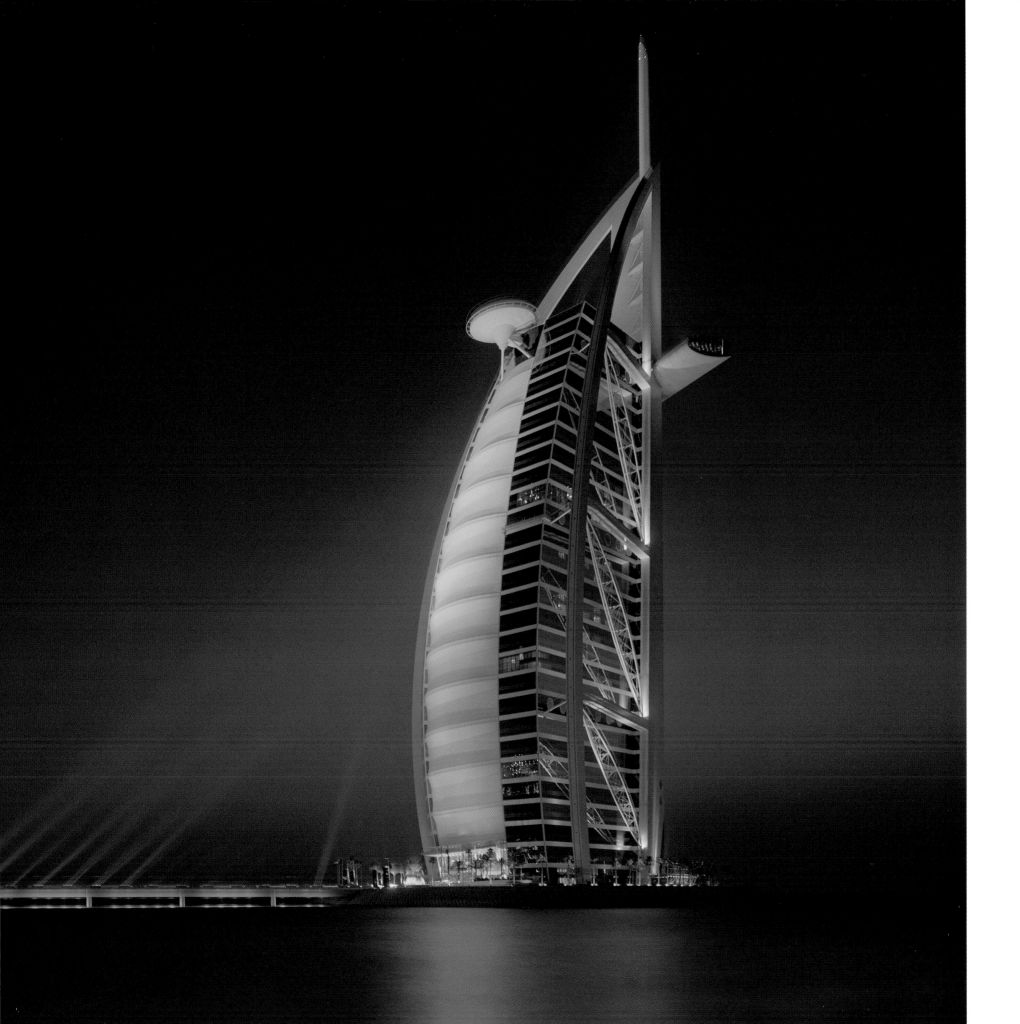

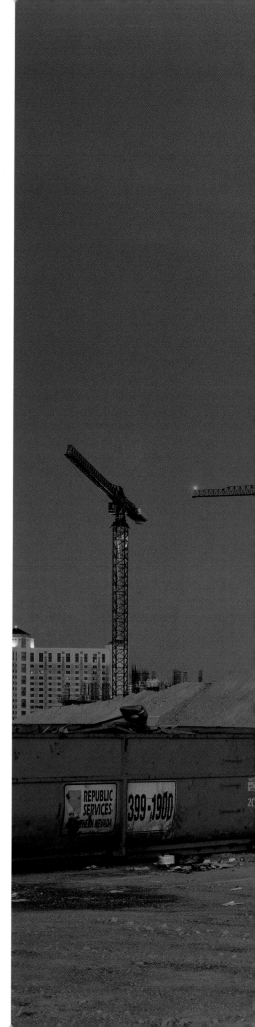

ON PHOTOGRAPHING IN LAS VEGAS

Even though it's colorful and photogenic, Las Vegas is the probably the most difficult city to photograph in the United States. That's because it's really a private city masquerading as a public one: the home of corporate-property fascism. Every single space there has layers of bureaucracy and requires tons of phone calls before you can shoot it. Las Vegas was probably better—or at least more human—when the mob ran it; maybe then there was a live person ultimately responsible that one could direct their appeals to. For an amateur photographer, walking around with a handheld digital camera, it must be paradise. But the minute you set up a tripod, it's a royal pain in the ass. Security guards and surveillance cameras are everywhere and they're all over you within minutes. There's no other option but to submit and obey.

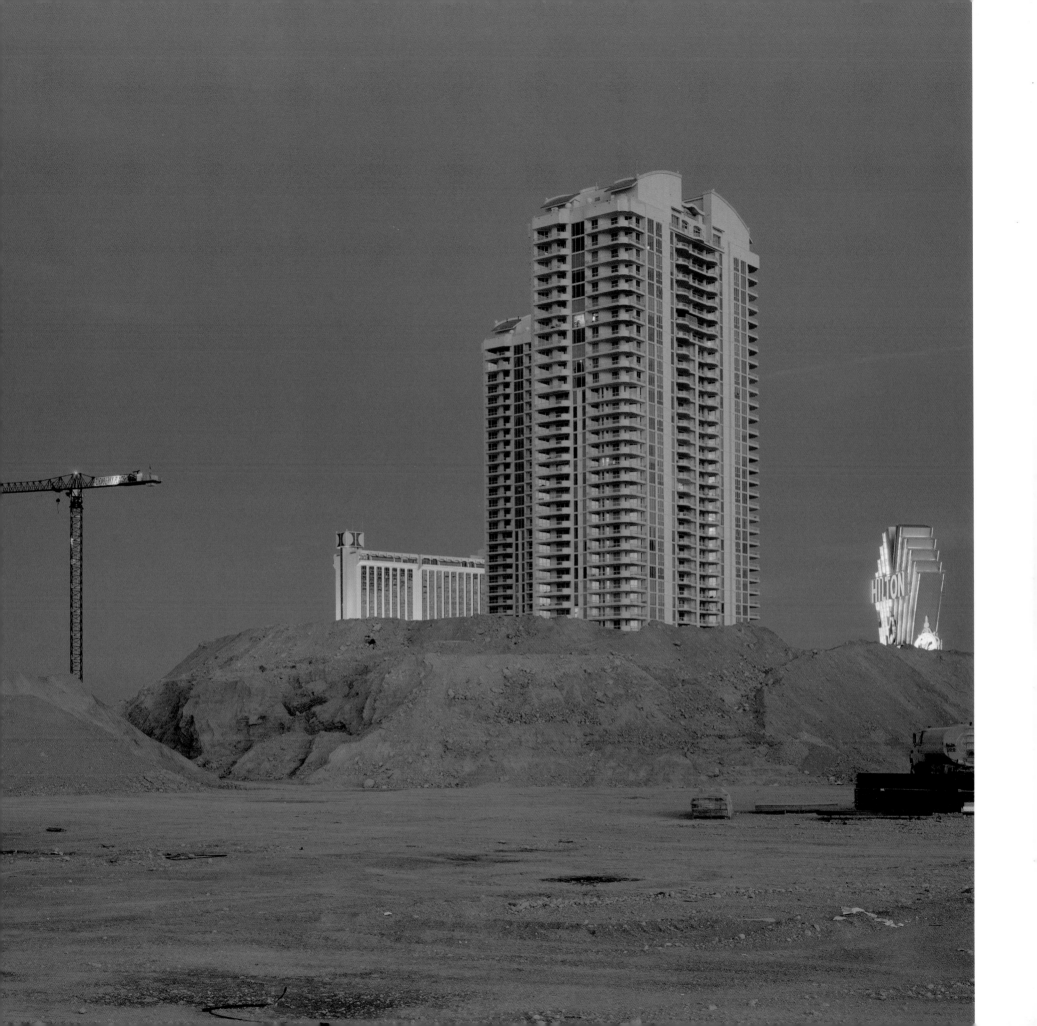

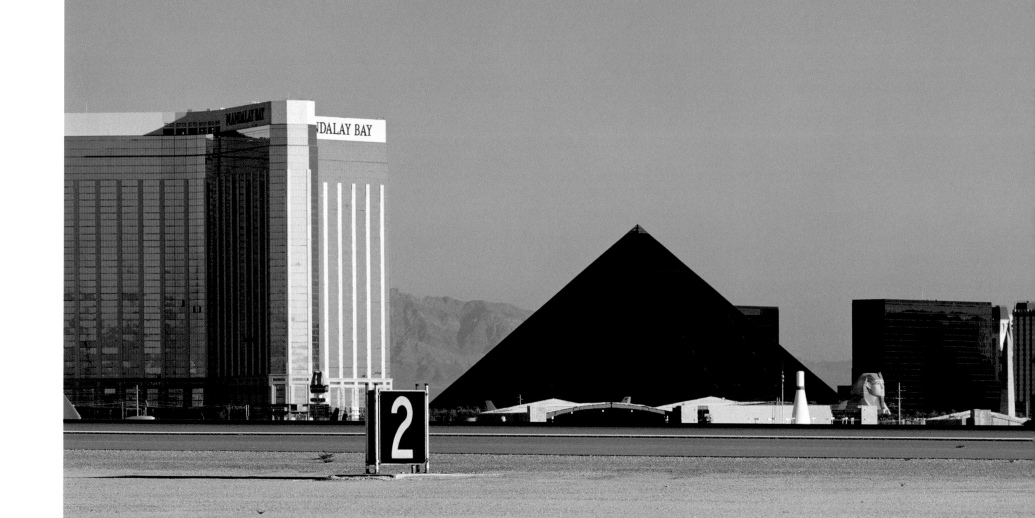

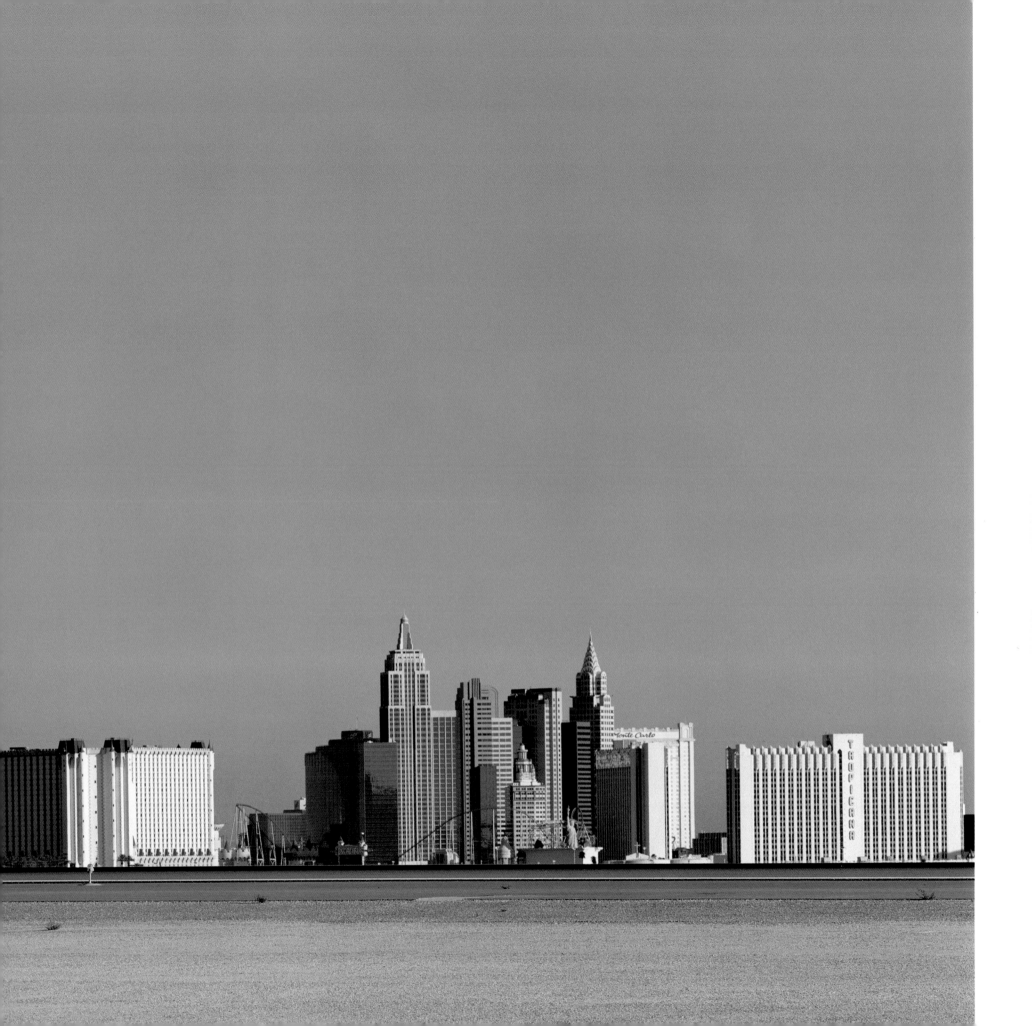

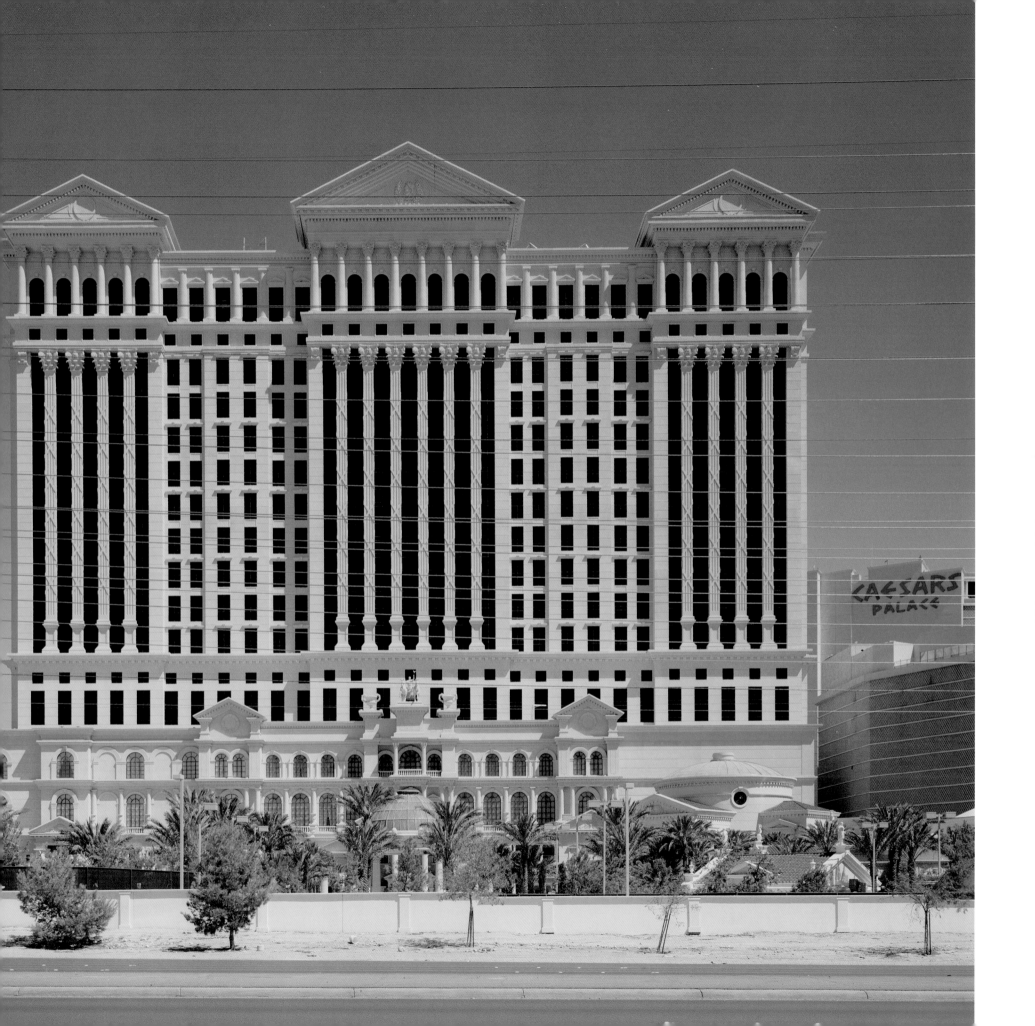

ON CEAUSESCU'S BUCHAREST

In 1977 Bucharest suffered an earthquake that caused considerable property damage. Romania's dictator, Nicolae Ceausescu —who had already demolished villages and towns and replaced them with housing blocks—took this as a sign to continue his campaign of rebuilding at a much grander scale. He leveled a huge section of the city's historic center and evicted tens of thousands of people with only a single day's notice—all this to make way for his vision of a new Bucharest. He began constructing one of the largest structures in the world, officially called the Casa Poporului (House of the People) and now referred to as either the Palatul Parliamentului (Palace of Parliament) or even the Casa Nebunului (Madman's House).

I visited in 1995, six years after the coup and execution of Ceausescu and his wife. Even though the locals knew that the palace had no rational reason for being and bordered on the delirious, they remained proud of the fact that it was the second-largest building in the world next to the Pentagon. I think it is now ranked third. I went to Bucharest to photograph two buildings: Ceausescu's country house, the Villa Primavera, and the Casa Poporului, which was to have become his residence and Parliament all rolled into one.

I shot Primavera first. It was just a normal bourgeois villa with a very large and curious indoor pool whose walls were covered with mosaiqued astrological symbols in an order that made absolutely no sense to me. The Ceausescu family's reputation for the ostentatious was legendary in Romania; one of the celebrated sore points had been the infamous gold-plated furniture and bathroom fittings. I was shocked to discover that the gilded pieces in question were nothing more than gold spray paint on cheap wood commodes. But even stranger was the almost pathologic loyalty of the state-employed housemaids and maintenance crews to

the dead and disgraced Ceausescus.

Still, I was there with the authorization of the country's Cultural Ministry and went about my work. When I shoot interiors, I occasionally move a chair or table six or eight inches to achieve a clean composition. As soon as I started doing this, the head housekeeper walked up to me and handed me her phone.

"Excuse me sir, Mr. Polidori." It was my coordinator from the Cultural Ministry. "The housekeeper has just informed us that you have moved one chair in the Primavera Salon. Could you please inform us as to why this has been done?"

"Yes. I am using a 72mm lens and my back is against the wall. If I don't move it, only a quarter of the chair will be visible on the right side of the frame. As a rule, I don't like chairs cropped. I prefer them either in or out."

"Please hand the phone back to Mrs._____."

After a few seconds the housekeeper started yelling, became red-faced and enraged, and slammed down the receiver. The timing here was unfortunate since I already knew I had to perform a similar procedure for the left side of the frame. As I quickly began moving the furniture, I made sure not to look as I heard her dialing the phone. Hurrying, I managed to take the shot just before she handed me the phone again.

"Mr. Polidori?" the coordinator asked.

"Yes, it's me."

"Would I be correct in assuming that the other chair was moved for similar visual photographic reasons?"

"Correct."

"How many more photographs with furniture movings do you foresee executing?"

"I don't know. I don't usually count beforehand. Please tell her these are small adjustments. After taking the shot, I will move them back to where they were before."

"Unfortunately, no. She must be

informed of every change. In fact, these changes are never allowed unless validated by a written permission signed by the Cultural Minister himself. I shall do my best to get these by, but since I am leaving soon I would suggest that it would be advisable if you would refrain from further furniture movings." The coordinator went on to say that the housekeeper had actually worked in the villa as part of the Ceausescus' personal staff. They had met her in a rural village while she was still an adolescent, and she had worked in their house ever since. She remained fiercely loyal to them. In a more embarrassed and apologetic tone, the coordinator explained that even though the regime had been overthrown, old habits die hard.

The next afternoon I took interior shots of the Casa Poporului. I guess news of my altercation at the villa had shot up the chain of command. When I arrived the Cultural Minister himself ushered me into the large ceremonial rooms on the ground floor. He was a tall, sophisticated man in his late thirties who took a kind of ironic pride in witnessing how flabbergasted I was walking through the vast number of huge, high-ceilinged rooms. Wanting to avoid yesterday's fiasco, I immediately determined which rooms I wanted to photograph since time was short. I wasn't even finished with my first set-up when suddenly I was jolted by a voice behind me. I turned and saw a uniformed woman dragging a vacuum cleaner, yelling at the minister. What's up this time, I wondered. I'm innocent—I didn't move anything. He responded in a firm, composed voice, though I did notice a slight sign of apprehension in his face. She continued to protest my presence, but finally acquiesced by yanking the cord of her vacuum cleaner from the wall socket and storming out. I looked at the Cultural Minister, who shrugged and said, "Unfortunately, we have interrupted her normal routine."

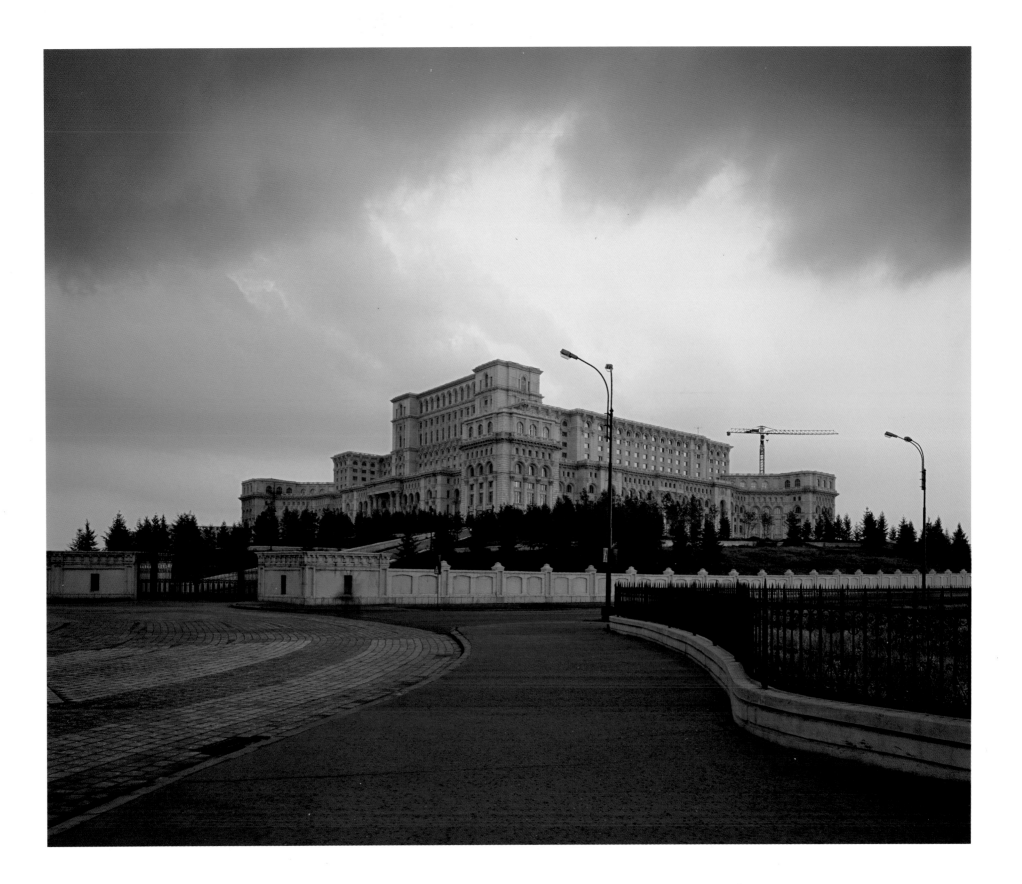

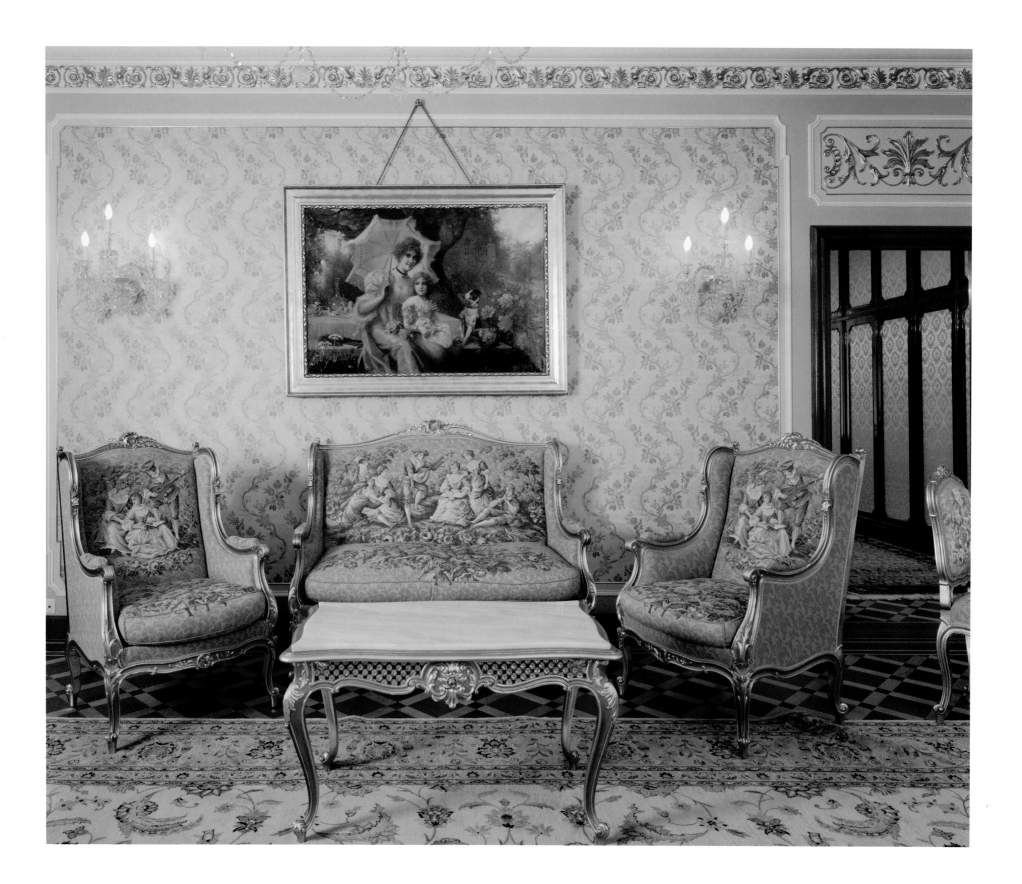

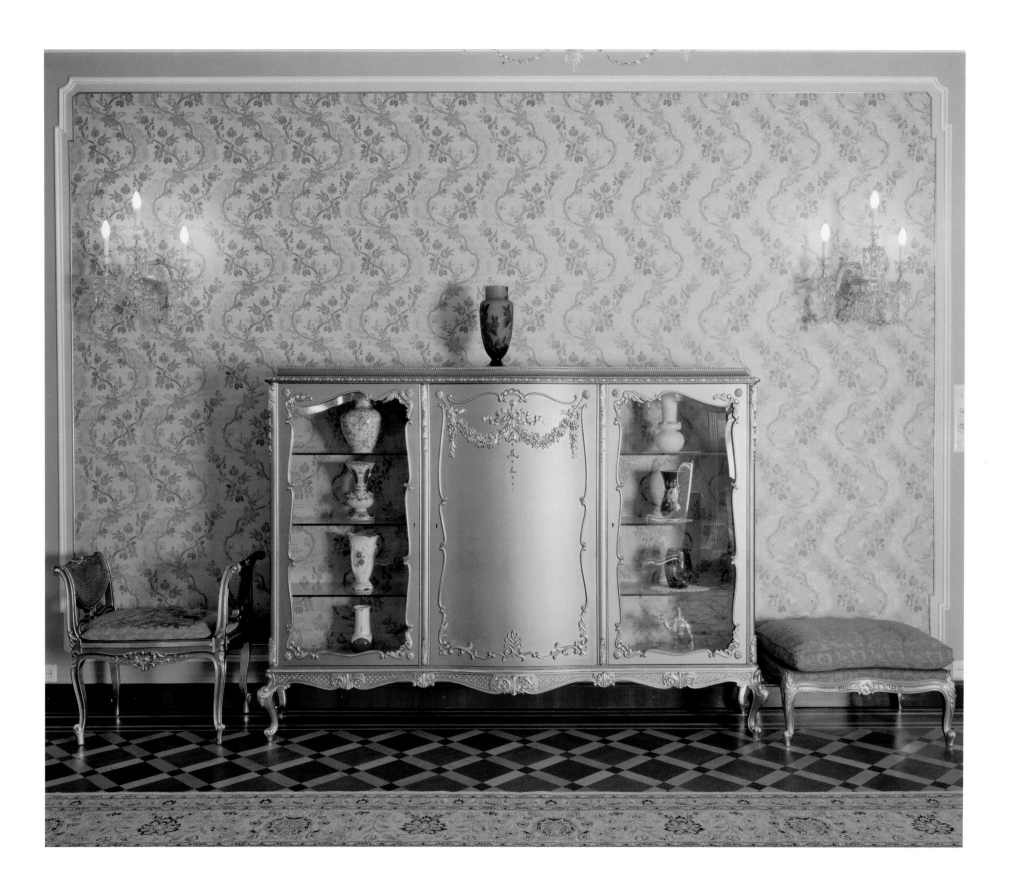

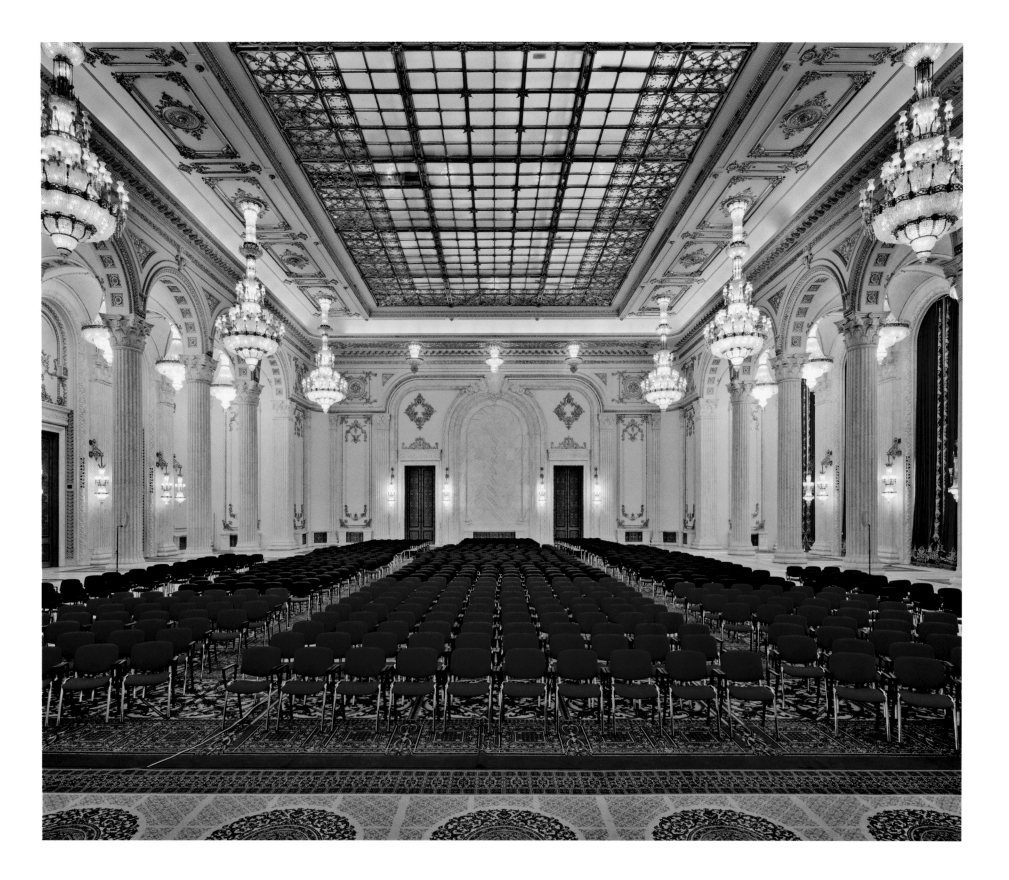

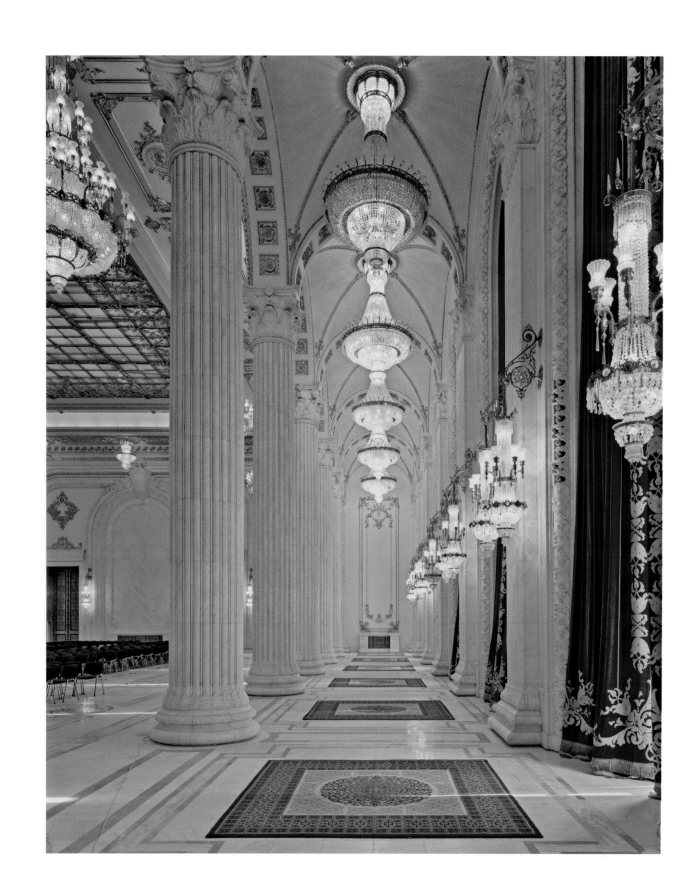

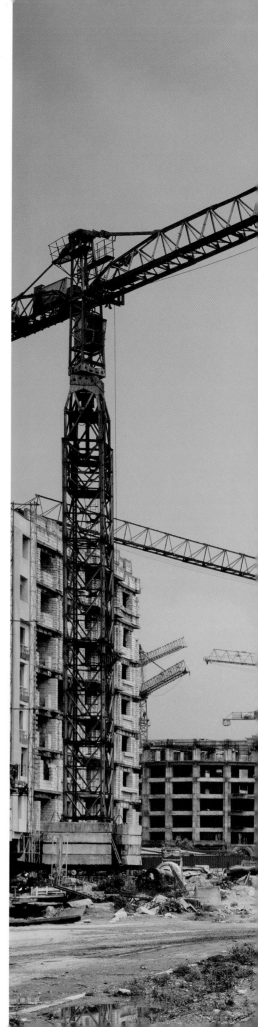

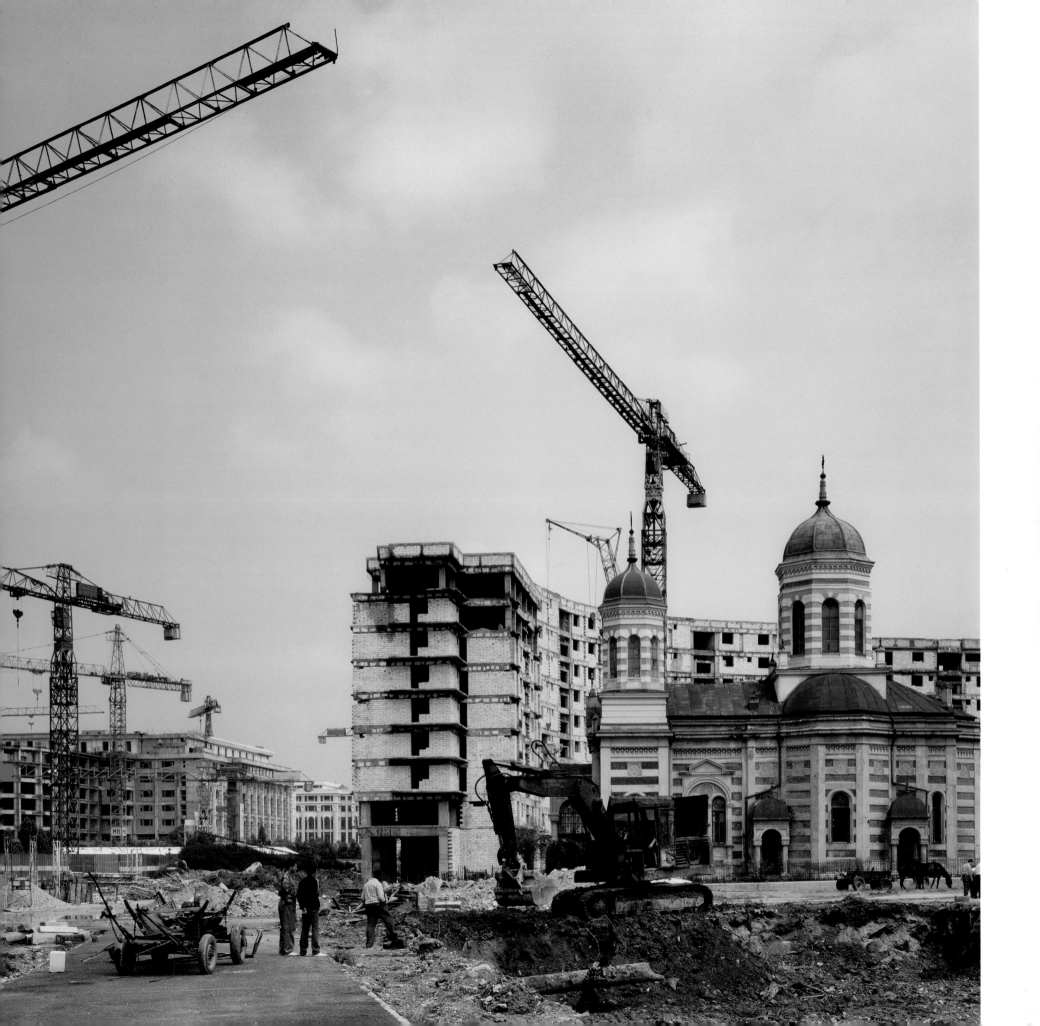

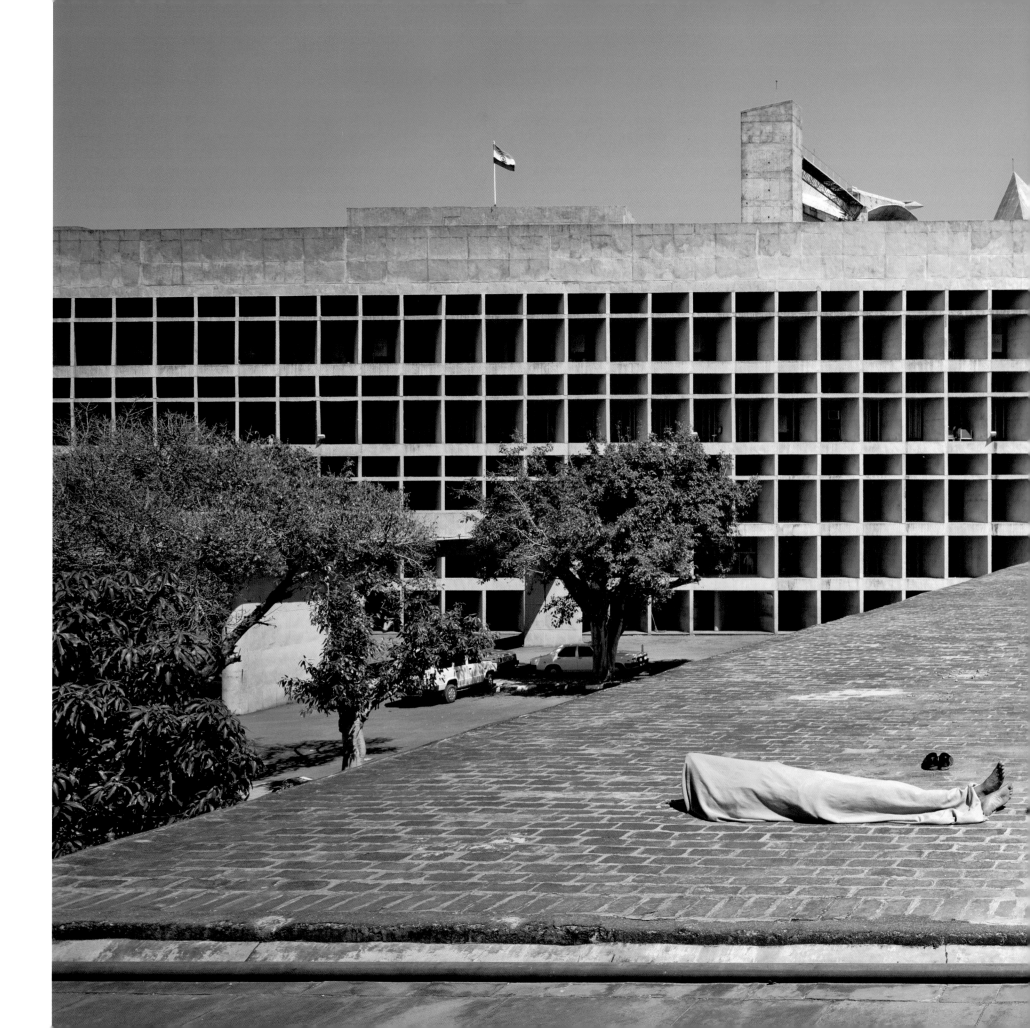

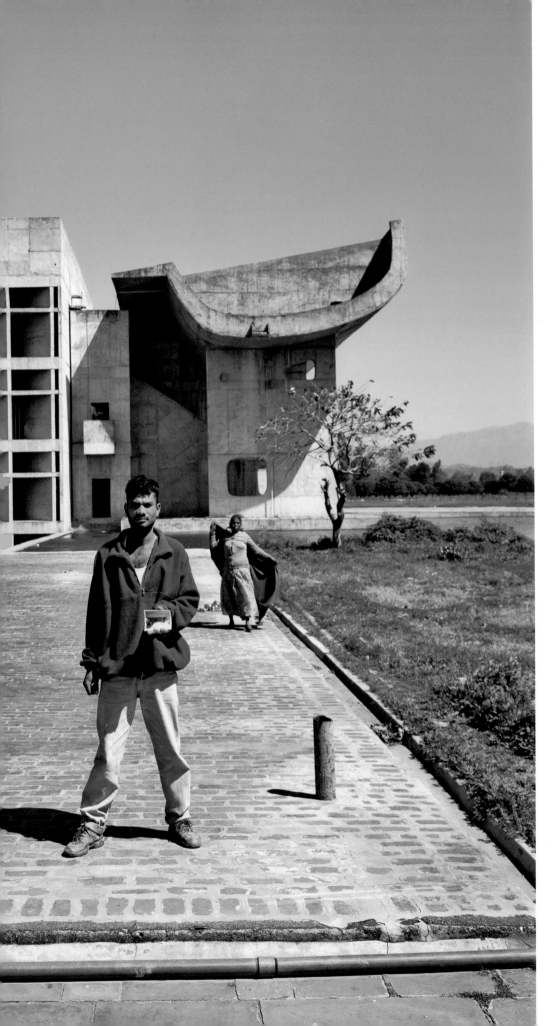

ON CHANDIGARH

The period after World War II inspired the notion of the ideal capital. Two of the most significant examples are Brasília and Chandigarh. The latter is Le Corbusier's capital for the Indian state of Punjab, which replaced Lahore after it was lost to Pakistan in the painful partition of August 1947. So the creation of Chandigarh became important for the country's self image. India had worked hard to rid itself of colonialism, but that didn't mean it rejected all things Western. On the contrary, it's proud of being open-minded. Part of this open-mindedness was an embrace of modernism.

Chandigarh is an outgrowth of this attitude. Le Corbusier conceived of the capital almost as an intellectual construct. The reigning metaphor is city-as-body. Chandigarh is divided into numbered sectors. The northern sector, where the government buildings designed by Le Corbusier are located, is Chandigarh's "head." This is home to the Secretariat, the Palace of Assembly, and the Palace of Justice—the classic Chandigarh of architectural lore. The opposite end—"the feet"—is where the people live. These residential sectors feature something quite rare in India: open space. Housing units are often placed in a quadlike configuration with a large communal space in the middle. And India being India, these are populated by cows, people, commerce—they're teeming with life. Now I must confess that I'm not a big fan of Le Corbusier. I find his approach intellectually overbearing and insensitive to local culture. Suryakant Patel, an Indian architect who worked on Chandigarh, once told me that Corb could be "quite cross with the clients and bully them into accepting everything he wanted." I don't think Le Corbusier was sensitive about what Indians could teach *him*. Regardless, the residents find their city clean and orderly. The open spaces make for a relaxed way of continuing their village traditions in a modern urban context. 51

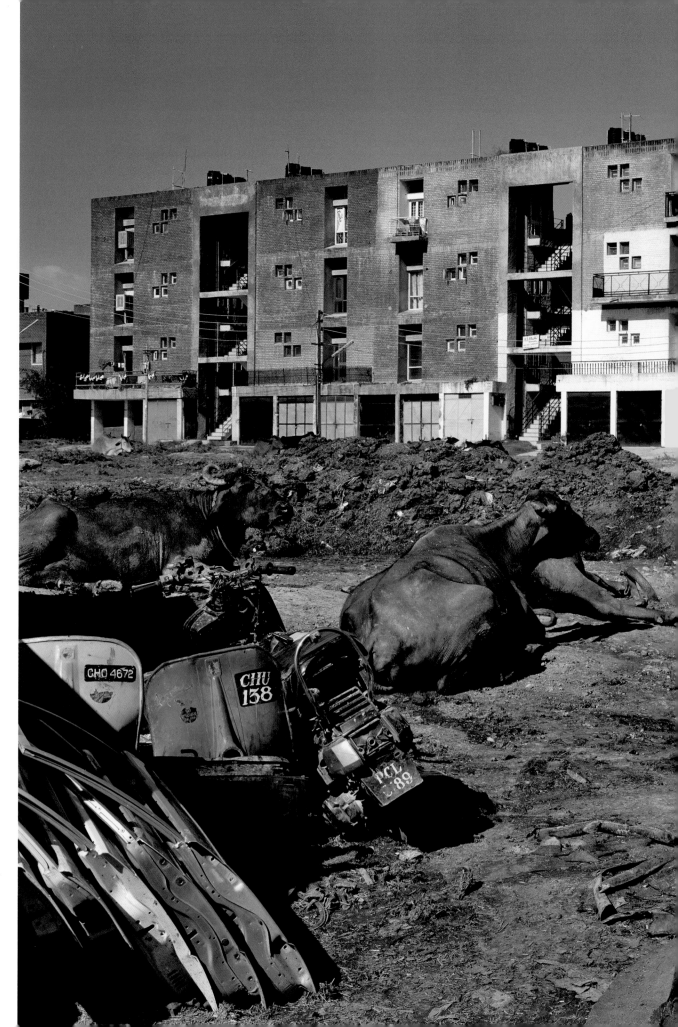

I visit India a lot and love the people. The Indian way of life tries to find physical manifestations for spiritualism. Indians are not hung up on notions of paradise or heaven. And what I love about their gods—and the mythic stories they use to define them—is that they have human motivations with superhuman powers. Western gods do not have human motivations, which is what makes their religions blind and uncompromising. It's an all-or-nothing game. Indians view god as a way to help them understand their place in the cosmos. That's what attracts me to India—their civility, their love of wisdom, the seeming modesty of their gods. Until I visited Chandigarh, I'd never shot a building designed by Le Corbusier. The truth is I'm still not drawn to his architecture (and I hated his plan for Paris). But Indians love his city of Chandigarh. So who am I to judge?

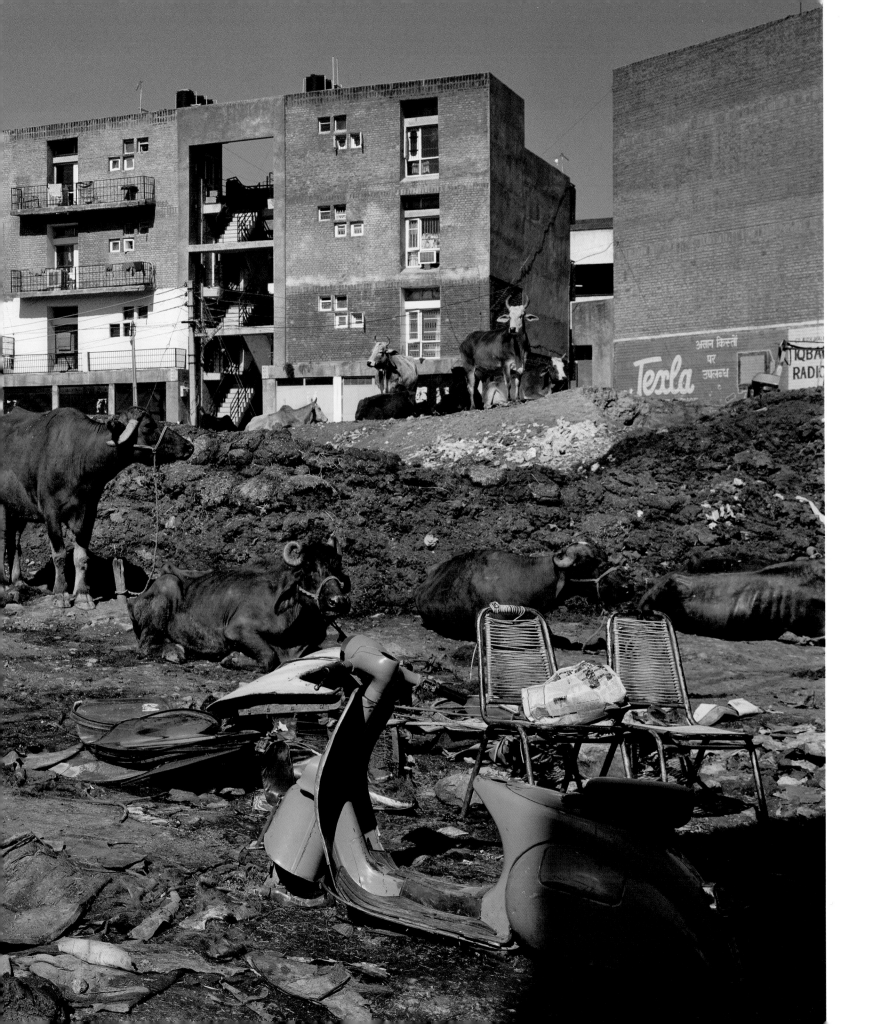

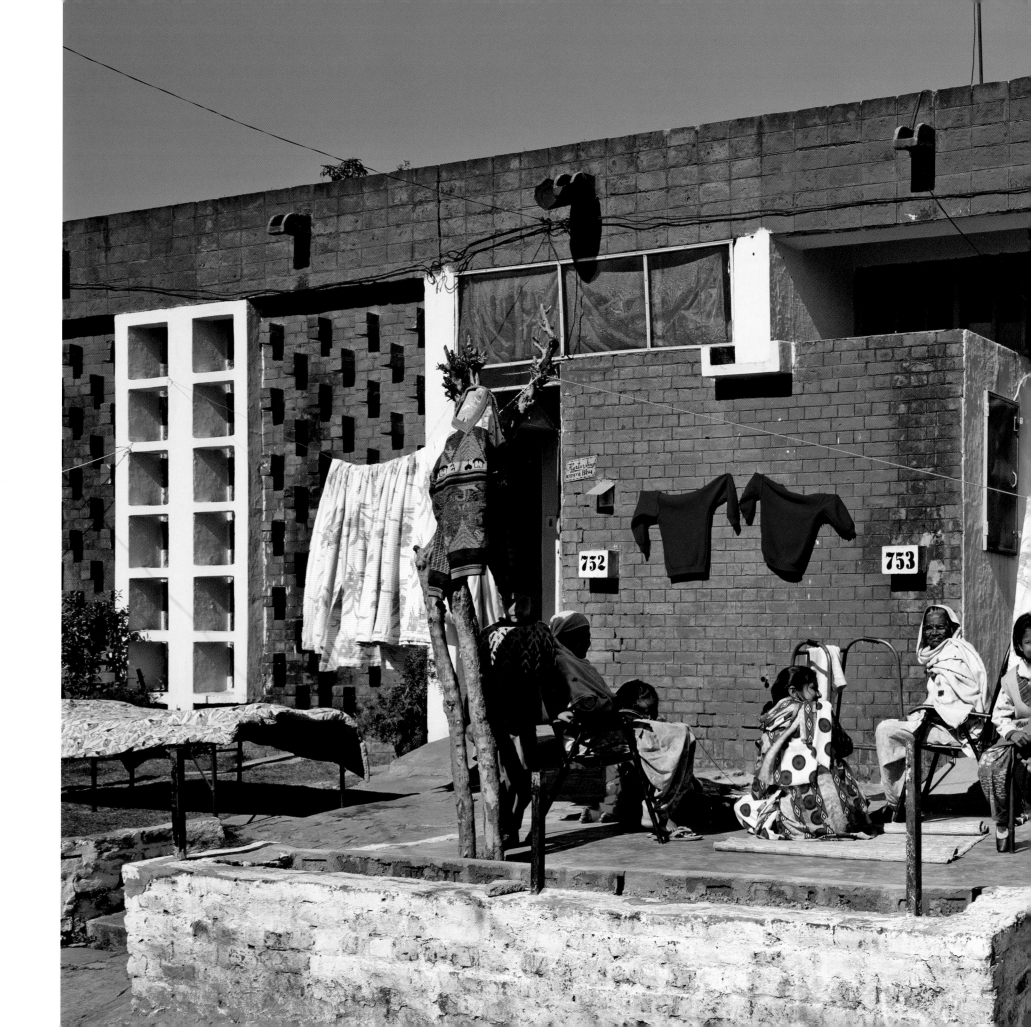

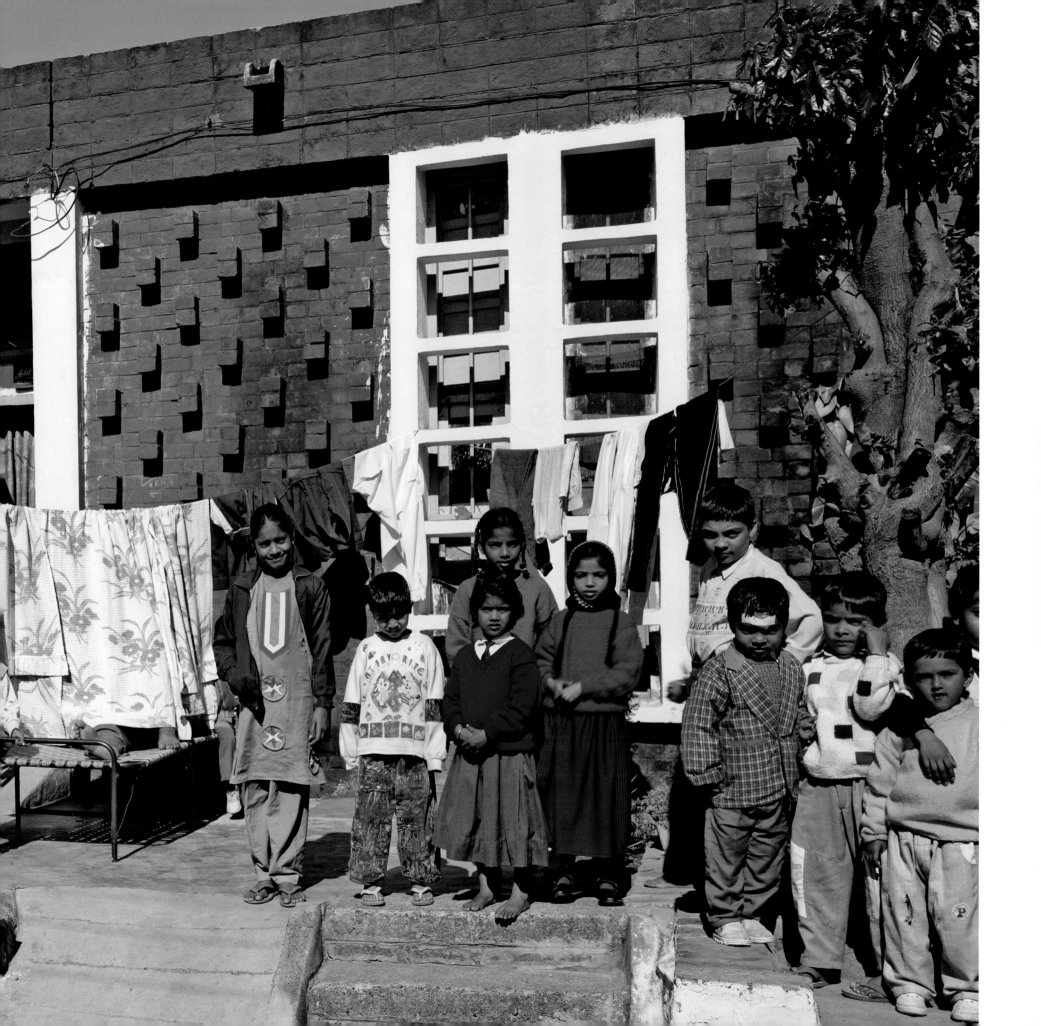

ON BRASÍLIA

I just love Brasília. When I was growing up in the 1950s and '60s and the idea of the future was still an optimistic and expansive concept, the topic of Brasília would invariably come up. Then in the '80s and '90s the world changed, and the future became more about limits and diminishing returns. So today we don't dwell on utopian cities of the future—and Brasília isn't a hot topic. When I was asked to go there I thought I was going to cover a "Paradise Lost" type of story, but to my surprise it turned out to be more "Unfinished Masterpiece."

Brasília is a rare case study where most of the significant public buildings are designed by one architect, Oscar Niemeyer. To say that these buildings are stunning is an understatement. What's great about them? The use of the horizontal expanses championed by Mies van der Rohe, combined with the stylized sensual wit of the curve? Yes, that's part of it. But Brasília's profound charm was best summed up by a remark I once overheard at an exhibition featuring Niemeyer's work. "Look," the gallery visitor said, "the buildings are like UFO's! They levitate!" I don't know about the UFO part, but Niemeyer's buildings give the illusion of near weightlessness. They do seem to levitate. So it's about the future after all.

My only problem with Brasília—and why I could never live there—is that it's an automobile town. Still, Niemeyer remains my favorite living architect. I used to live on New York's Upper West Side and every time I walked down Broadway I'd think: Gee, Brasília minus the spirit and sex appeal equals Lincoln Center—a cheap imitation of the real thing.

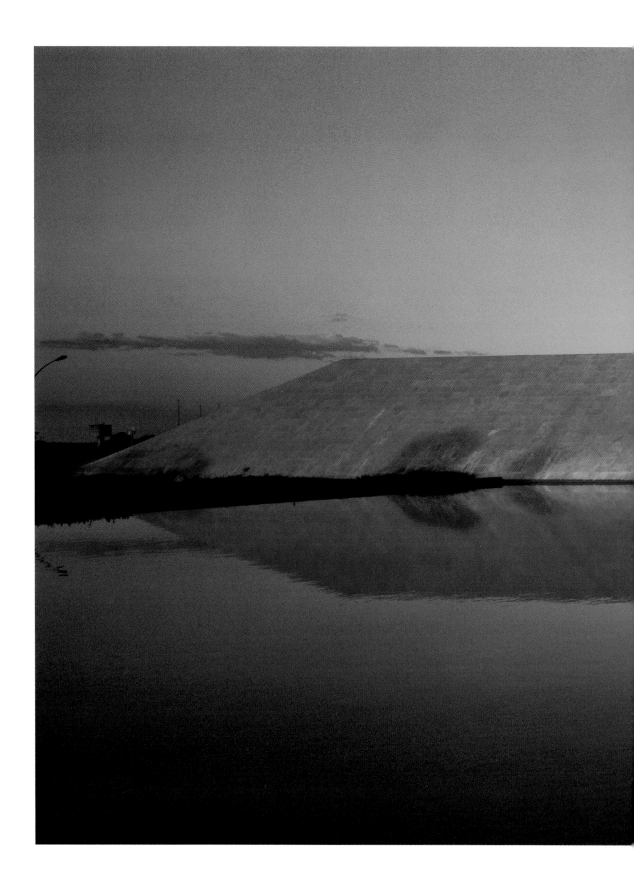

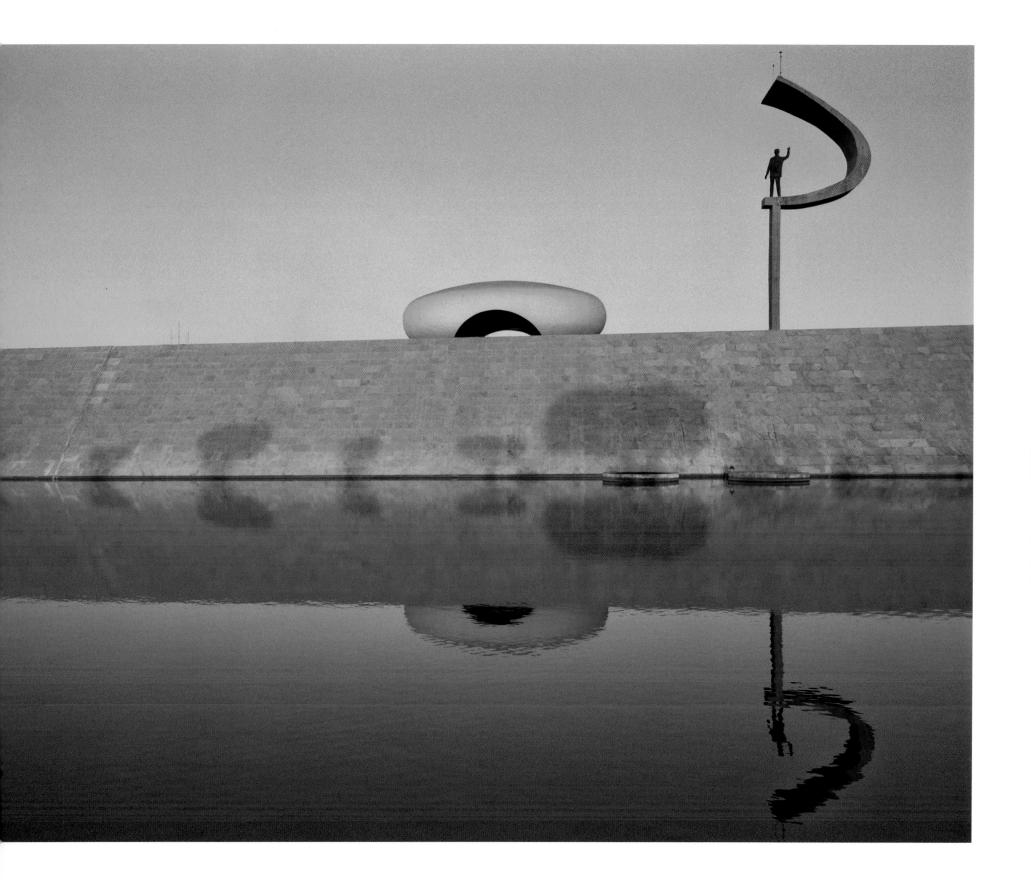

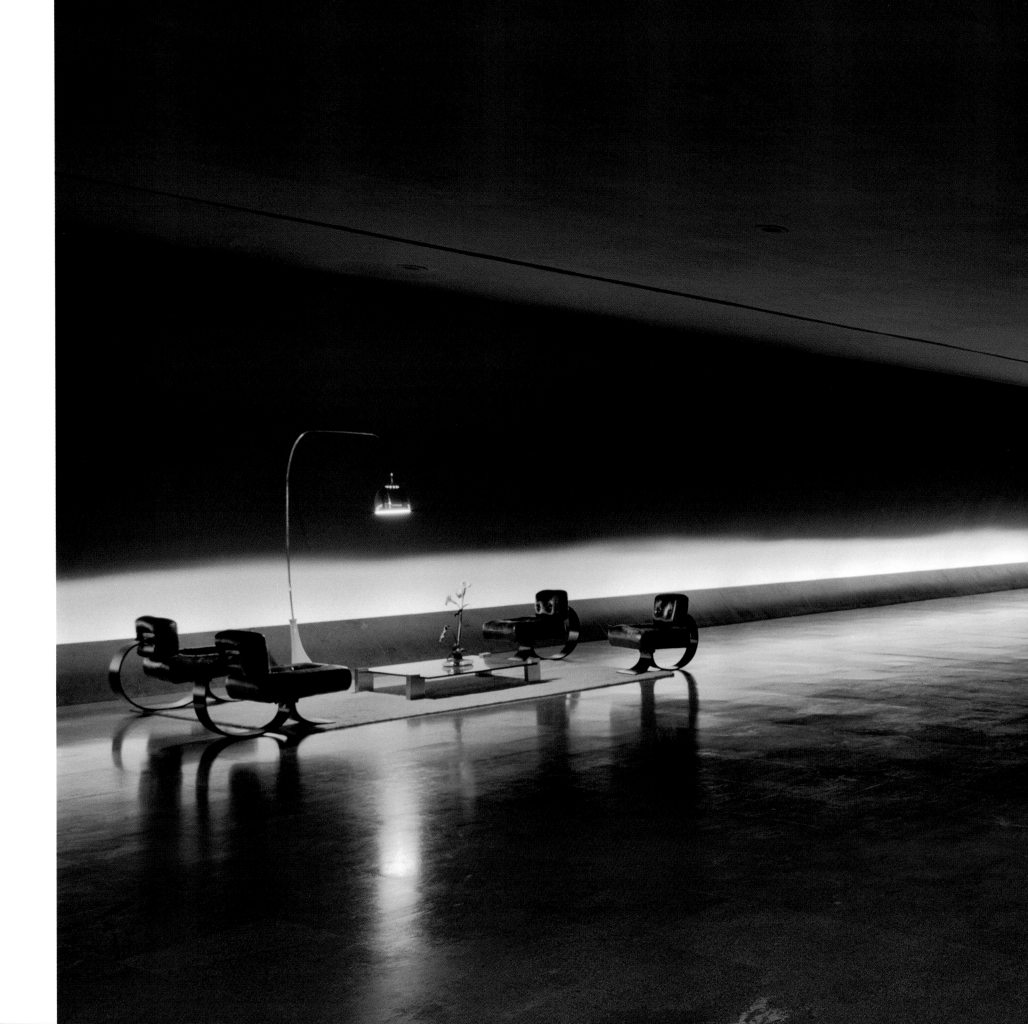

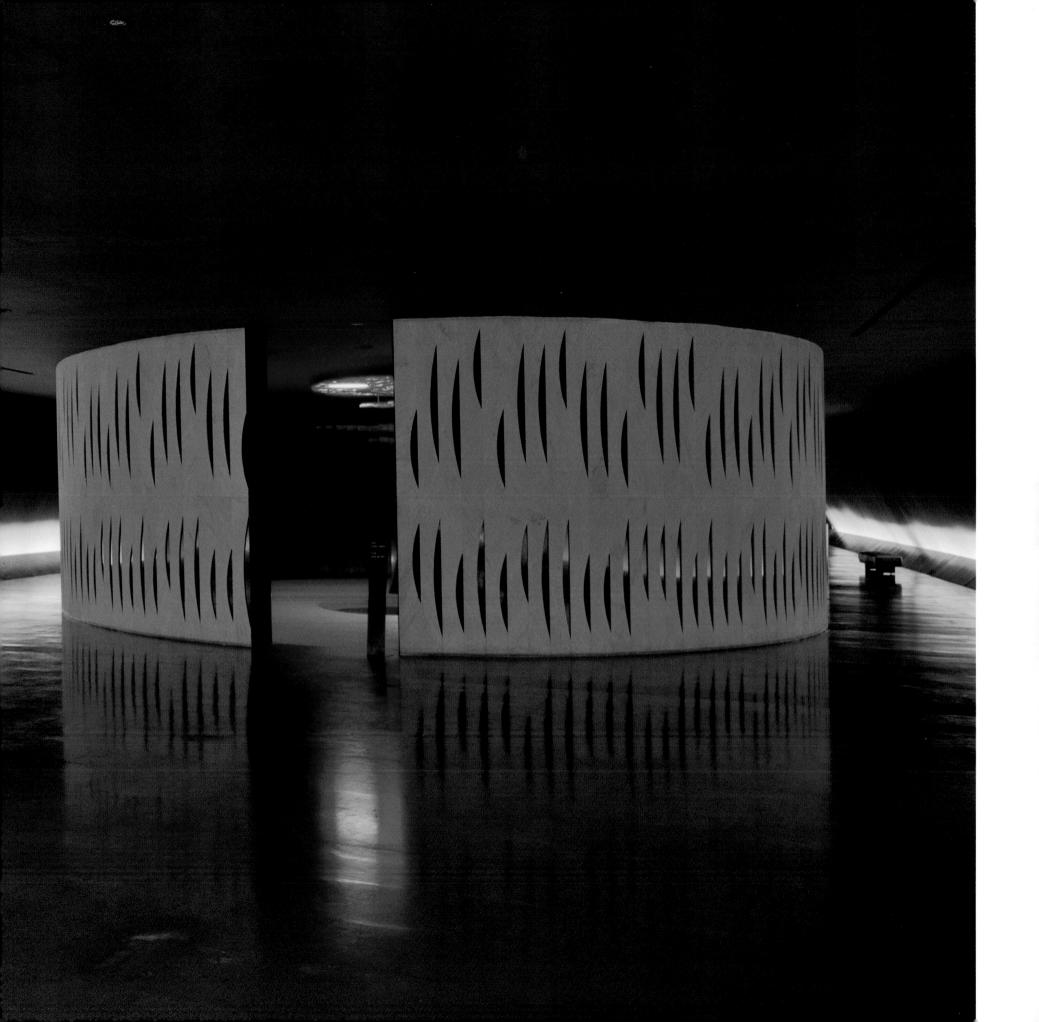

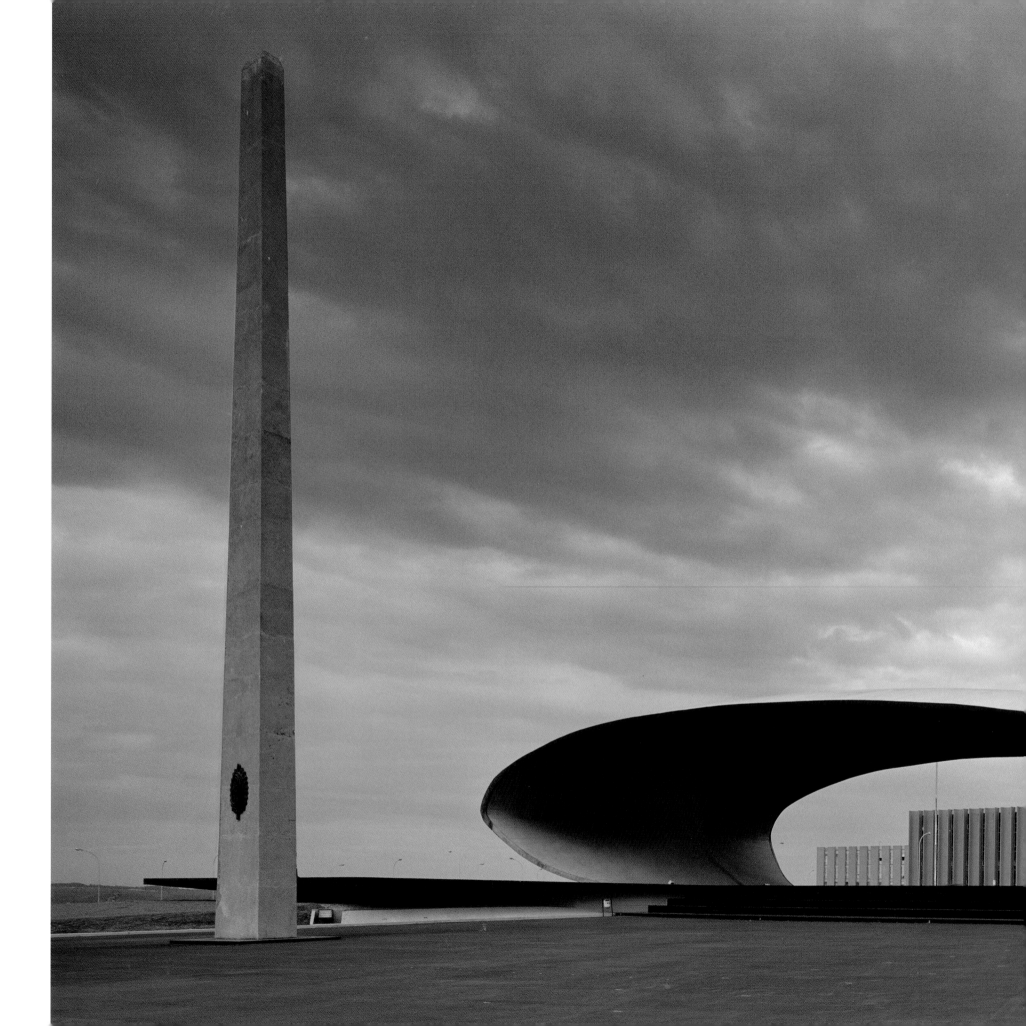

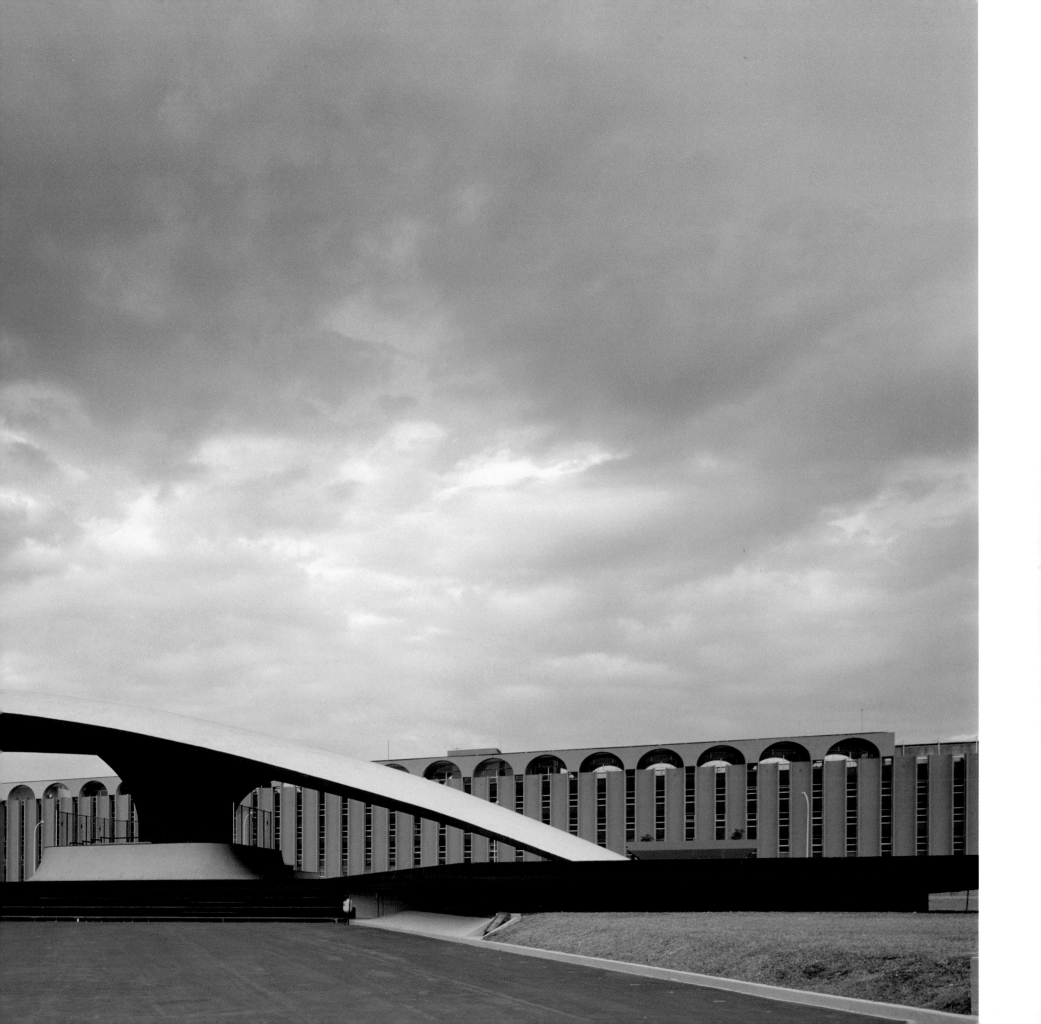

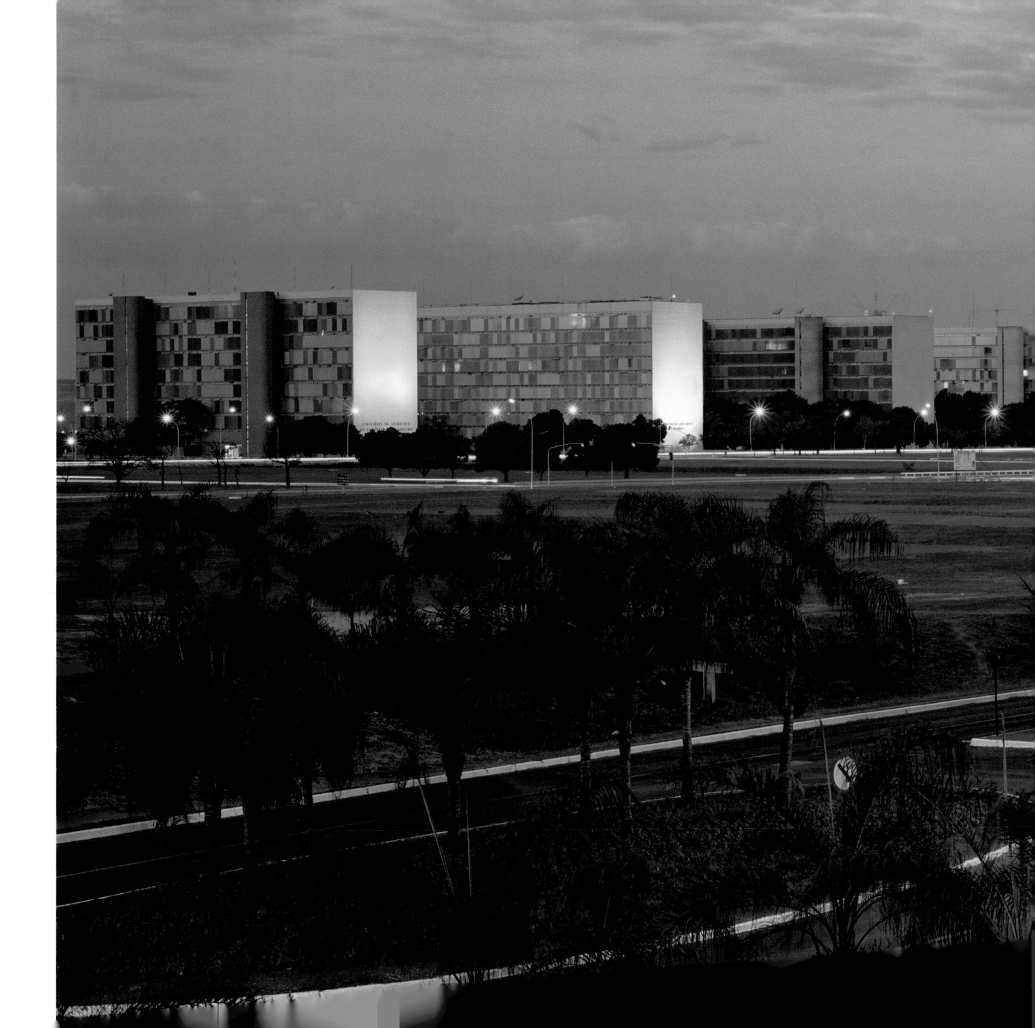

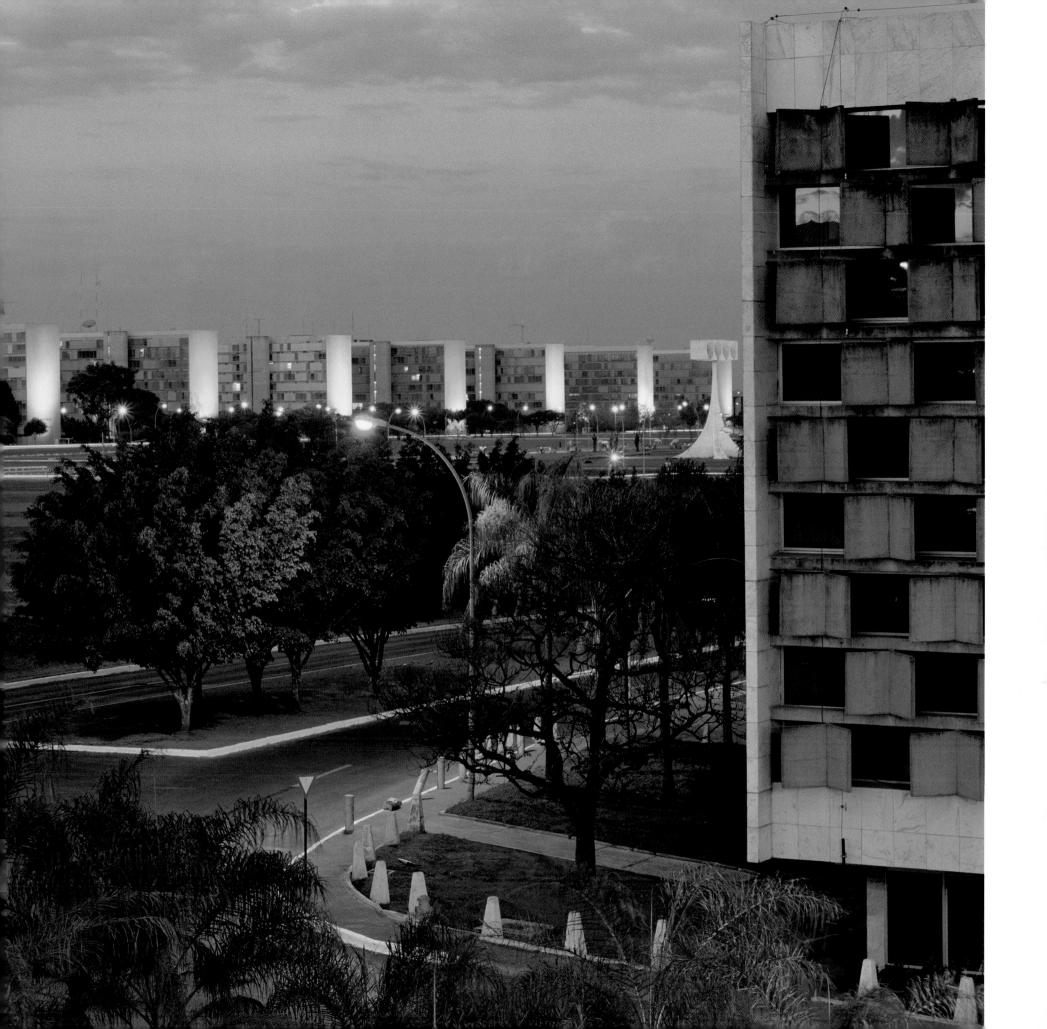

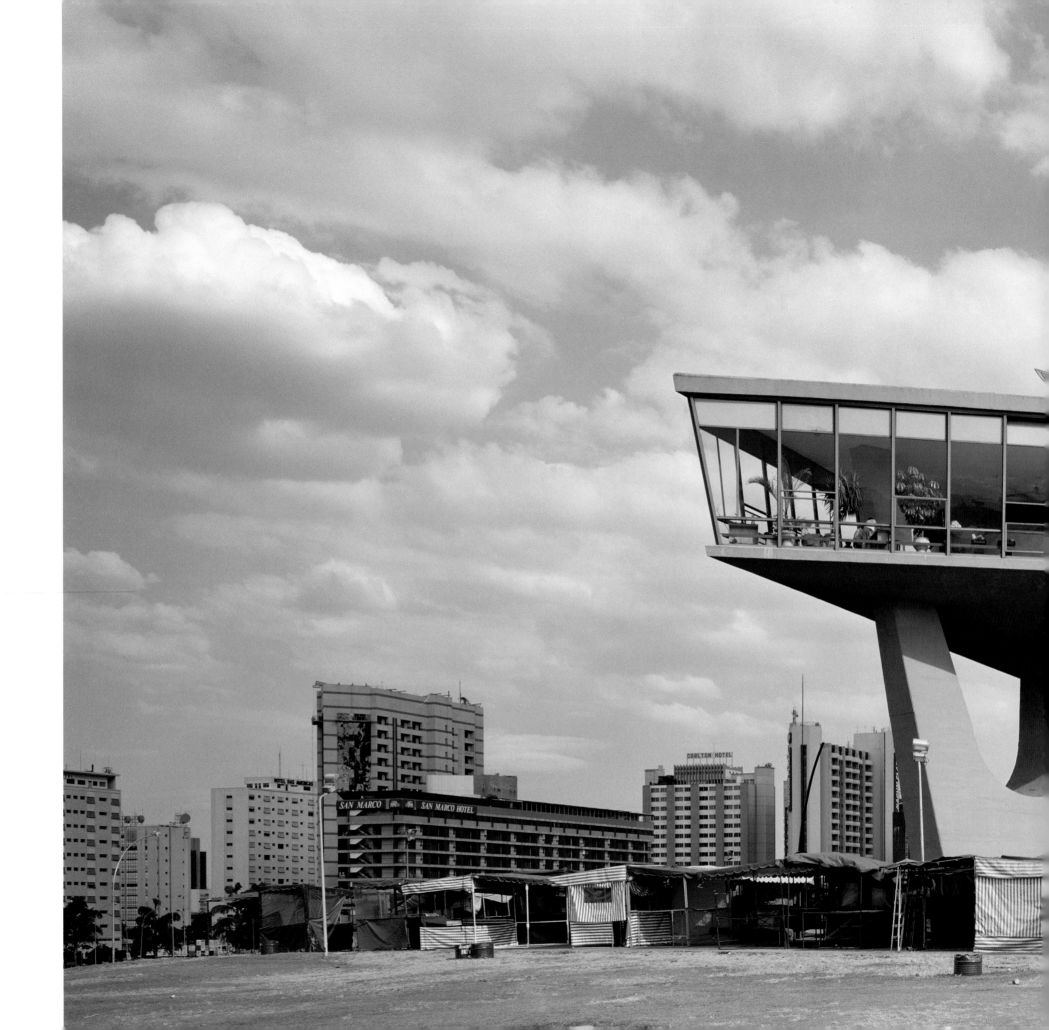

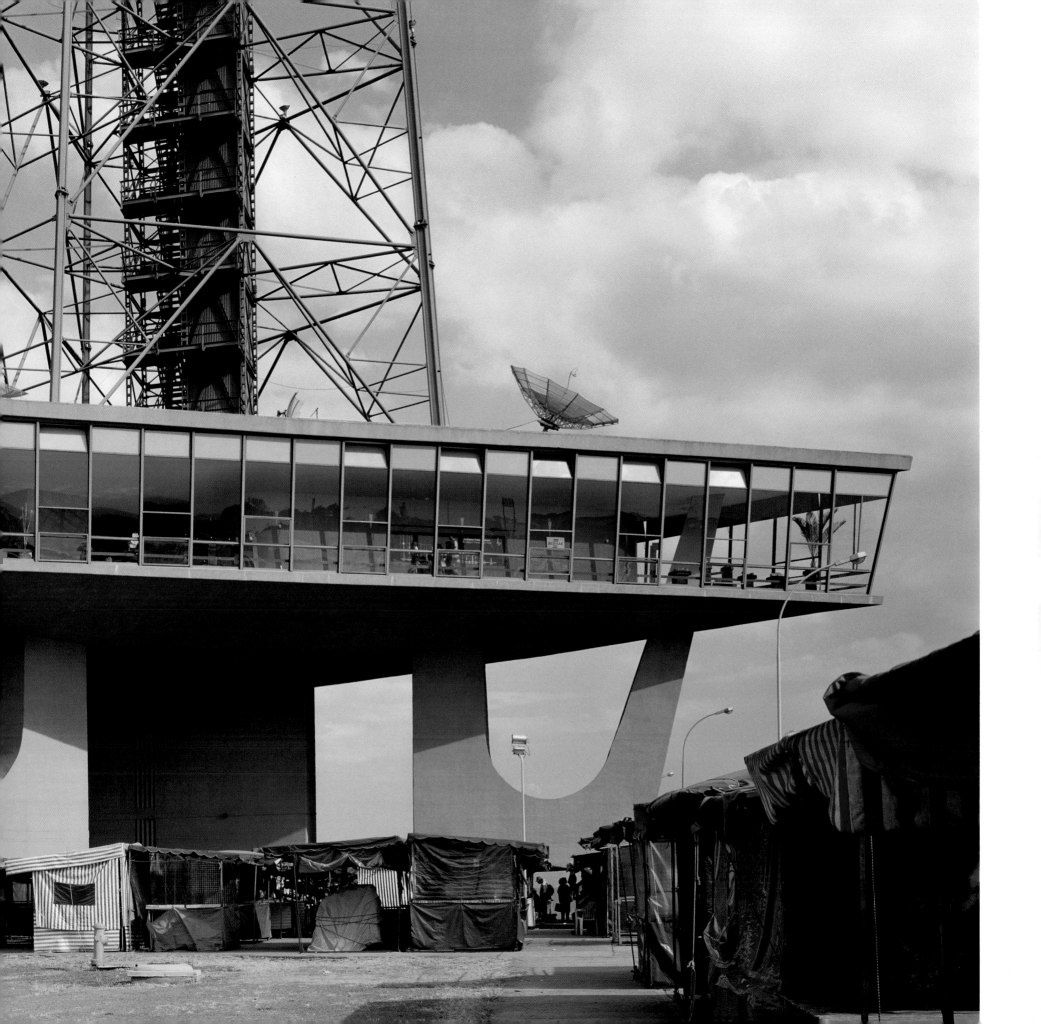

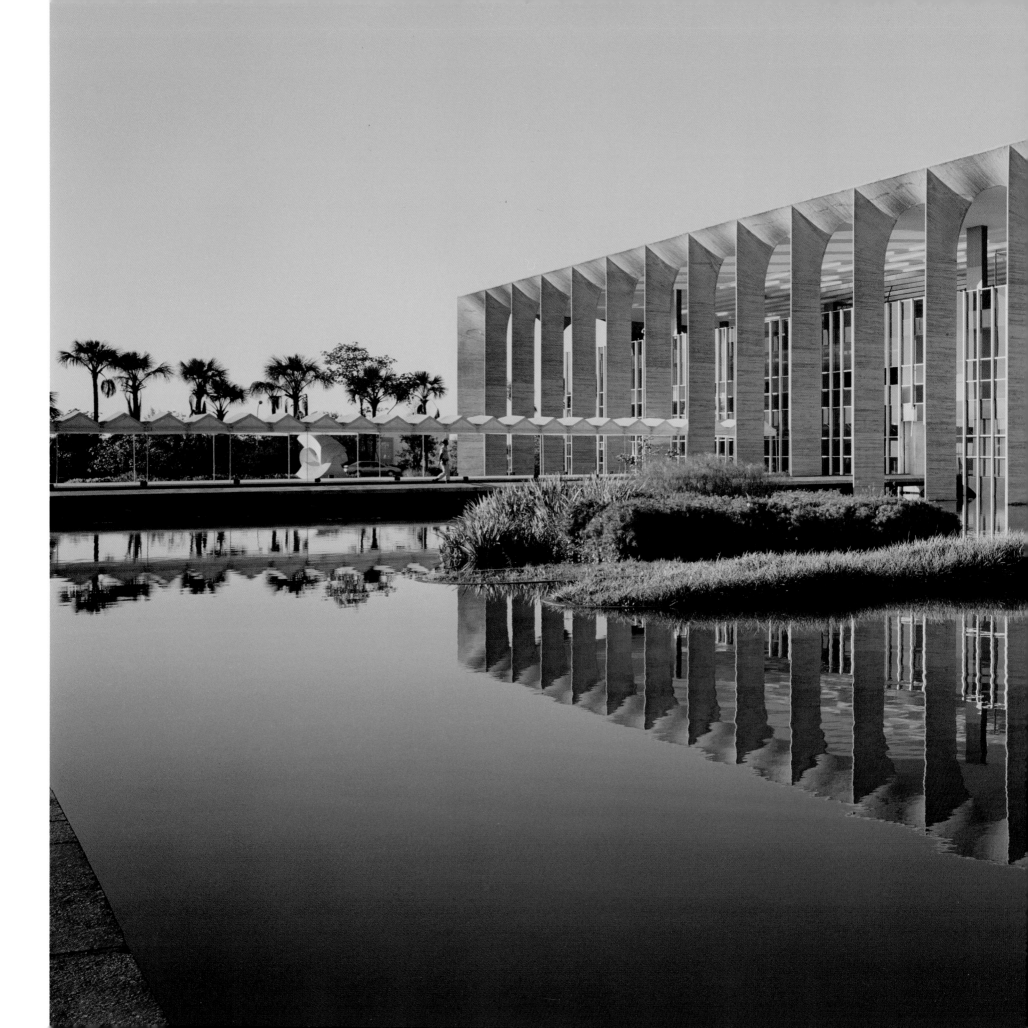

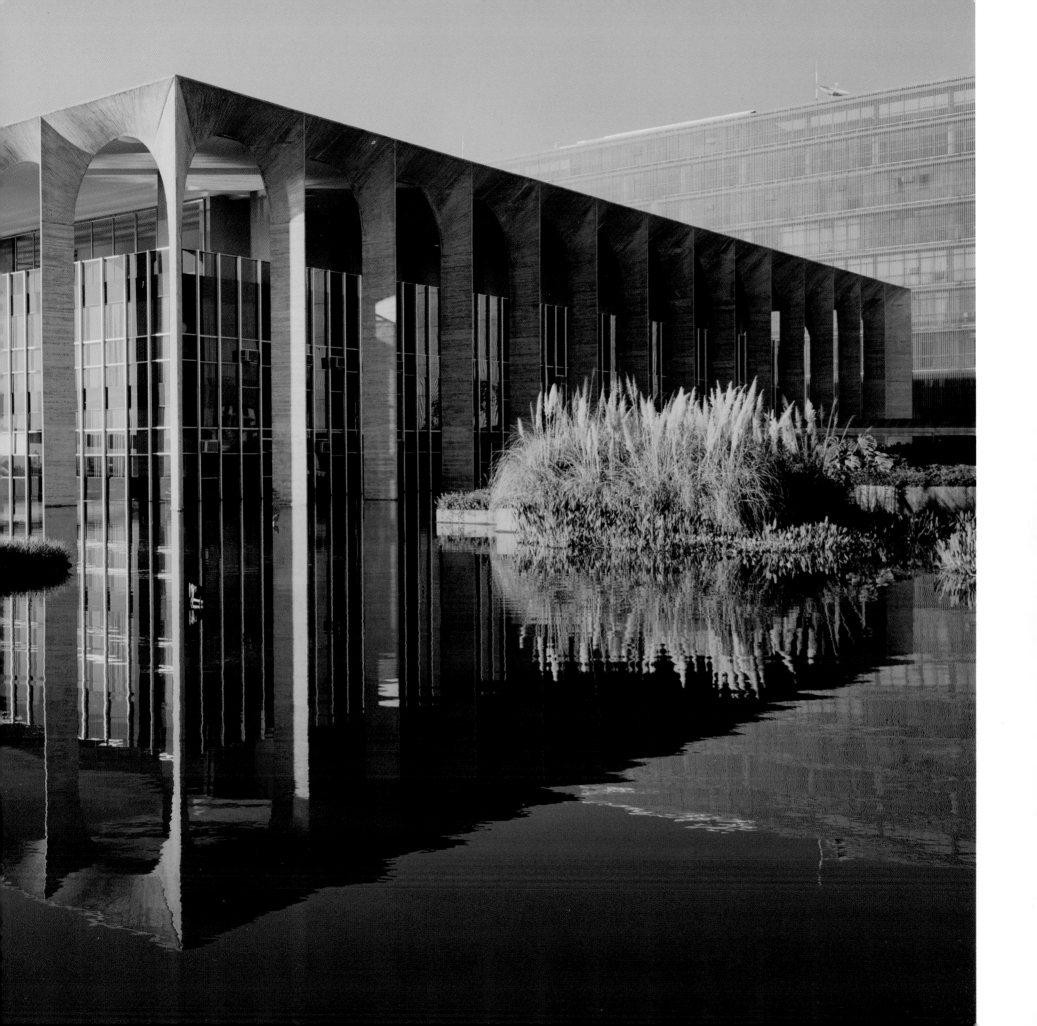

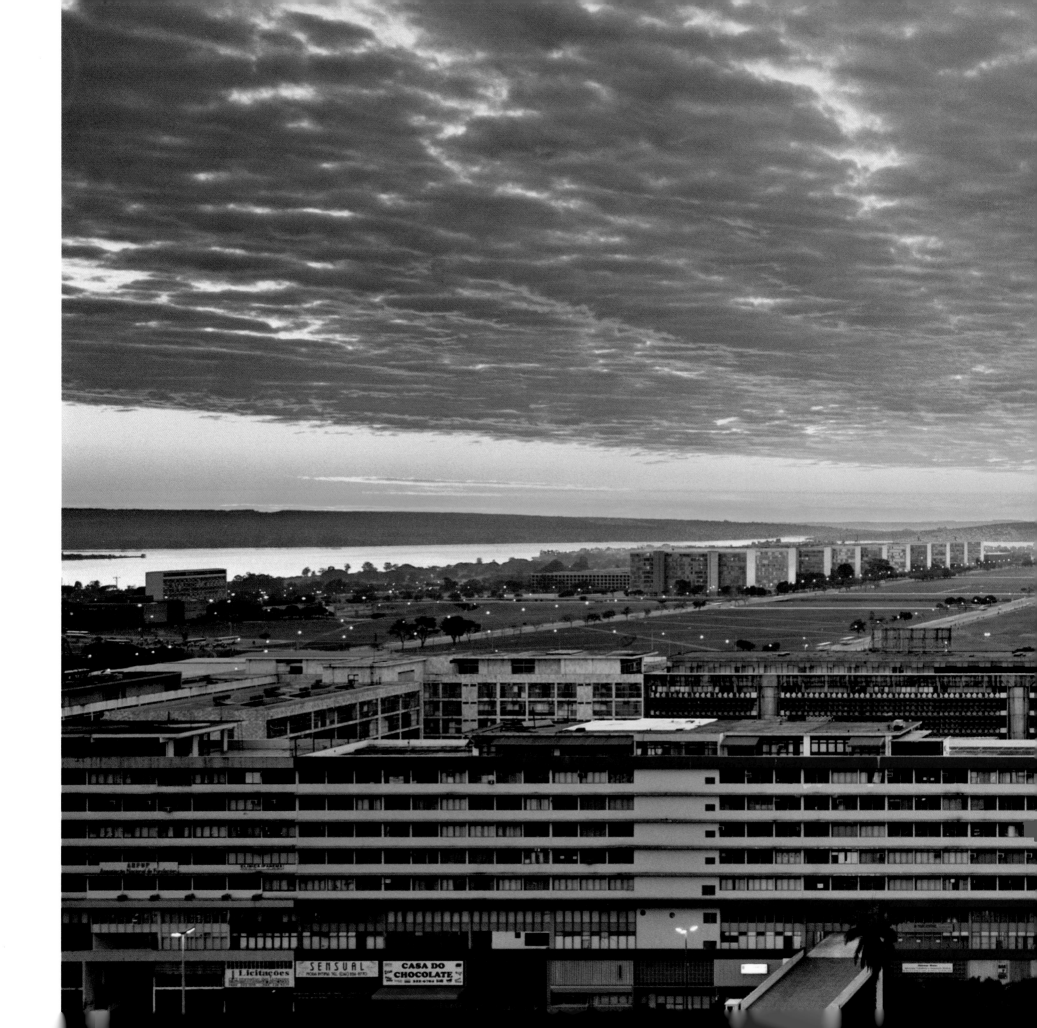

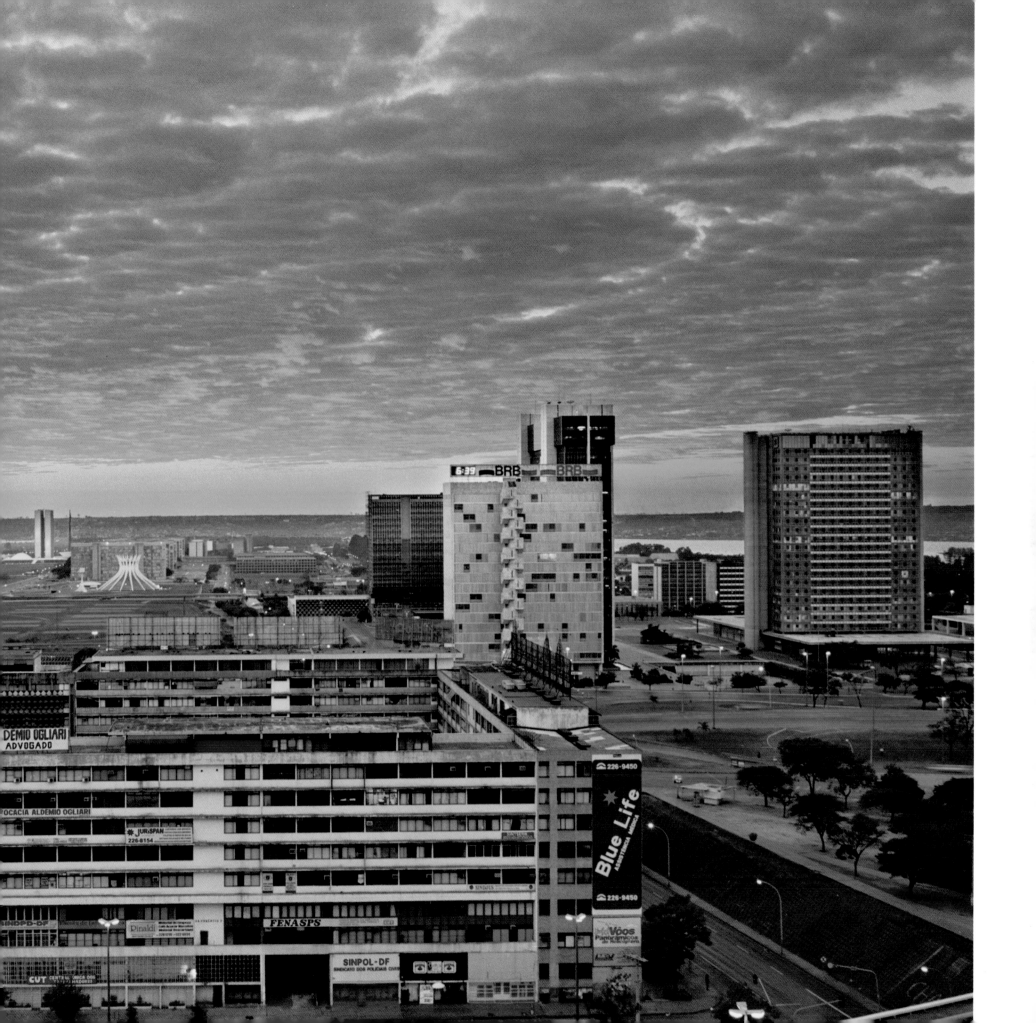

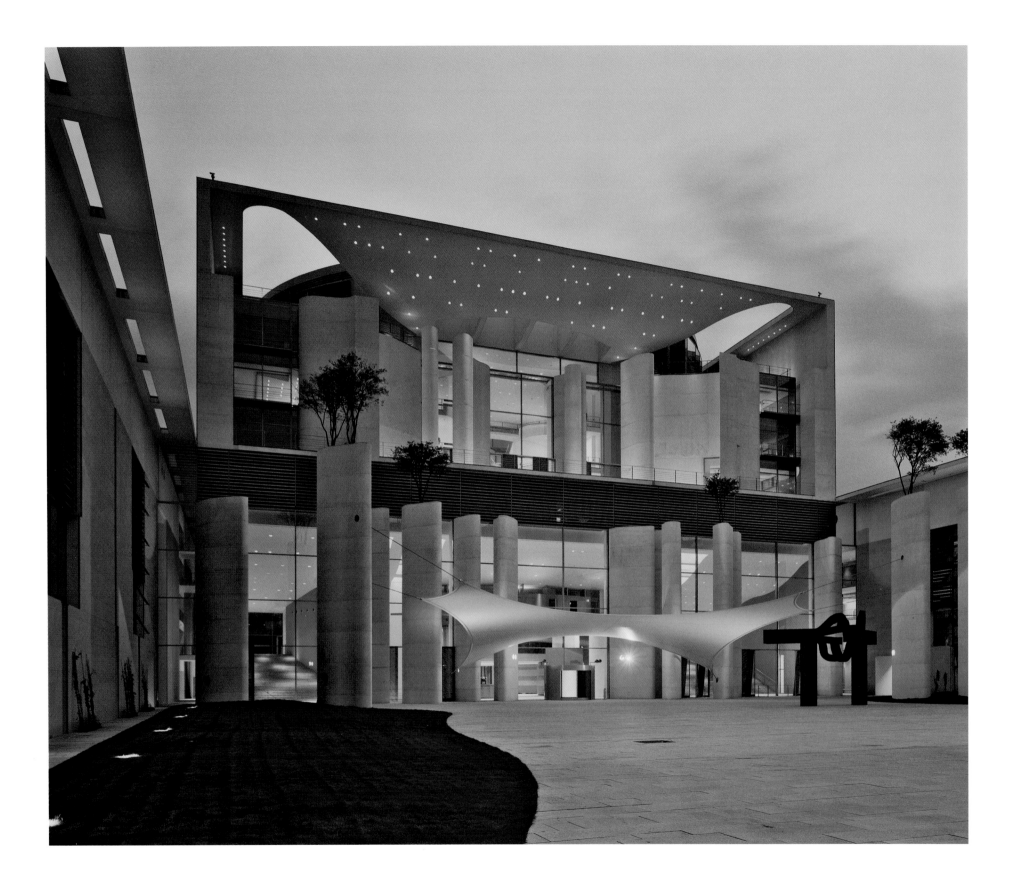

ON BERLIN

It's rare that a nation with close to a thousand years of history gets the opportunity to give itself an identity makeover and in the process build a new capital. This is exactly what happened in Berlin after the reunification of Germany. For architects charged with this task it's a daunting challenge: How do you make a statement that represents the superego of a nation and in turn have that nation approve of its new self-portrait? There's always a period of adjustment, like breaking in new shoes.

The new German Chancellery, designed by Axel Schultes and Charlotte Frank, had to confront these problems. It had the unfortunate fate of being disliked by almost everyone, including the German people and even Chancellor Gerhard Schröder, who described it as an "oversize washing machine." For me the Chancellery seems like New Zoroastrian architecture. It has an almost Persian feel to it. It wouldn't look too out of place as a civic center in downtown Yazd, Iran, or as a new children's hospital in Mumbay's predominantly Parsi Malabar Hill neighborhood in India. What's it doing in the new Berlin? In matters of German identity the not-so-hidden taboos are Nazism and the Holocaust. Germans can build a new capital, but they can't undo history. And in this case they can't hide behind classicism—the default mode for many Western capitals—because of the uneasy associations with the Third Reich. So the result is a weird stylistic contortion.

I'm reminded of another national capitol complex completed more than seventy years ago, itself a masterpiece of pastiche architecture: the Rashtrapati Bhawan, formerly the Viceroyalty House, in imperial Delhi. This harmonic Roman-Franco-Anglo-Moghul mix was not designed by an Indian. And yet Edwin Lutyens, an Englishman commissioned by the British government, still managed to convey something important about Indian national character. Somehow that was easier for an outsider to interpret. It makes me think of those photographs that Annie Leibowitz did in the 1970s for *Rolling Stone*, where she got rock stars to pose for portraits that expressed what we as fans already thought about them. That is easier to do to others than it is to yourself, since no one walks around looking at himself all day.

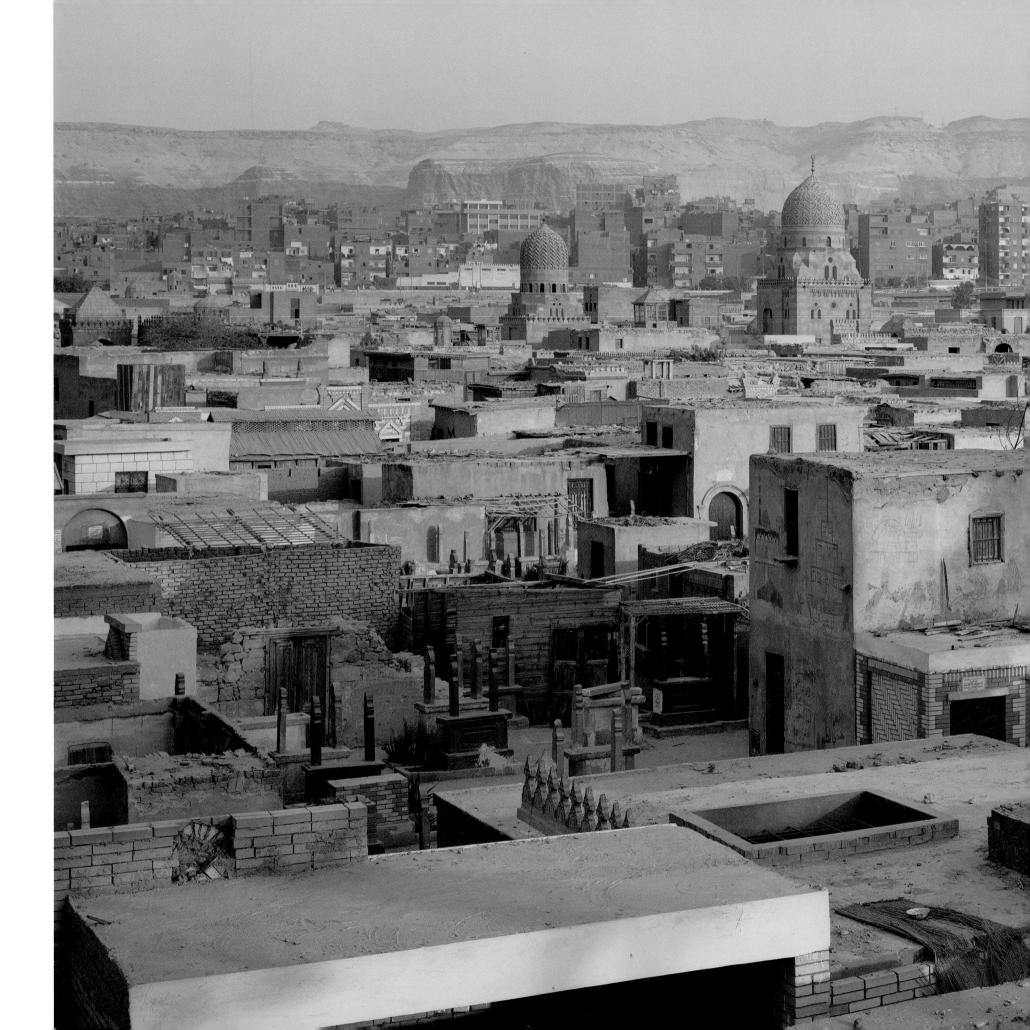

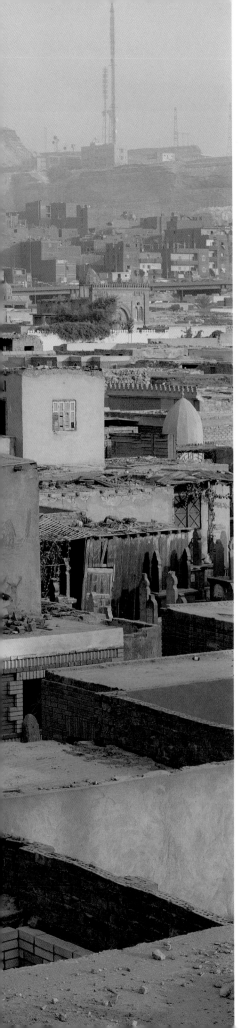

ON STEALING SOULS

I had heard about the City of the Dead for years. Thousands of people living in a cemetery in central Cairo. I was working in Egypt and had a couple of days off, so I decided to visit the cemetery. First, following protocol, I went down to the Information Ministry and through the good luck of the draw was assigned an interesting guide whom I really liked. A former national chess champion, he had been chosen by his federation to represent Egypt at an international chess tournament in Nova Scotia. The bad luck of his draw was that his first opponent was a Russian who eliminated him in the first round. Humiliated, my guide felt too ashamed to return home. So he stayed in Canada for five years, delivering pizzas for a living until he felt compelled to return to attend his mother's funeral. He had now recycled his life as a specialized guide for foreign media.

It was prayer day when we visited the cemetery, and the place was deserted. "Where is everybody?" I asked. "Maybe they're at mosque," my guide said. "It's just as well. Sometimes they aren't so friendly here." So I went about my work. About an hour later an old man showed up and started yelling at him. My guide didn't respond. The old man kept screaming and then walked off. "So what did he say?" I asked him. "I'd rather not say." "Why not?" "It might offend you." "It won't." "Please, spare me." "Come on—tell me."

"Well, politely translated he said: 'Look at him, there he is, the son of Satan with his yellow hair, taking those photos. When he clicks that thing and the hole opens, our souls are sucked in and stolen from us. Why do you let him do this?'"

I didn't reply; I kept shooting. This wasn't the first time that I'd been accused of soul theft. In fact, I've been thinking about the metaphysical implications of photography for a while. And the truth is I do not feel any guilt about what I do. I think I'm a good guy, but for all I know if Satan exists maybe he thinks he's a good guy, too. Furthermore, I'd be thrilled to death to find out what it looks like to capture some souls.

73

ON ALEXANDRIA

Before I'd even visited Alexandria, Egypt, I saw a badly photographed version of this image on the cover of an archeological brochure in a bookshop in Paris. I was immediately taken by it. I stared at it thinking how I would shoot it differently, figuring that by doing this or that I could get a much better result. I remember thinking: I *have* to shoot this. I left the bookstore and, you know, life goes on, and like so many great ideas I soon forgot all about it.

As fate would have it, a year or so later I was asked by *The New Yorker* to shoot the new Alexandrian Library. Once in Alexandria, I found the city fascinating and decided to spend some extra time shooting on my watch. Early on during my scouting phase—remembering that photo—I asked my driver to bring me to that place, Gabbari. It was a slum not far from the port area. I say *was* because I've been told it's completely covered by the highway now. What happened was remnants of a first-century-B.C. necropolis were discovered by road crews as they were making the pillar foundations for a new highway. Seasoned archeologists, already working on other parts of the city, had long suspected this area was ripe for some discoveries. Word got out and different schools of archeologists lobbied government officials for the renewable dig permits that are so prevalent in the Middle East. These academics, students, and local crews do their work as quickly as possible—measuring, photographing, mapping the site, and then taking out artifacts—racing against the clock until the local population's need for normal life once again takes the upper hand. In this case it meant that the highway had to be completed. It surprised me that archeologists usually oversee the reburying of their sites without too much pain. They admit that in the long run history is better preserved underground. The real pros just run off to another site that's ready for them.

When I showed up to take this shot, I faced two obstacles. First, the light was bad, but that was easily remedied by photographing at a different time of day, the afternoon. Second, the French archeologists didn't want any photographs taken. They were so worried that someone would release images of the site before they published their articles that they hired guards to deter photographers, trespassers, and looters. Those guys you see sitting by the umbrella didn't let me shoot. The irony is that I had actually met one of the archeologists and knew he would let me shoot. Unfortunately, he was not in town, and the guards, like all good guards, were unwavering. So I found a rooftop where I knew the afternoon light would be perfect. I prearranged my access with some tenants and found a circuitous route through the building so I wouldn't be noticed returning. I was up there maybe twenty minutes or so, and managed to take a dozen shots before the police and security guards arrived. They wanted to confiscate my equipment and arrest me. My local guide from the Information Ministry had a huge argument with them and finally talked them out of it. I pulled the trick that usually never works— I opened one or two unexposed sheets of film and then handed them over to appease their anger (the exposed film— including this shot—was already in my bag).

Months later, back in New York, while scanning and printing the photo, I thought back to the image I saw in Paris. I knew I'd done it, that I'd made a greater shot. This probably sounds self-serving, but if you're going to commit plagiarism, you have to at least do better than what you copied.

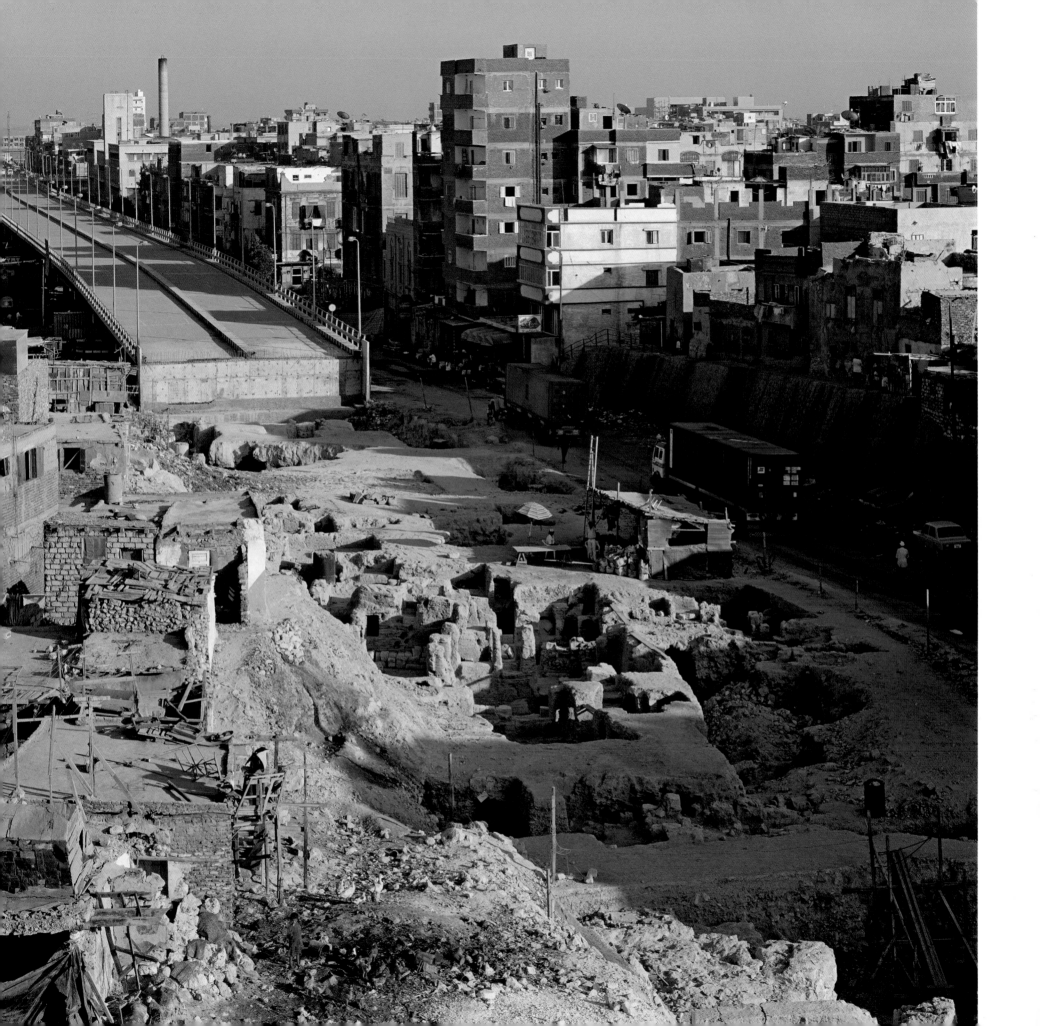

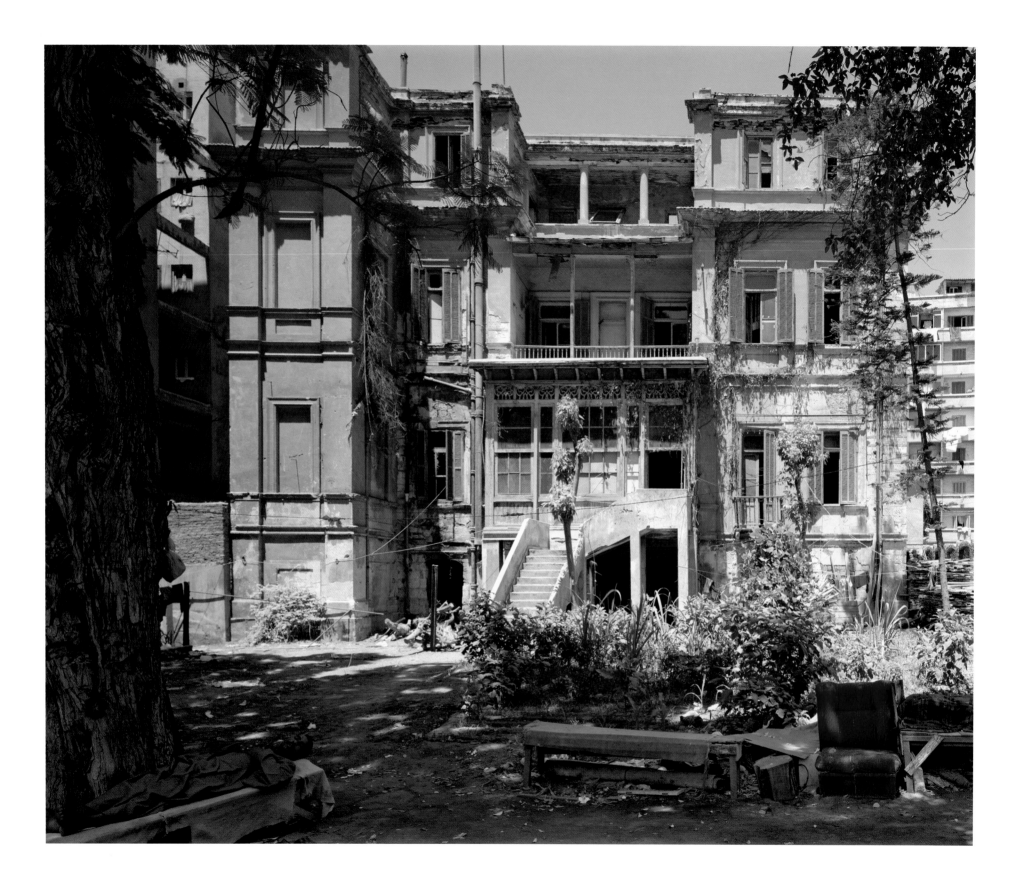

ON THE DURRELL HOUSE

Novelist Lawrence Durrell lived for a time in Alexandria. He wrote *The Alexandria Quartet,* and in the early '80s a new French translation became a big deal among the liberal French intellectuals. This is a picture of one of the houses he once lived in. As far as I can tell he was a radical womanizer and had many girlfriends who put him up when he wrote, and that is how he became associated with this house.

Unfortunately for a local Egyptian businessman who later bought the house so he could demolish it and construct a modern high-rise apartment building, an important British magazine ran an article about how the Egyptians were unabashedly ready to destroy their great cultural landmarks for the sake of financial gain. The response of pressured shame from the local authorities had forced a temporary injunction on the project. They canceled his building permits pending further study, which severely frustrated this up-and-coming real estate developer. He felt he was the victim of some unjust and bizarre Western conspiracy. I persisted in my quest for photo authorization from him for several days,

because I foolishly thought I had run across a real scoop for *The New Yorker,* since it's a kind of literary journal and all. So I kept it up. He couldn't understand why I kept coming back: What did Westerners have about this building anyway? Why is Durrell so important? Why should his memory stand in the way of the welfare of Egyptians today? We drank a lot of tea. Over time we actually grew to like each other. I even offered money, which he refused, but suddenly his opinion changed. I could tell in his eyes that he had a great idea. He would let me shoot the house if I signed an agreement stating that the picture could only appear with text that included the phrase "broken beyond repair." We wrote it on the back of a piece of hotel letterhead and arranged that I would come back the following day to shoot no more than three photos. He proceeded to explain this in Arabic to his guard, who was sitting under the tree across from him.

That night, to celebrate my victory, I had a great meal by myself at the city's only Chinese restaurant, at an old hotel whose rate exceeded my per diem, and

I contemplated the shoot. When I arrived at about 4:30 the next afternoon I realized that the guard was fast asleep on his bench under the tree. So I was able to quietly open the gate and set up my equipment without waking him or provoking the dogs, who had gotten used to my presence. Without making a sound I took the picture and left. The guard never knew I had been there.

Back in New York, I proudly presented my prized shot to the photo department. They considered it for all of about ten seconds. It wasn't relevant to the assignment, I was told, but not wanting to hurt my feelings they added that they thought it was a nice shot just the same. Reflecting on this whole experience now makes me examine the wisdom of the adage "If at first you don't succeed, try, try again." I've come to realize that it's a stupid saying. It's my opinion that if it doesn't happen right off the bat, you're chasing diminishing returns, buddy. It is simply not meant to be. Is this picture really that great? Maybe not. If you weren't reading this text, you might already have turned the page to look at something else.

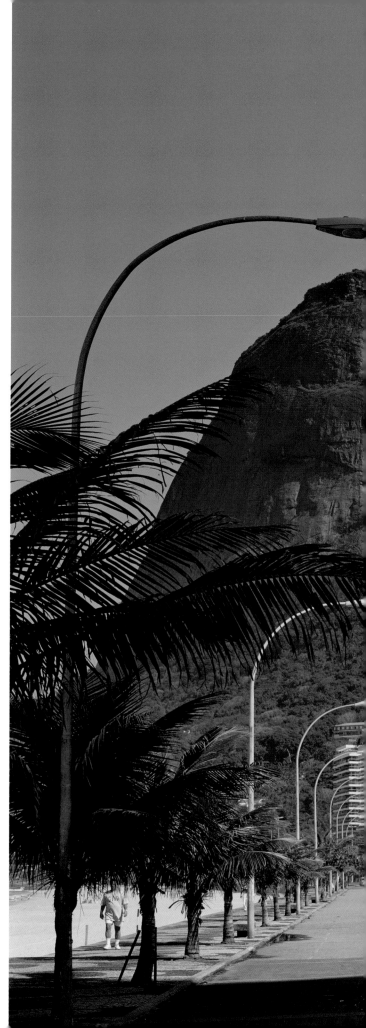

ON RIO

Rio has the most beautiful and extraordinary natural setting of any city in the world, and its uniqueness doesn't end there. In most great cities the rich command the views and the cooler, cleaner air, and the poor live down in the troughs. Here, the higher you live in the hills, the less money you have. There is almost a geometric equation at work: the closer you are to a ninety-degree incline, the poorer you are. It's hard work to live up there, way up where only narrowing foot trails exist. To get into one *favela* took three days of negotiation with the right people. In fact, when I was up in the helicopter the pilot refused to descend past a certain altitude because he was afraid of being shot at by machine guns. Meanwhile, all the way down by the expensive high-rises of Copacabana, where the wealthy live, every sunny day brings a huge influx of humanity, who come down from the hills to populate the beach from sunup to sundown. The only neighborhood where the rich are able to effectively keep to themselves is the strip by the Lagoa (perhaps the swimming is bad there). This whole spectacle is amazing to me. I guess they've got a different type of social contract going here than what's in effect between Mulholland Drive and Malibu Beach.

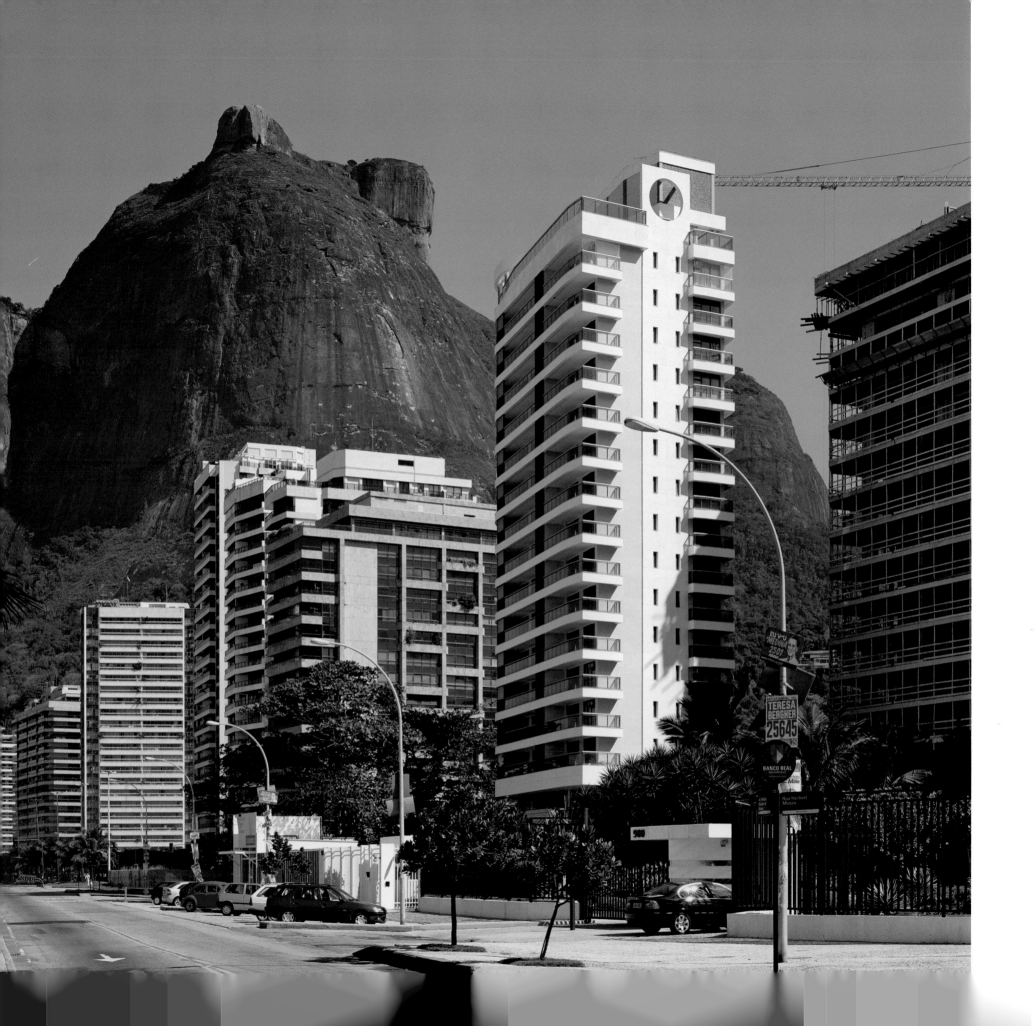

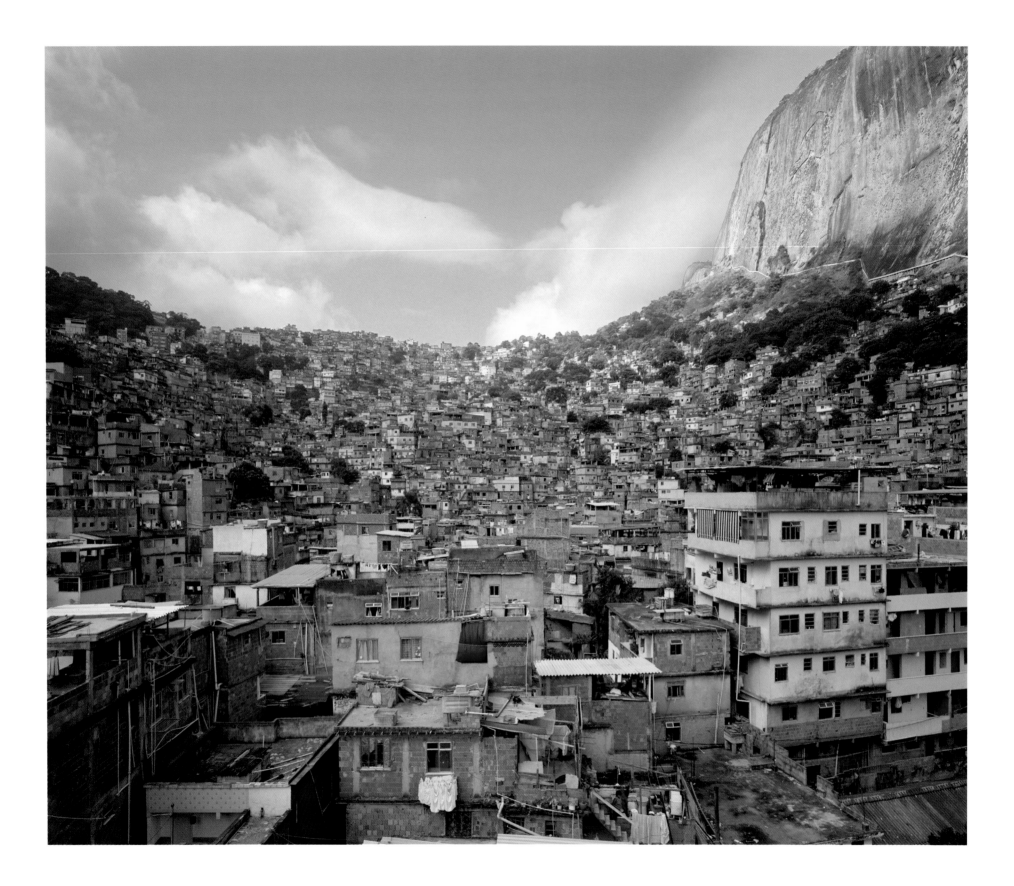

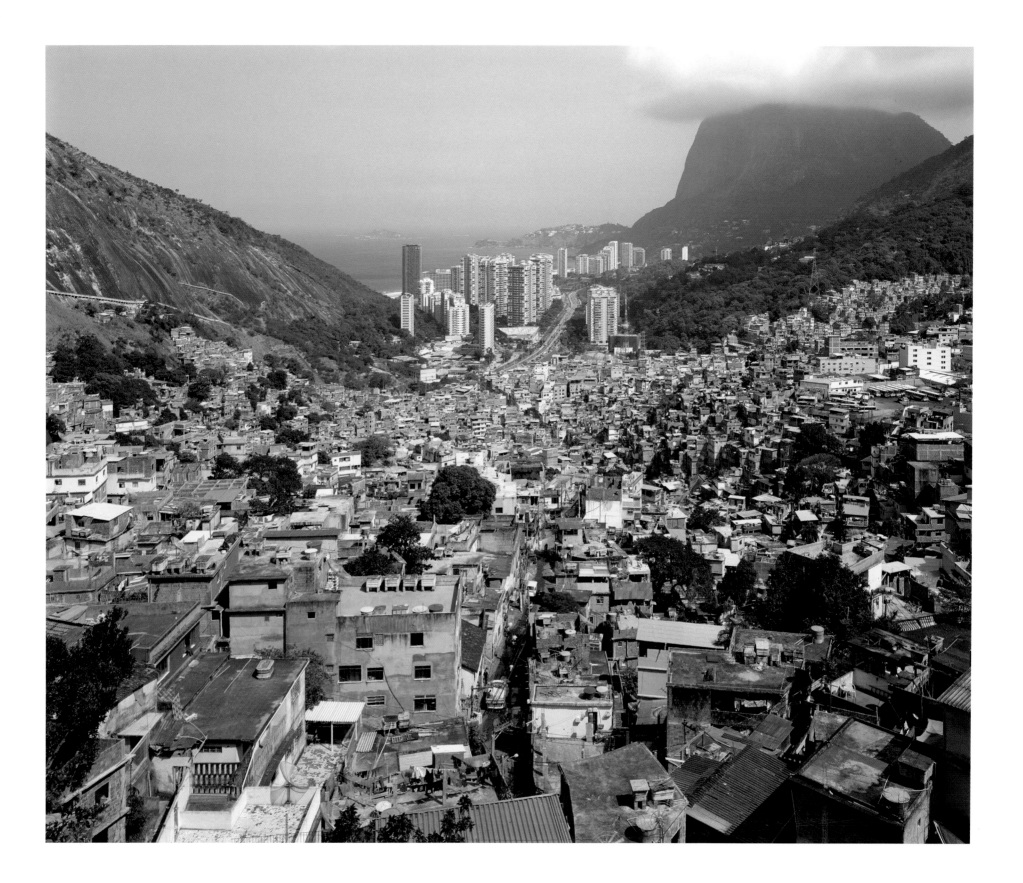

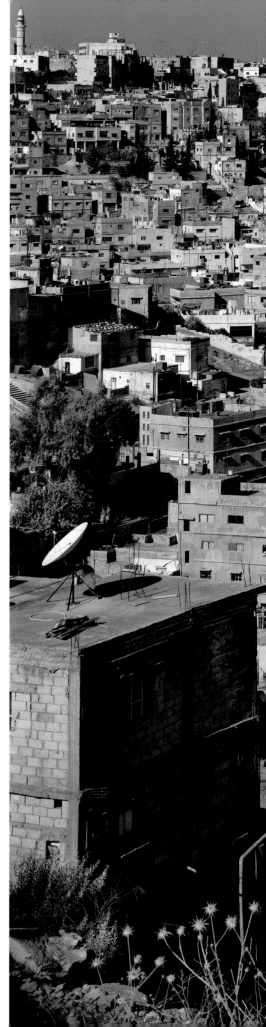

ON URBAN DENSITY

Set on a series of hills, Amman is super-exciting to shoot but the mood of the city is more like a holding pen. Most of these buildings went up within a couple of years after the 1991 expulsion of the Palestinians from Kuwait, and the place has a premium-quality cut to it as far as refugee camps go. That's because it's not exactly a refugee camp. Many of these families are thrice removed, and in each migration they somehow managed to trade up. It's interesting that so many remained together as a flock and did not get too scattered. When people feel their identity and survival are threatened, their normal reaction is to hold onto one another in close proximity. This image is exactly what those who love suburbia are fleeing from: the nightmare of hyperdensity. Personally, I find it visually rich. I love rookeries—dense, packed living. I don't believe that every man's home is his castle, or that good fences make good neighbors. These homespun homilies are merely excuses for bad social consciousness.

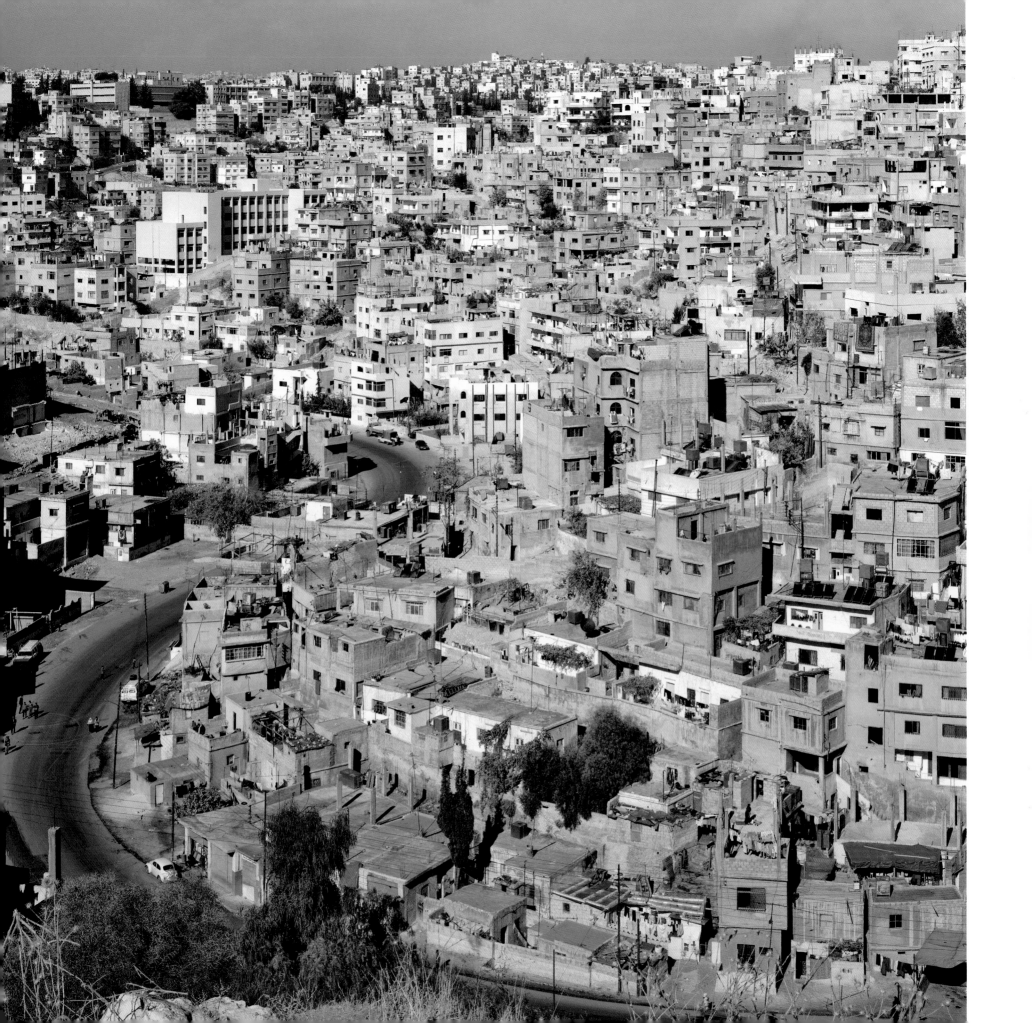

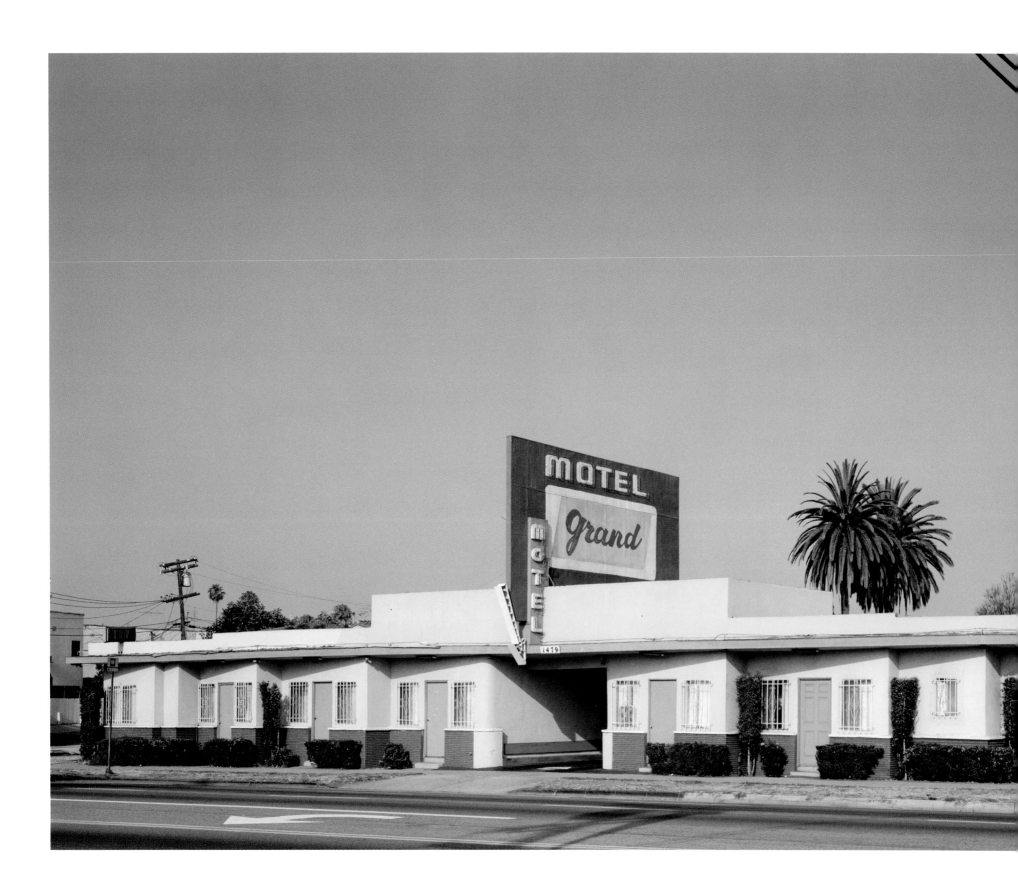

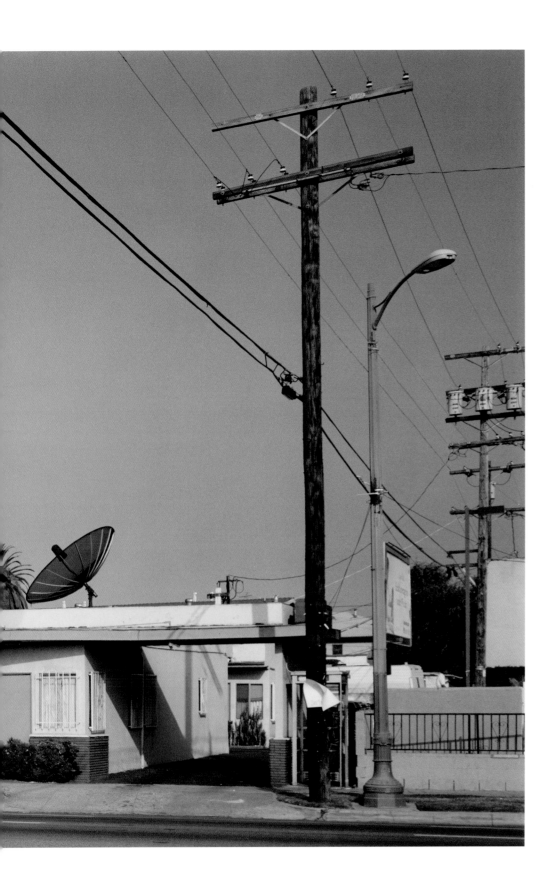

ON VERNACULAR ARCHITECTURE

The kitsch spirit of vernacular architecture usually makes me smile. Finally I can relax. What these "decorated sheds" really show is the extent to which the superficial lessons of globalism have been subconsciously adapted by non-self-conscious builders or homeowners. Why not shamelessly materialize your building ideas into a pastiche quiltwork that reflects who you think you are, or who you think you should be? After all, you're paying for it. It may not be the best architecture, or even be architecture at all, but it's sociologically rich. I'll be the first to admit that these facades often end up looking like graphic posters—and they usually make for better photos than actual living quarters. The examples I find the most fascinating are the ones executed by ethnically mixed cultures or groups in social transition. These attempts to bridge painful cultural divides are frank and emotionally revealing. And besides, they're more photogenic than celebrity buildings. As a photographer, it's draining always having to come up with a successful visual composition for the "innovative," "challenging," or "transgressive" structure conceived by the big-name architect who craves attention from society and his colleagues.

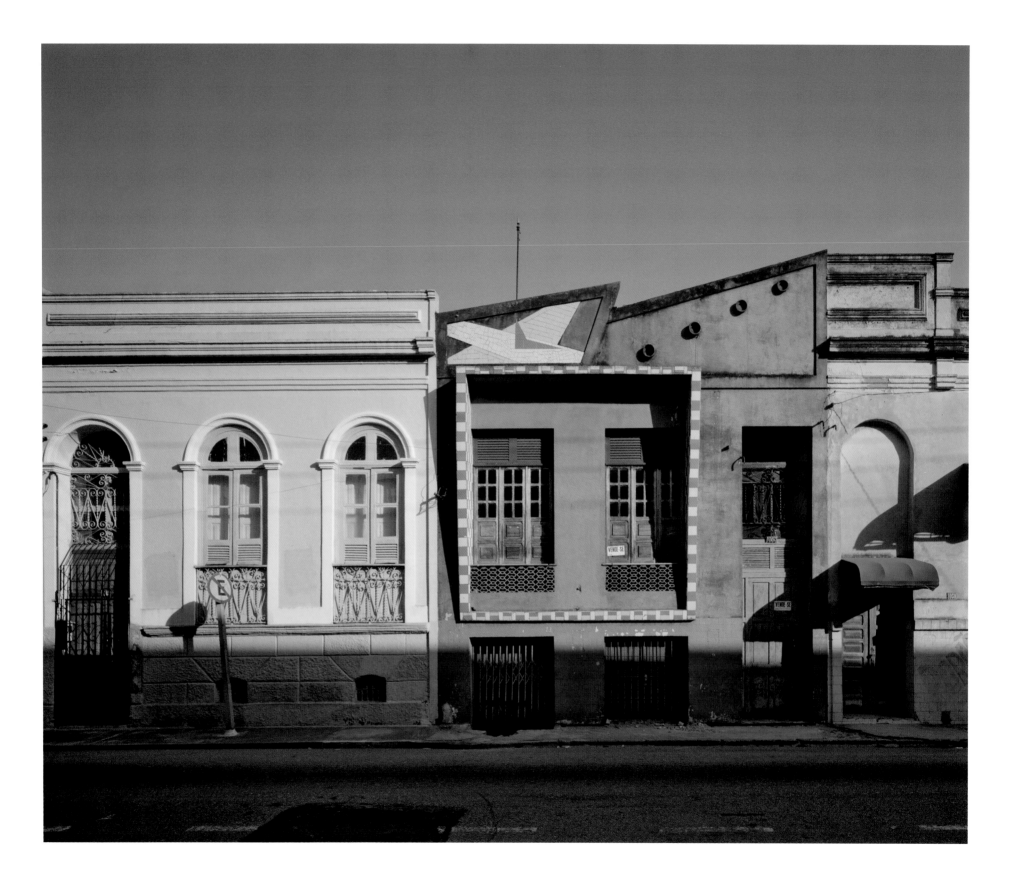

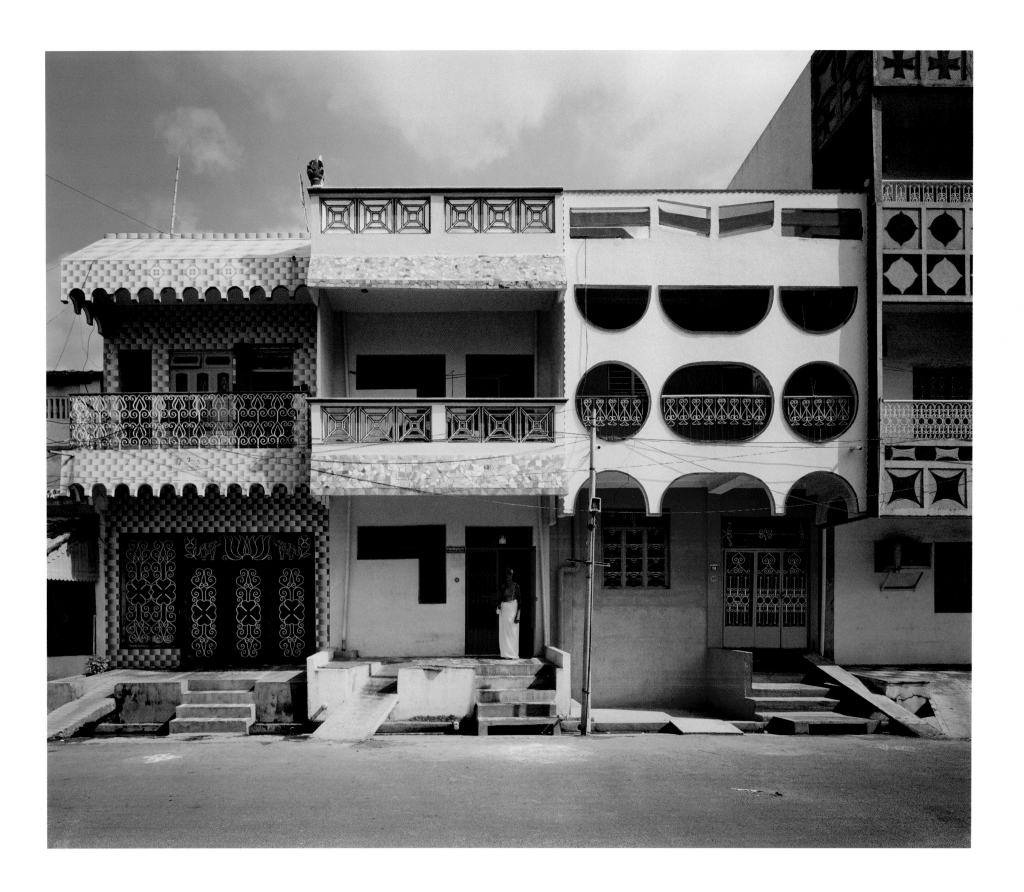

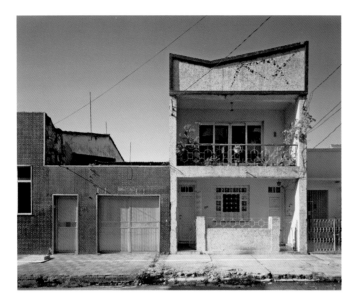

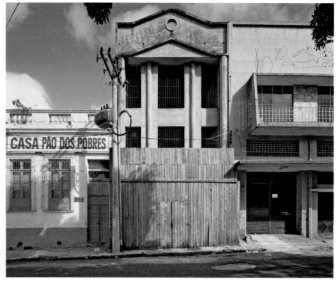

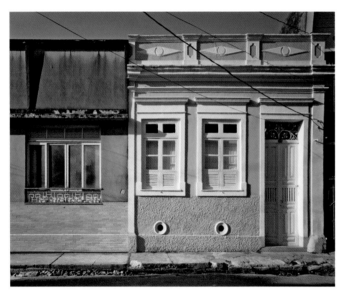

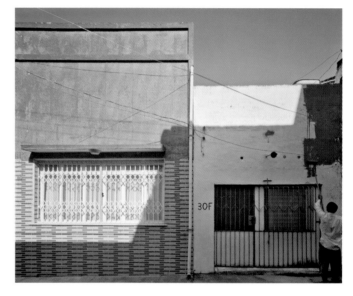

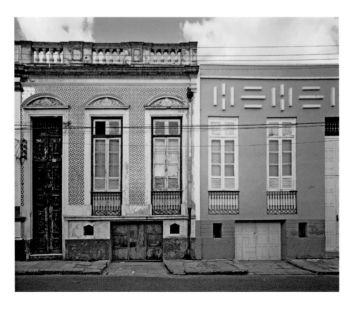

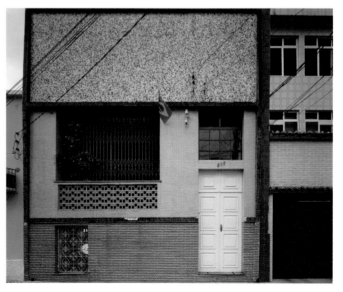

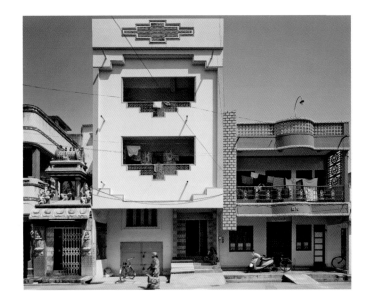

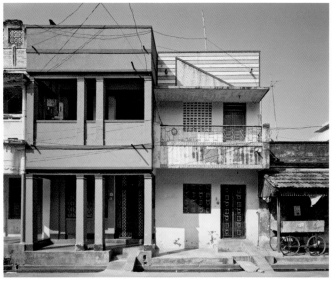

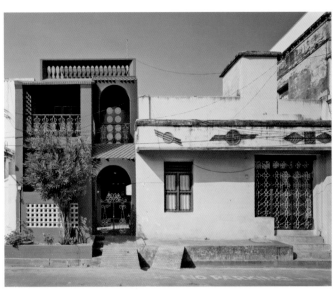

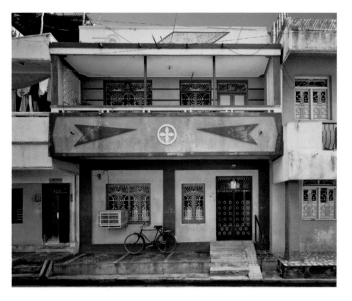

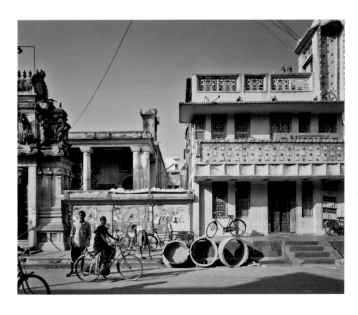

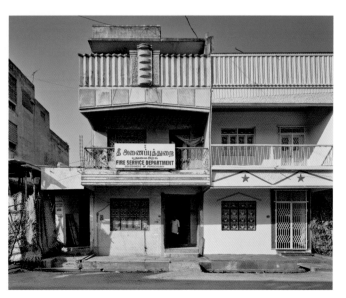

ON YEMEN

One of the questions I'm asked most frequently is, "What's your favorite place?" I always hesitate, because I really do love the whole world and I fear I'll get nailed for loving a politically incorrect country. "I don't know," I usually answer. "But I can tell you the two most unique countries in the world." One is India: it's a miracle that such a place can exist the way it does while actively engaged with the modern world. The other is Yemen: the mystery here is how such a sophisticated culture has managed to keep out the outside world for as long as it has. For urbanists and architects, Yemen is important because it is home to one of the world's largest concentrations of wood-beam mud-brick dwellings. The abundance and aesthetic variety of these gorgeous buildings are truly remarkable. In the town of Shibam, for example, nicknamed "The Chicago of the Desert," I saw structures as high as eight stories dating back to medieval times. My experience and understanding of Yemeni culture make me fear that its contact with modernity will force it into extinction.

90

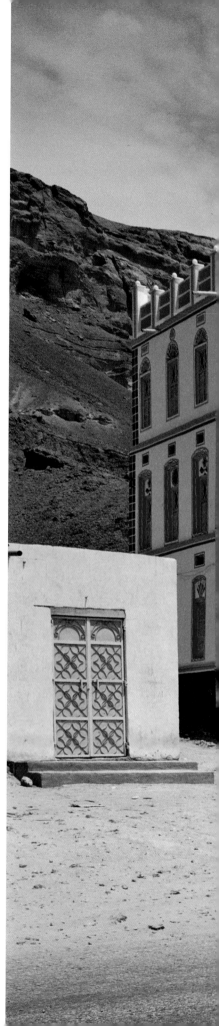

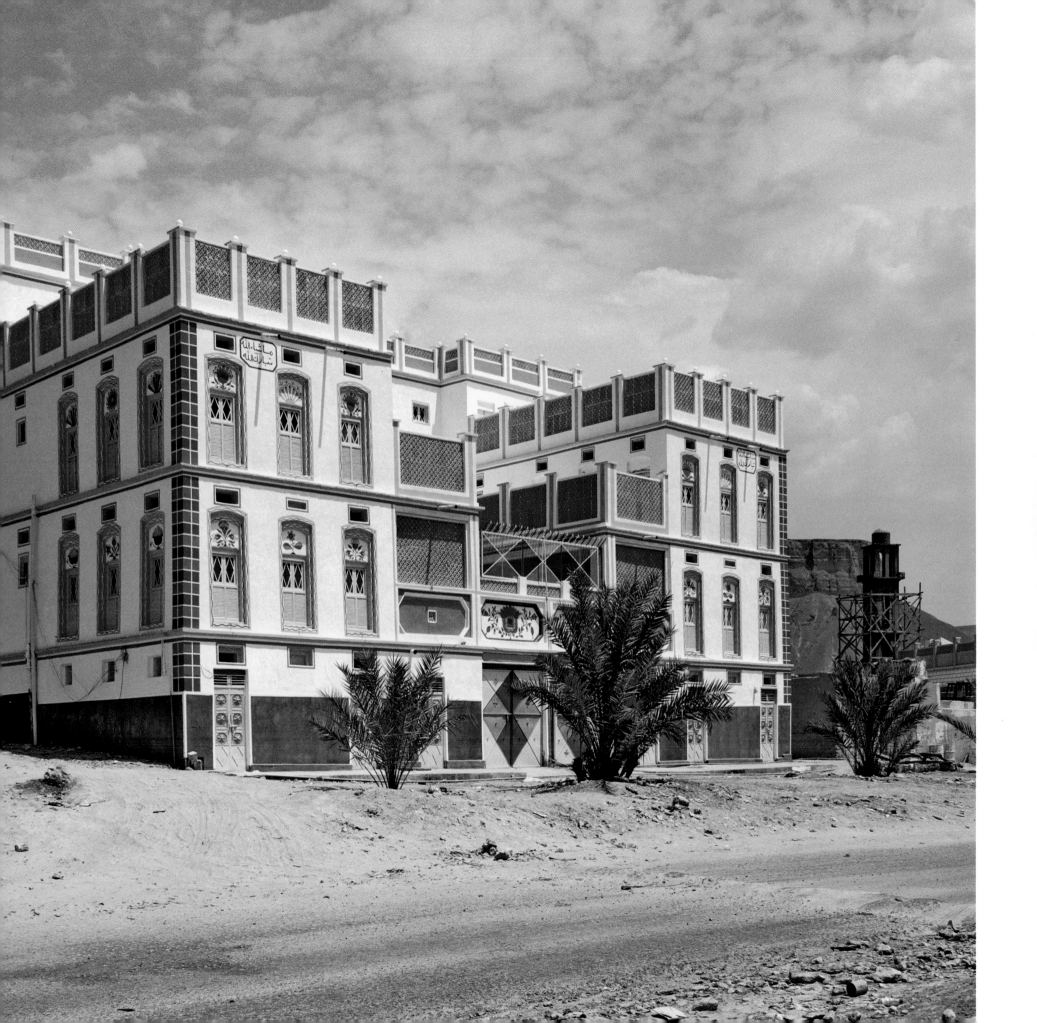

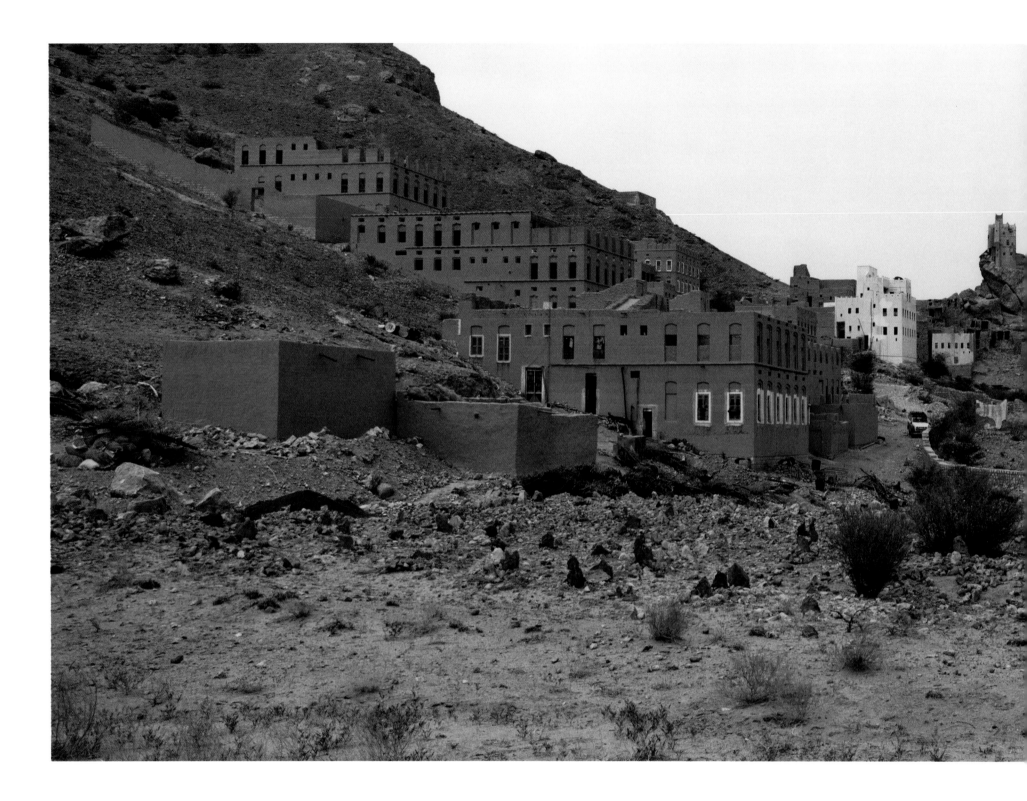

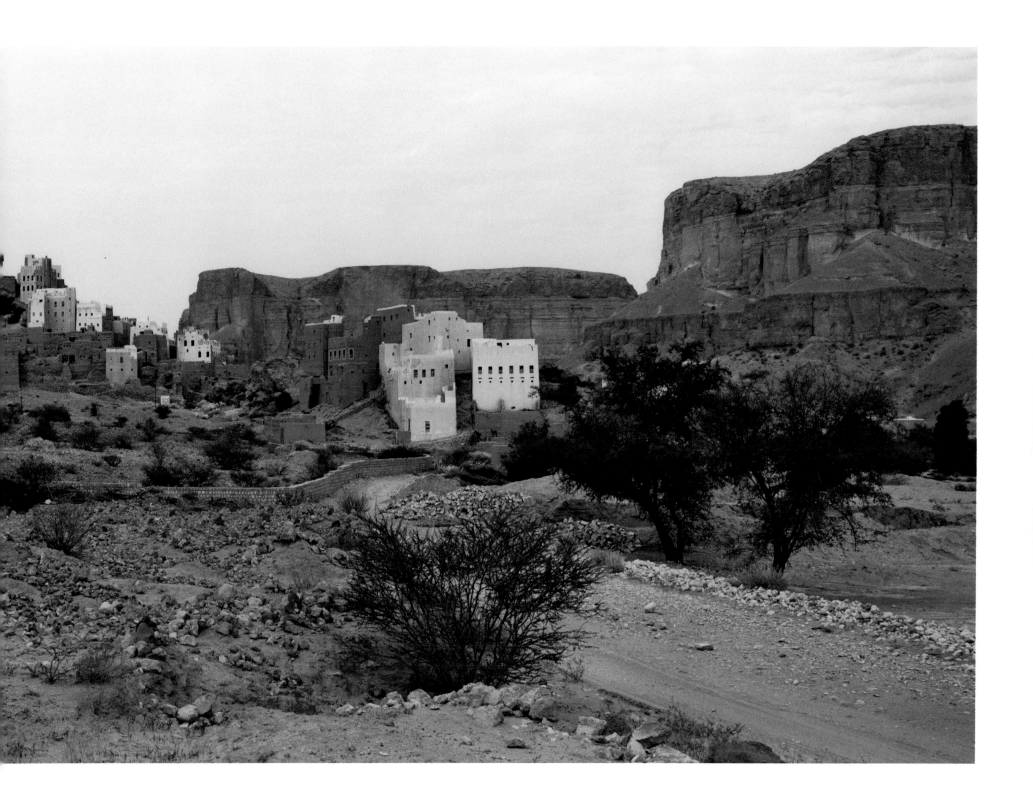

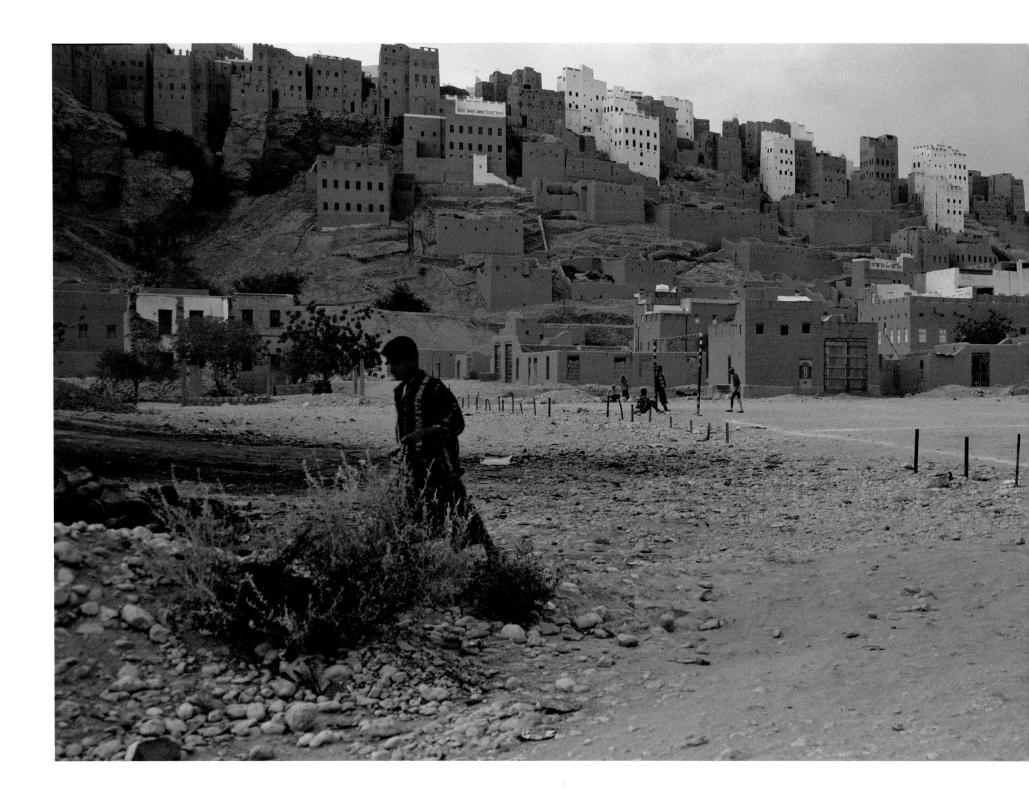

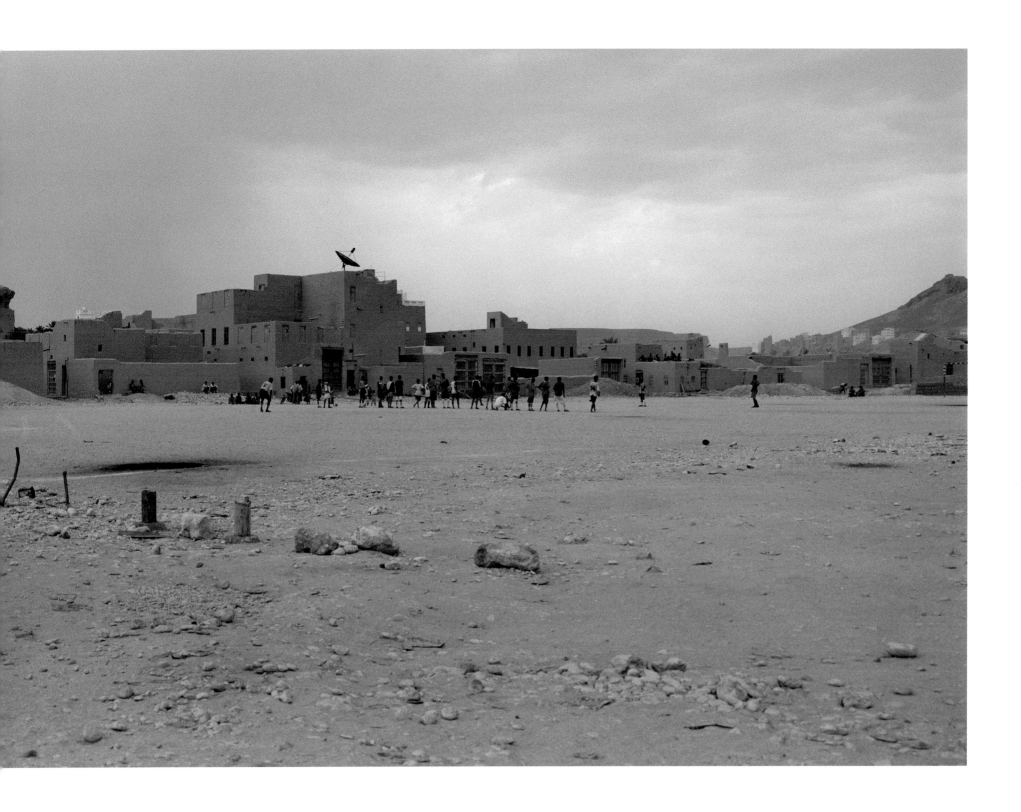

ON GAINING ACCESS
TO PRIVATE OR PROHIBITED
LOCATIONS

The important thing to accomplish here is what I call bonding. Or maybe it's seduction. Basically I first ask, "Who must I see to get permission to shoot from that house, roof, interior?" or whatever. It's always best to remember the fact that I want something from them and they don't need anything from me. It's not the strongest position to start from in any negotiation. I am the solicitor, and what I am requesting is usually related to entering their personal space. I'm asking to be granted a privilege that is generally not for sale. It requires methods not normally used in commercial transactions— which brings us back to bonding. It's amazing: 98 percent of the people in the world are really nice. At least it seems

that way to me. When two people first meet, there's a brief awkward phase, where each party tries to ascertain who will esteem the other first, or more. So I love the other first. What do I have to lose? And anyway, most of the time I do love them. Sometimes a little money helps it along, but I never use that as an introductory greeting. A lot of money plus a lot of attitude does not equal access. They don't want you coming in with the mind-set, "I'm rich, you're shit, I'm taking this photograph no matter what you say." Because then you are an imperialist—a cultural imperialist— and in the long run they will be offended and find a way to screw you up so you won't get the shot.

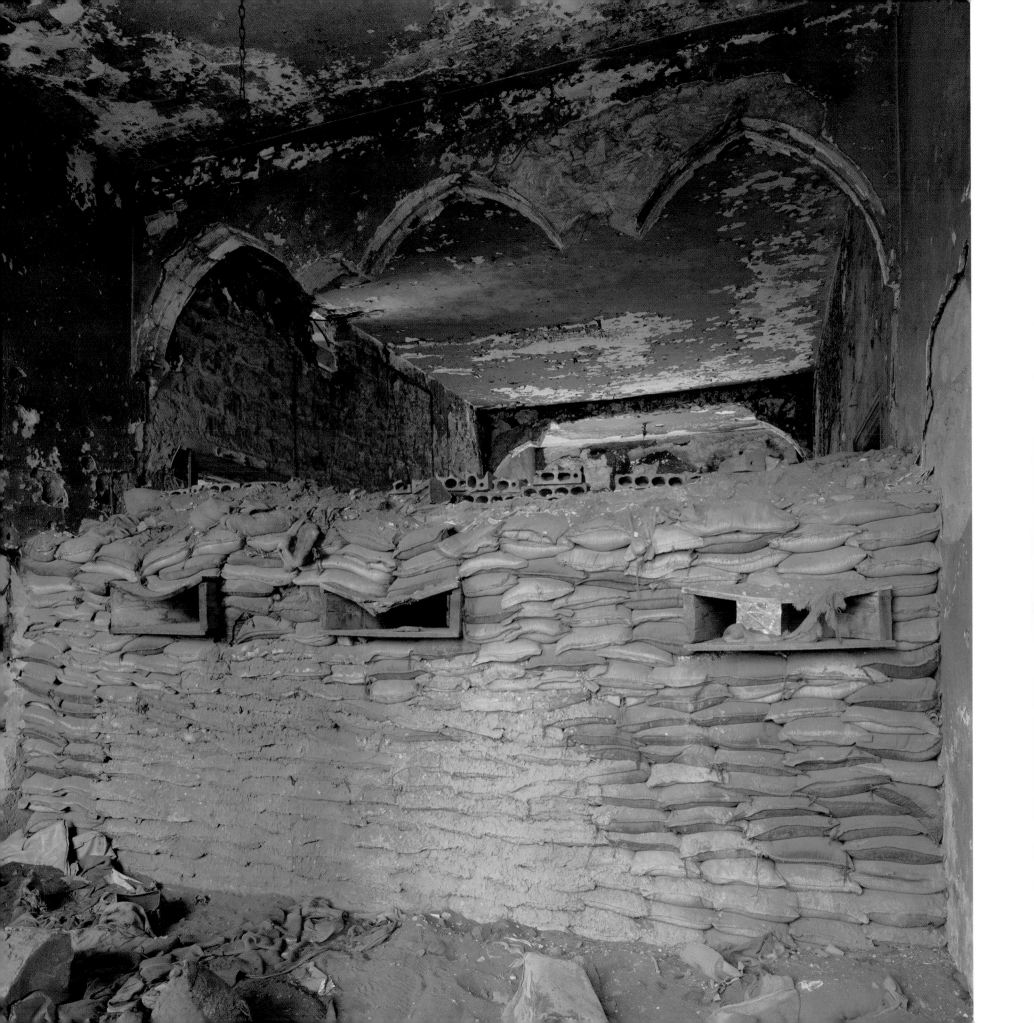

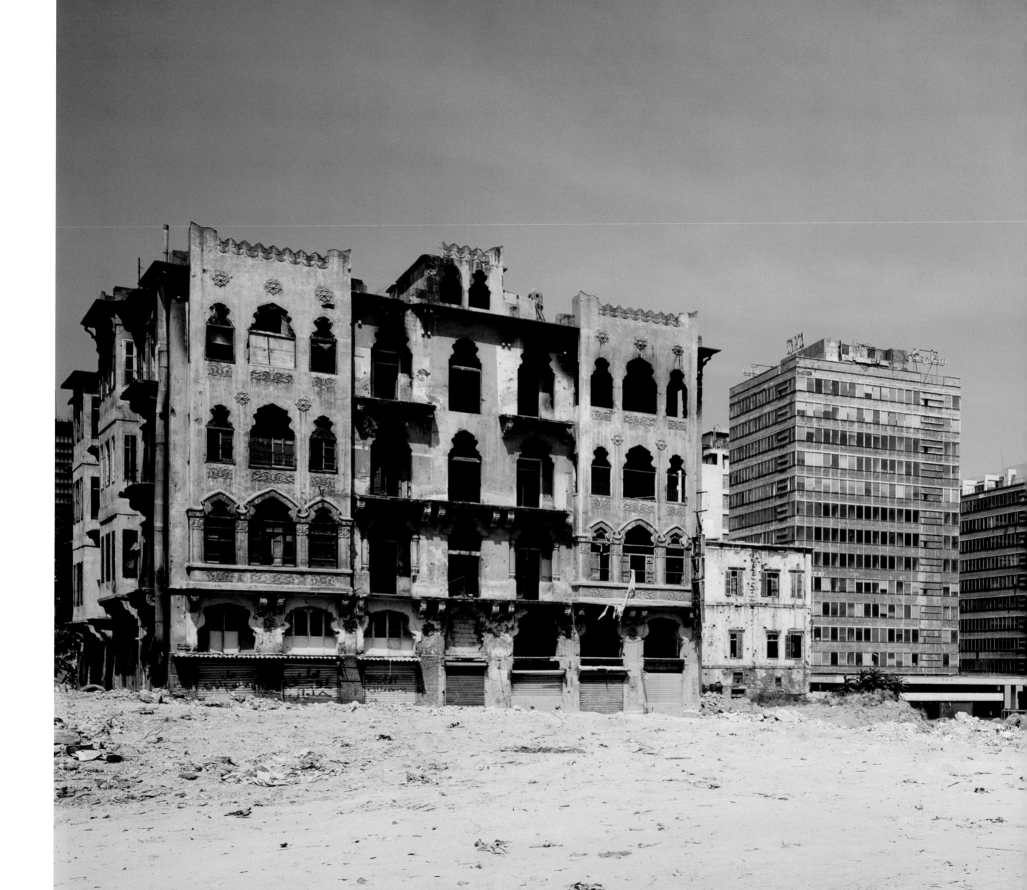

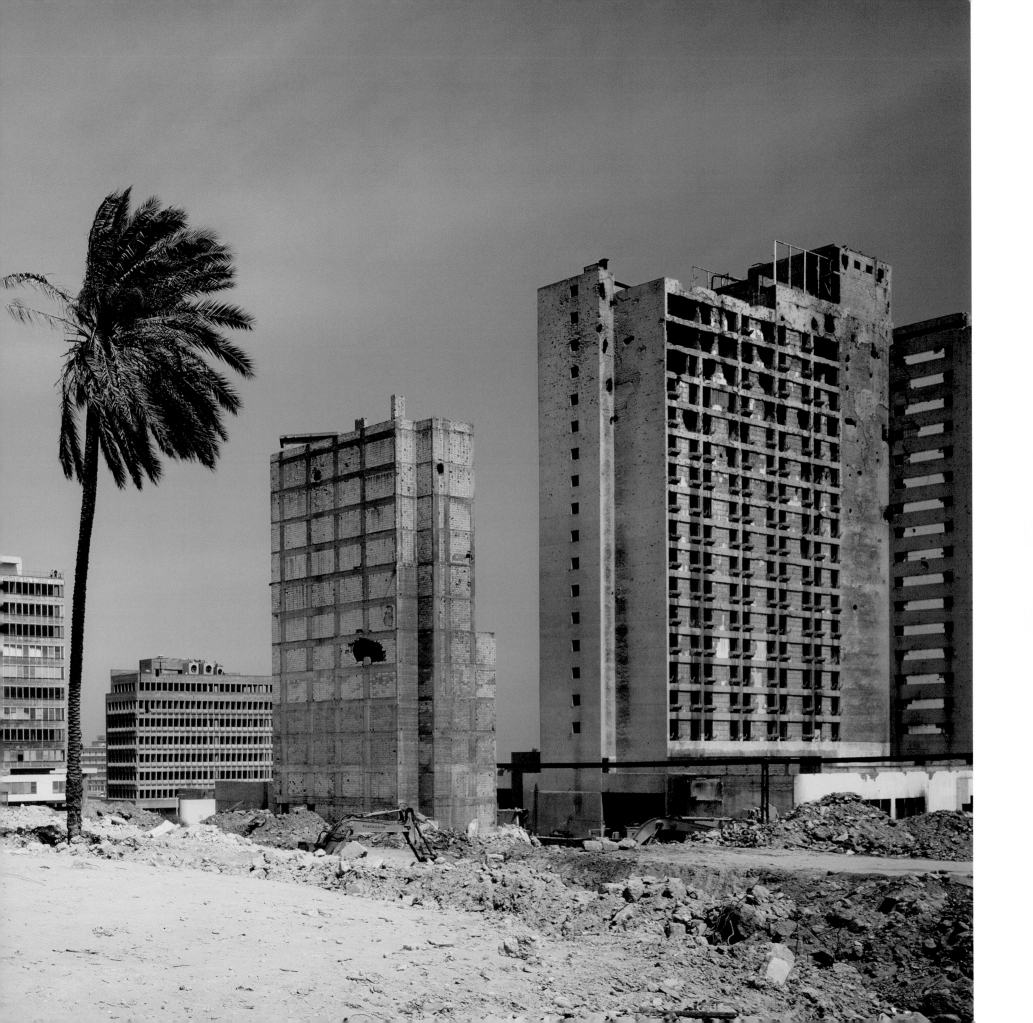

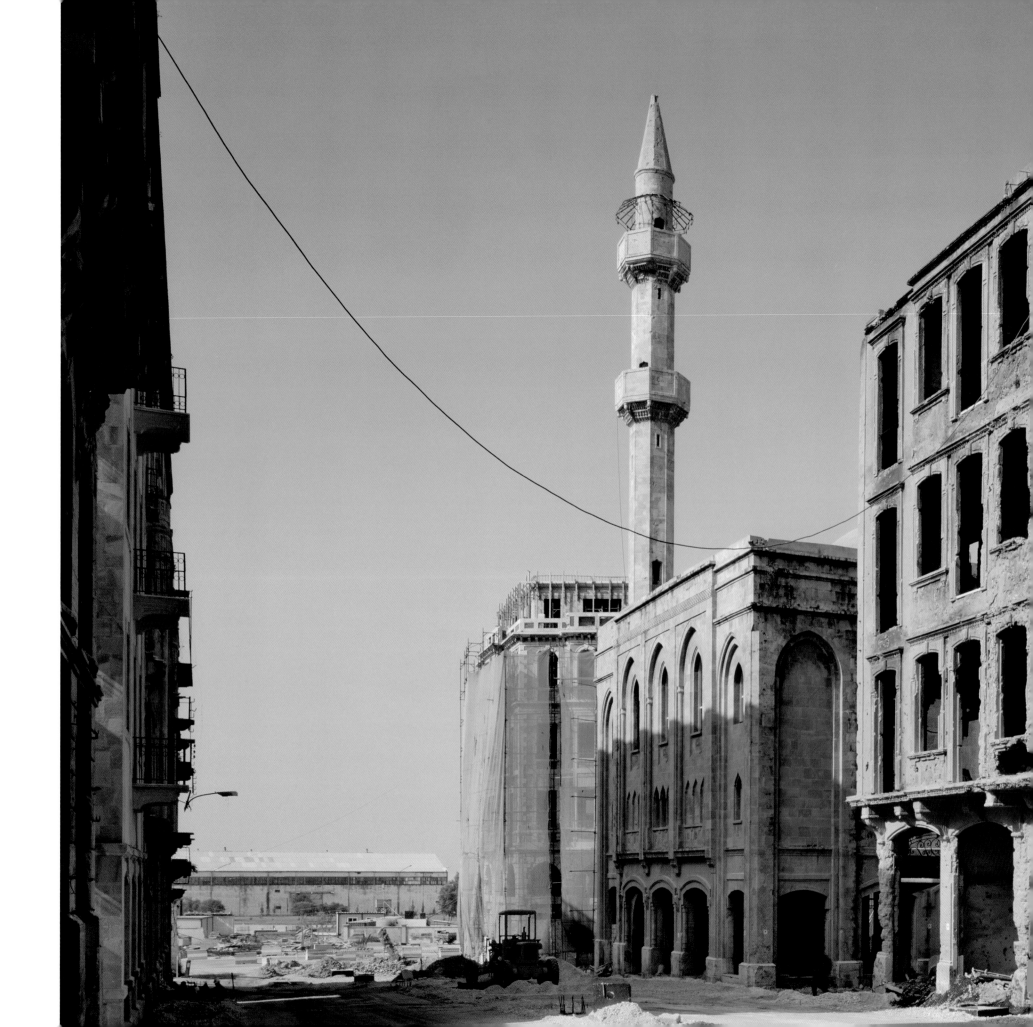

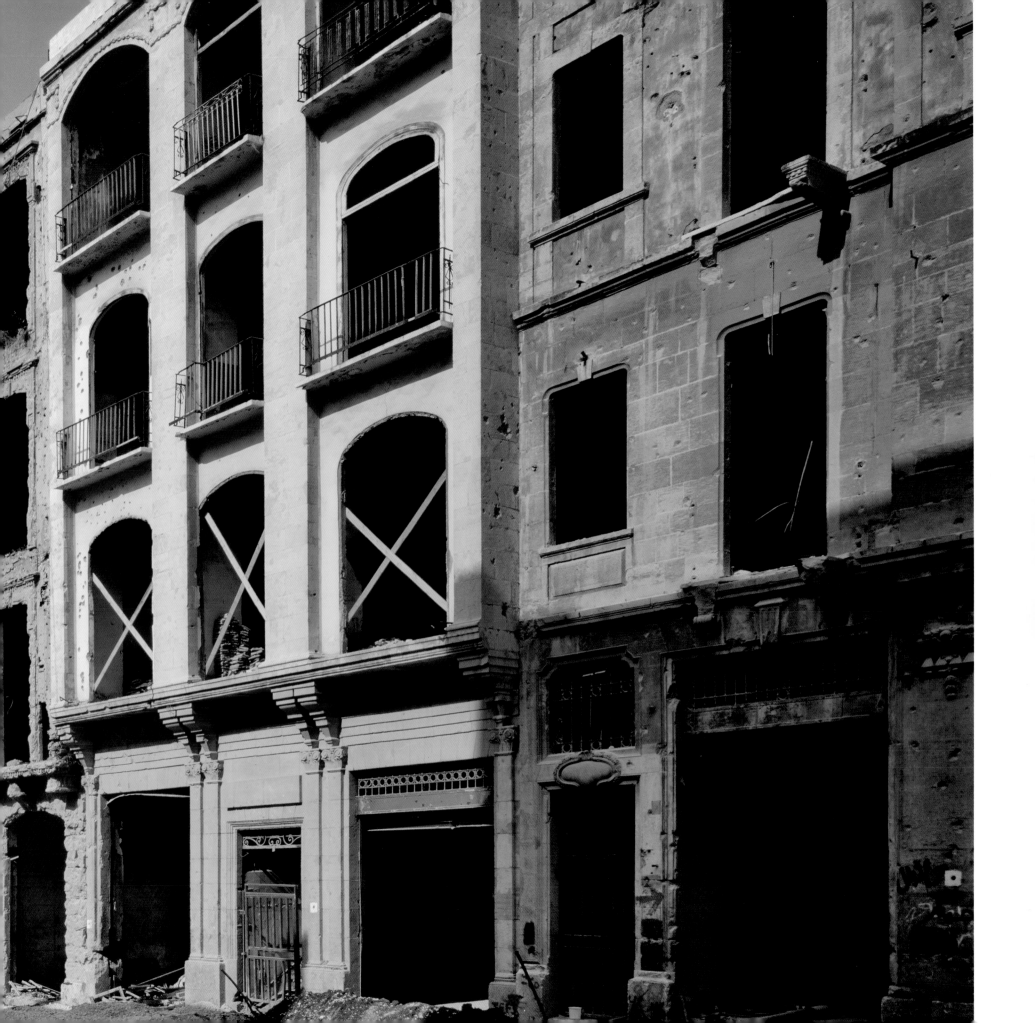

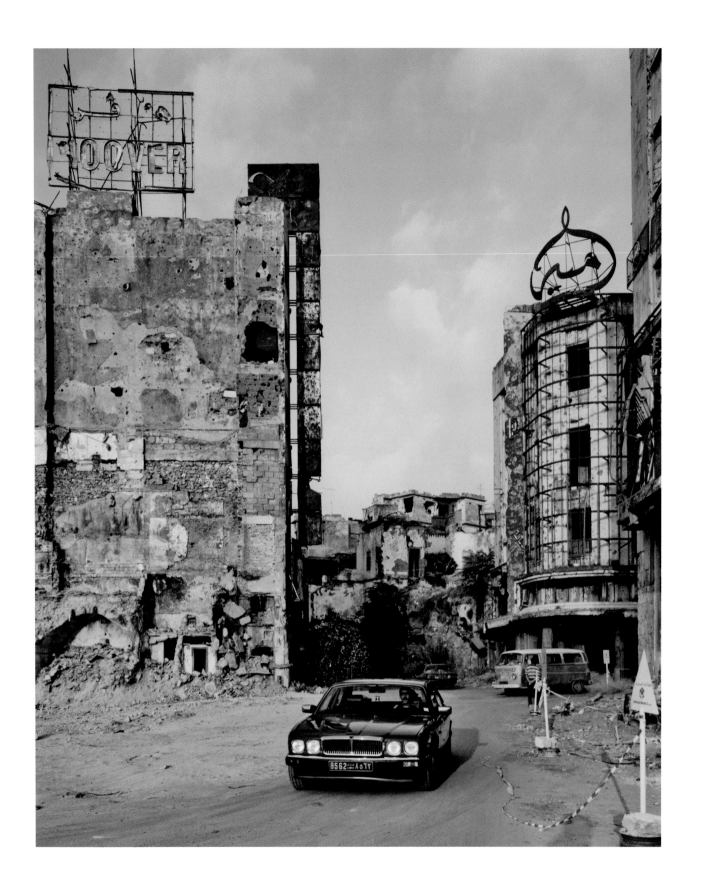
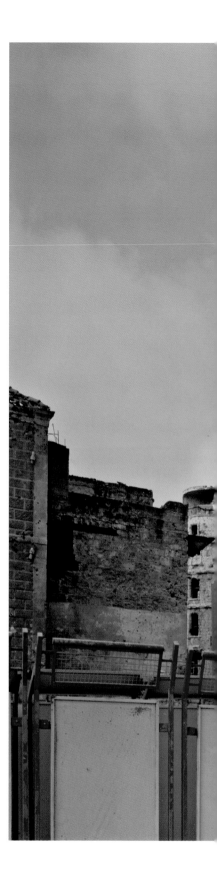

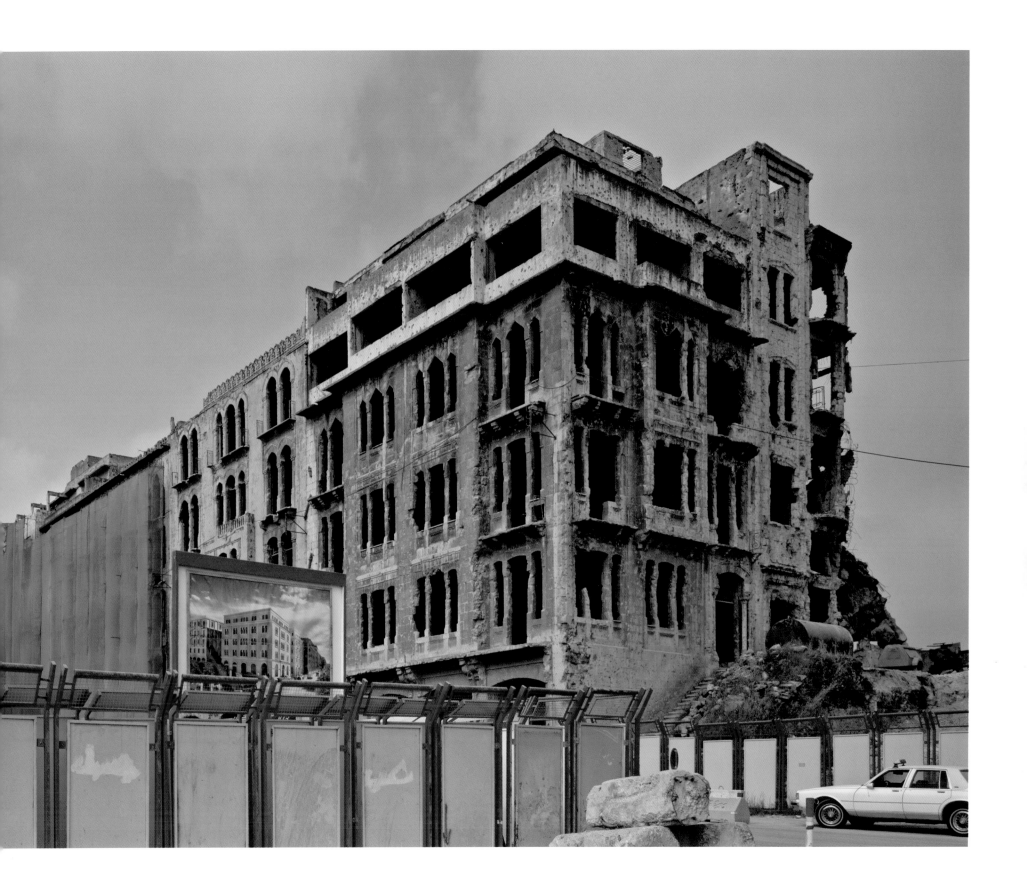

ON PHOTOGRAPHING
MOSQUES

Great architecture makes geometric sense. One of the reasons mosques are so photogenic is the intelligent and unabashed use of geometry. Beautiful forms, good access in and out. It fits like hand in glove. All religious architecture, though, is a manifestation of belief. This is why there are so many good new mosques in Islamic countries—because right now Muslims *believe*. And because of this, they aren't creating ego-driven tours de force. Still, there's a basic misperception about mosques here in the West. We're always shown images of formal prayer time, and I was surprised to discover that for most of the day the mosque serves the social function of an informal meeting hall. It is one big social hangout, the center of urban life—like a mall without material consumption. So when the light is good, when the form and the metaphor conform to each other, it's almost like a mathematical equation with emotional contours. Even an unintelligent person can take all this in unconsciously. It makes you smarter without you knowing it. Western malls, by contrast, lack geometry. They're amorphous, tubularly extruded blobs designed to avoid at all cost a meaningful center of gravity where people can congregate and interaction can flourish. They're just long entrance and exit corridors lined with vitrine dioramas. This is asocial architecture that makes you dumber without you knowing it.

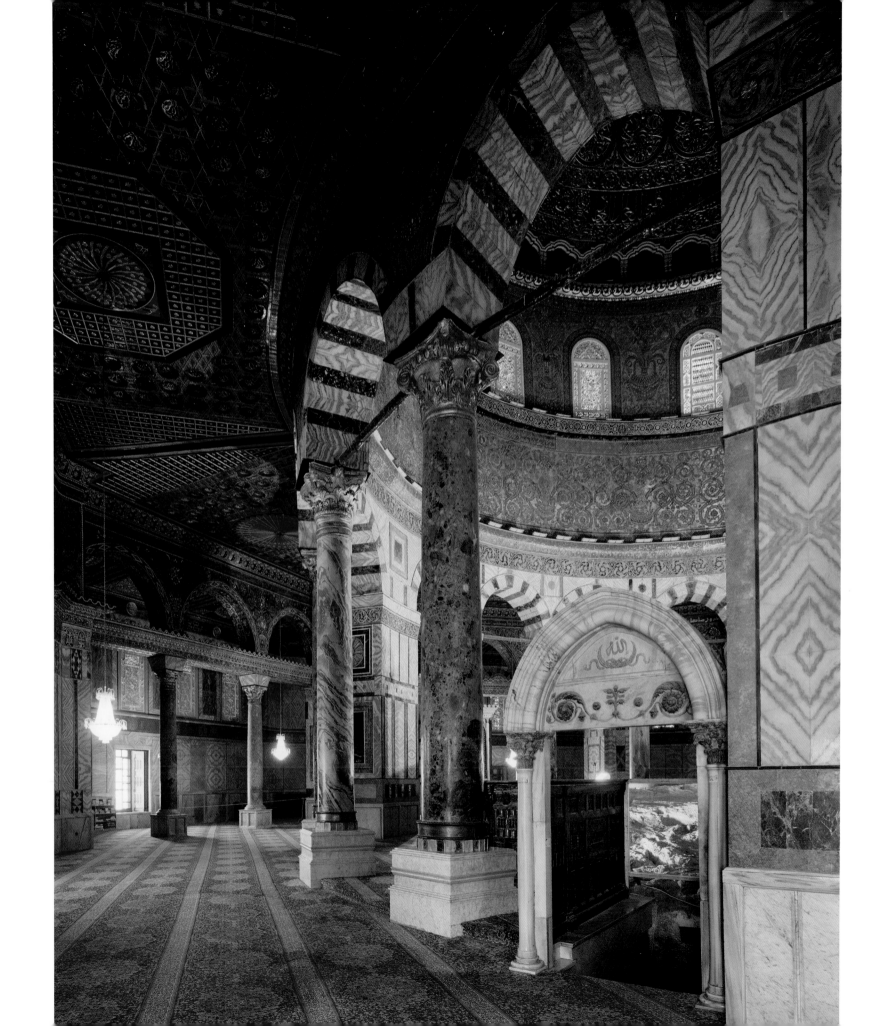

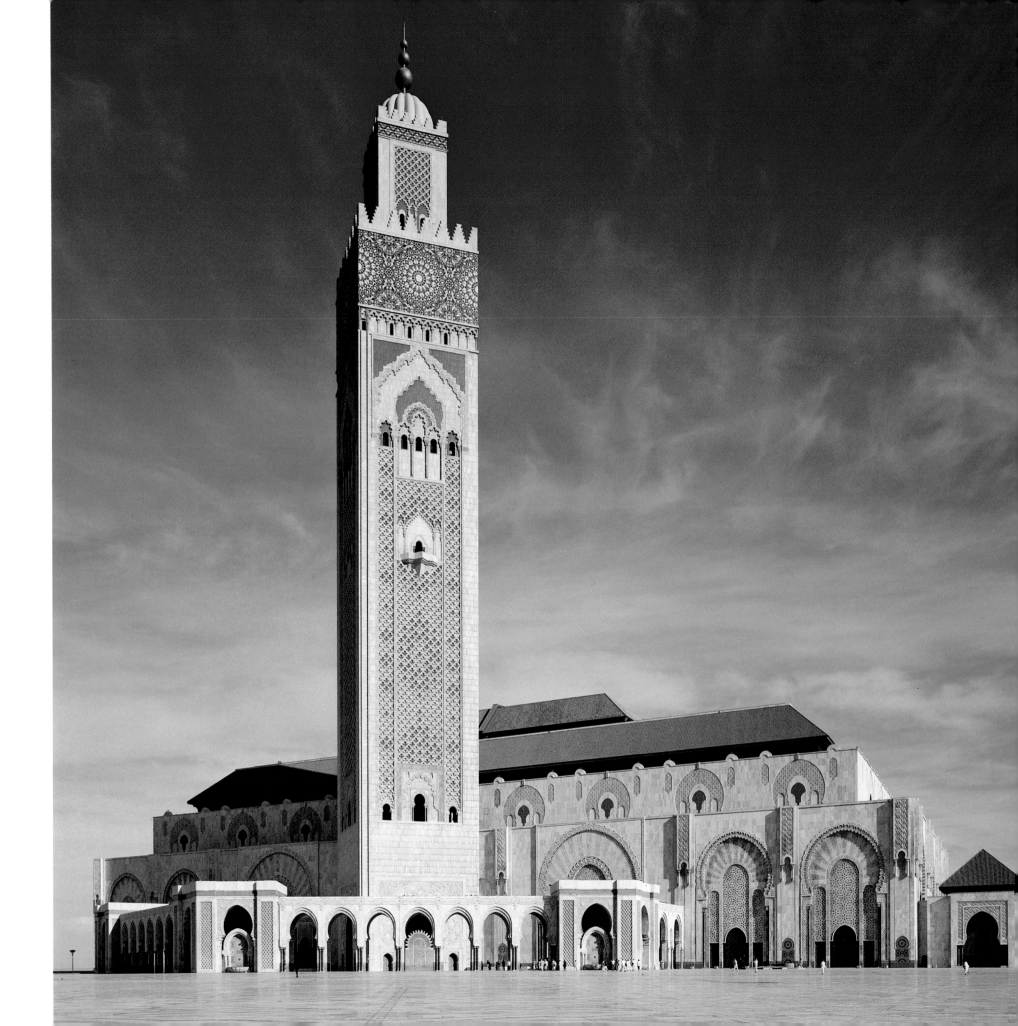

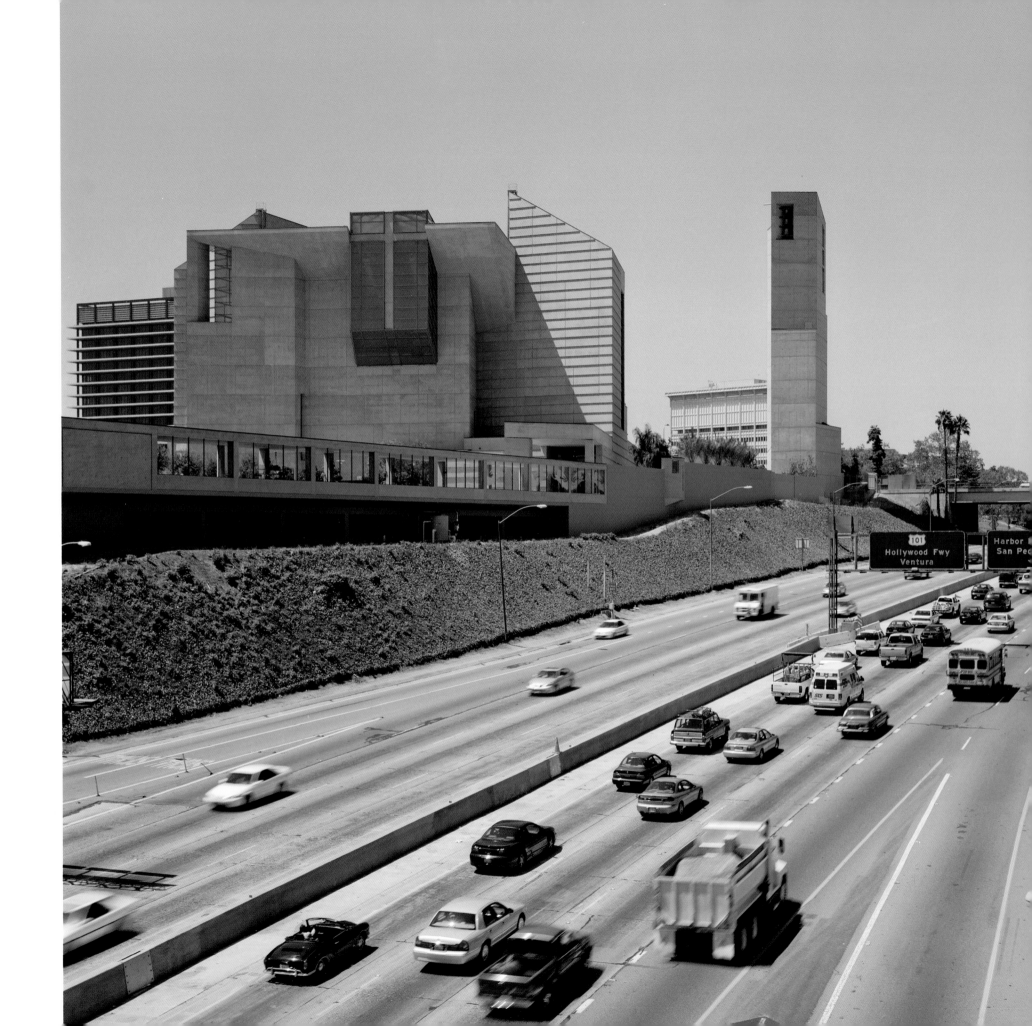

ON THE CATHEDRAL OF
OUR LADY OF THE ANGELS

The inside of Rafael Moneo's cathedral in Los Angeles looks to me like a contemporary airline terminal. Now I'm not saying I wasn't moved being there. But the truth is I was probably more impressed stepping into the TWA Terminal at Kennedy. Like Eero Saarinen's building, Moneo's is a secular cathedral. A temple of aesthetic humanism. It's not really about God, but about man's subjective relationship to space. I didn't think about it when I was shooting it, but looking at these photographs now prompts certain questions about the cathedral's social implications. By commissioning such a building is the Catholic Church moving away from its traditional monolithic vision of God and embracing its flock's subconscious tendencies? Or is it simply pandering to the masses by providing them with architectural eye-candy that it thinks will keep them coming in week after week? Either way, it's a humble and humbling gesture, but, paradoxically, it makes for less powerful architecture.

109

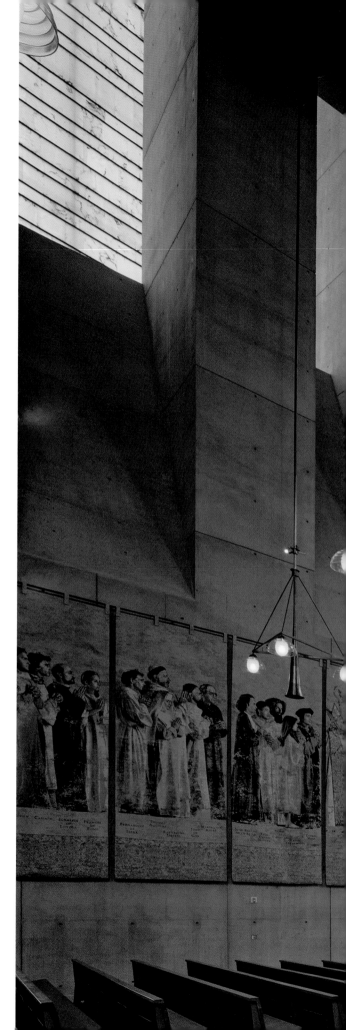

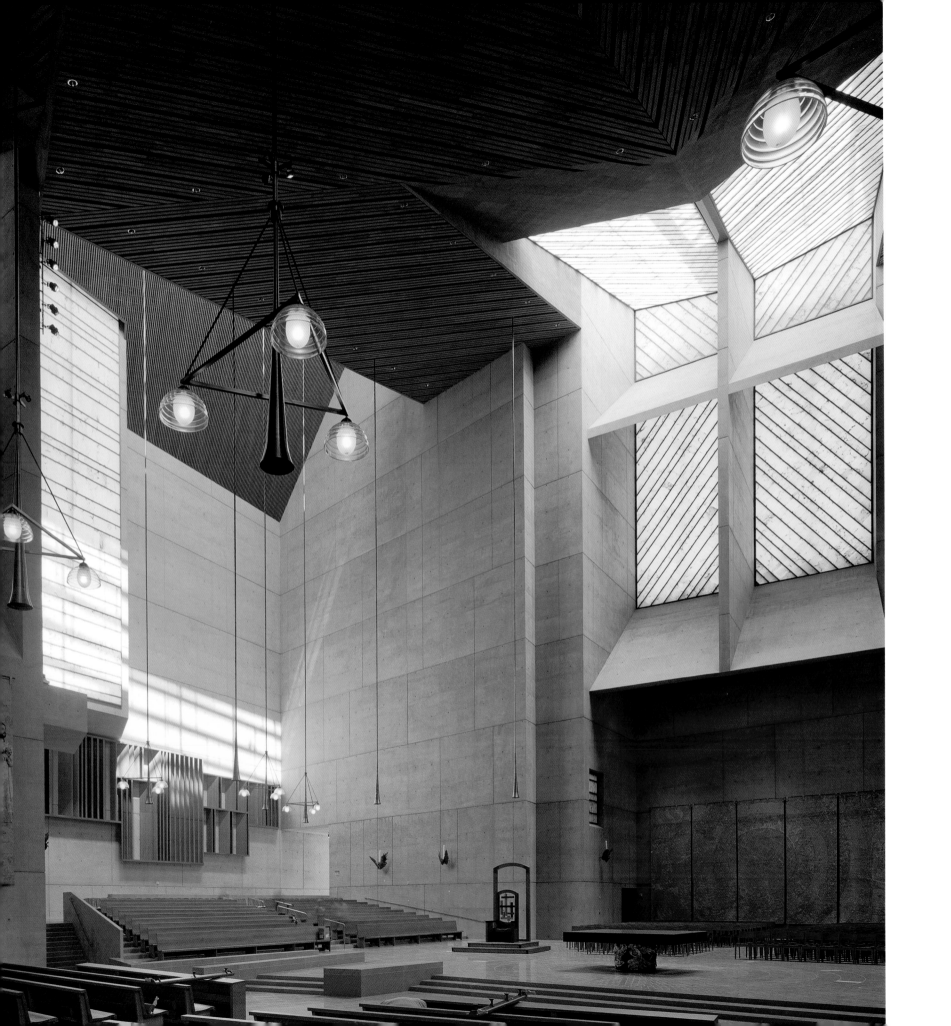

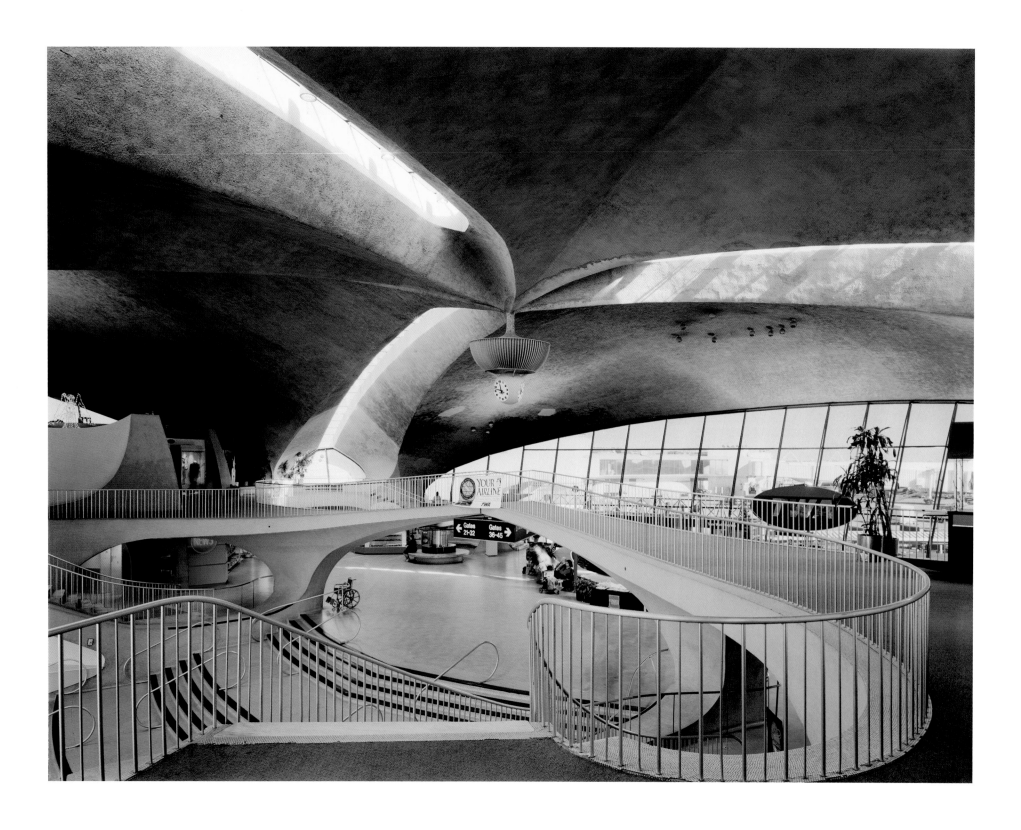

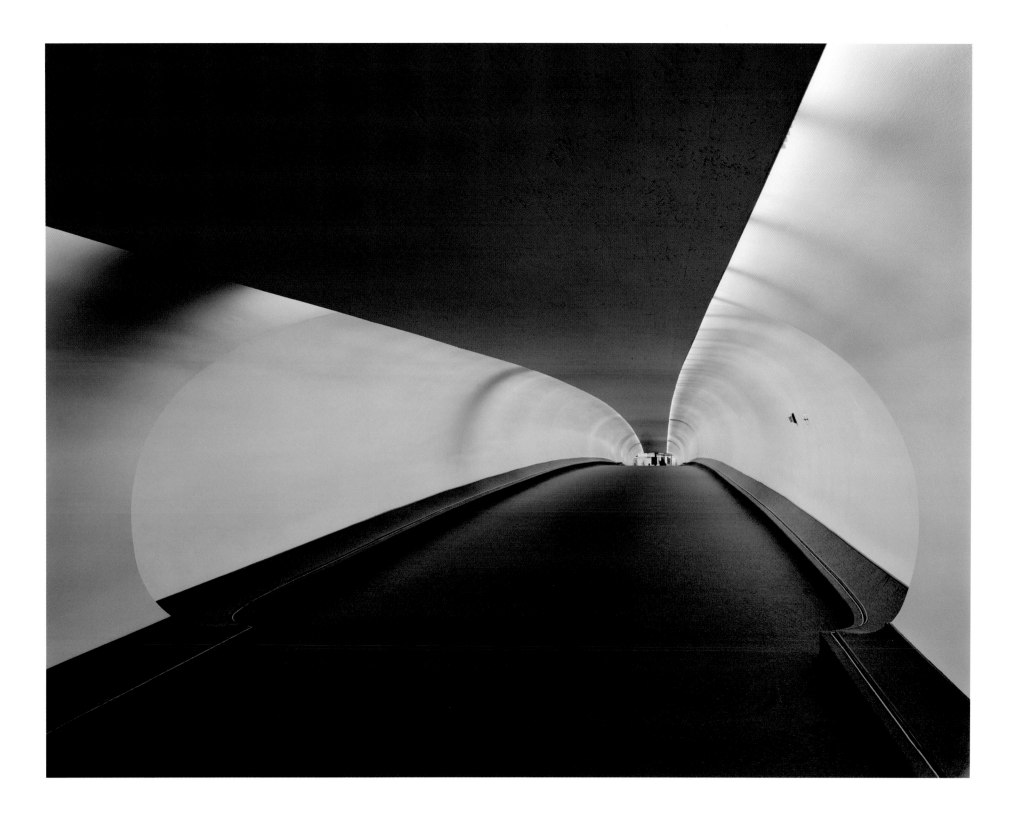

ON RODEN CRATER

Roden Crater happens at that magic hour of dusk or dawn, when the light inside starts to equal the intensity of the light outside, or vice versa. It's about that ethereal transition period, when one overtakes the other and your perception of light and color changes. When you stare at this phenomenon, unusual depth-perception anomalies occur, giving rise to a sense of wonderment or even deeper metaphysical inklings. But the effect is triggered as much by our own physiological perceptions as it is by the light itself. In my opinion Roden is more light art than sculpture. The sculptural part of it is the viewing chambers—they're almost stylized theatrical temples—which frame the light.

When I was shooting Roden for *The New Yorker*, I was met by a member of James Turrell's entourage who was there, I think, to make sure I was doing O.K. and basically "getting it." In case I wasn't, he commenced to lay on me what I felt was an abridged version of "the rap." He confided to me that among their considerations was what people two or three thousand years from today would think upon discovering the site. "Uhh... that's interesting," I said, but what I thought was: This is supreme arrogance.

If they even find this place in three thousand years, they'll think that whoever built it had a lot of money to construct monuments to himself. When the pharaohs did the same thing they were at least legitimate heads of government.

As far as I'm concerned, Roden Crater is not a *reverent* work. Look, it says, I know God intimately and I can show his face to you. Now there *is* beauty in what Turrell does. He is a great artist; I don't deny that. But I think what poses as an act of deep respect for the cosmos may in fact be something closer to an act of appropriation.

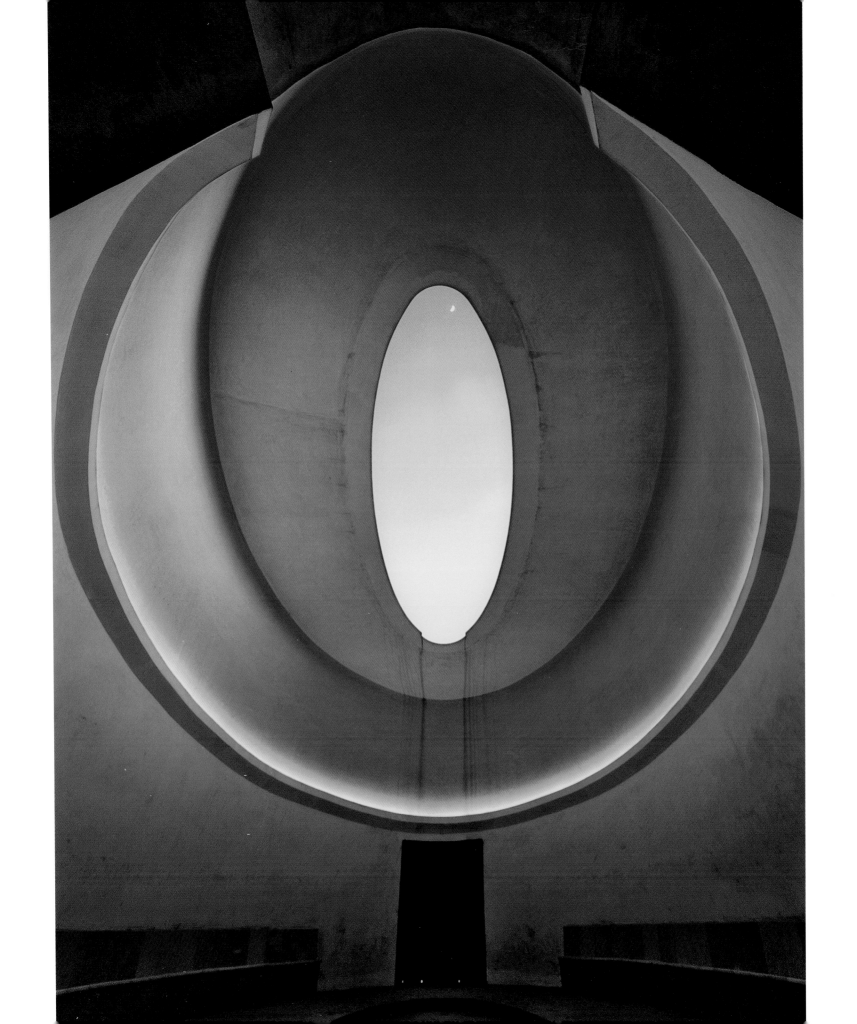

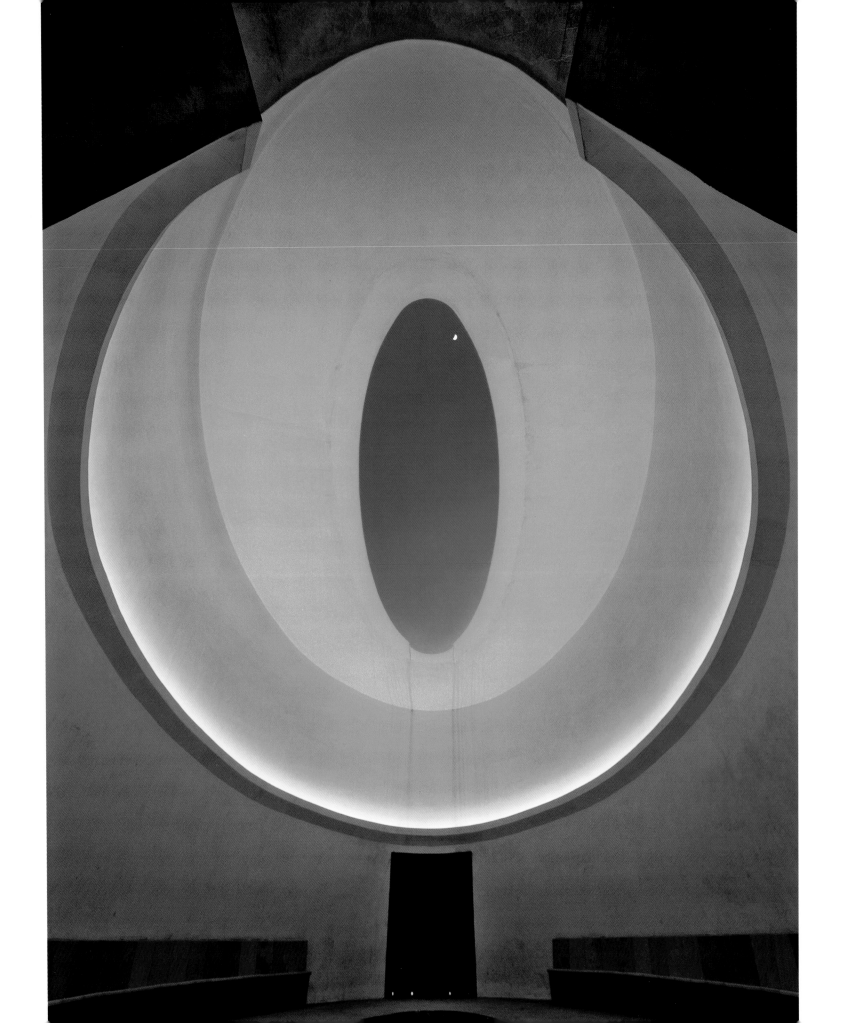

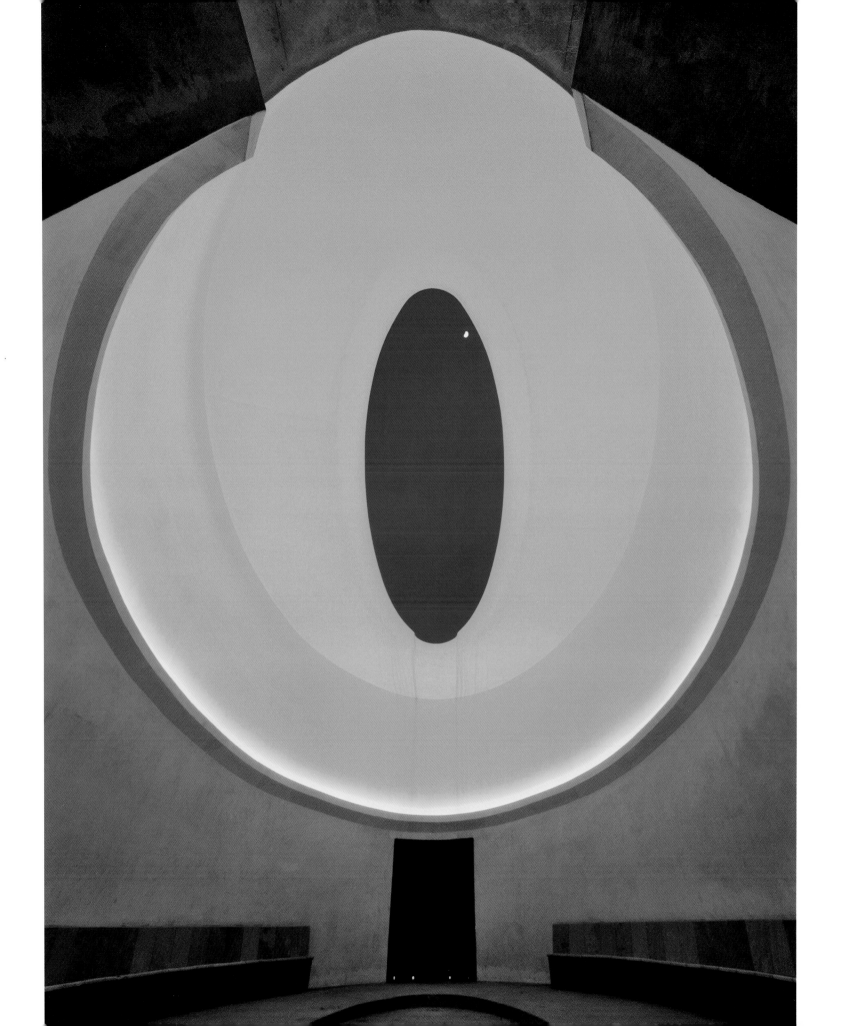

ON THE TATE MODERN

For some reason I think brick buildings are ugly. It's a personal-taste thing. I know it's irrational—and critically indefensible—but it doesn't matter. I just don't like bricks. Their color depresses me. Even though I respect their strength, and many architects have lectured me on their merits, bricks lack what I call material veracity. There's no soul to them; they're one of those composite matters, like cloning. I love the ancient buildings in Rome but I have this hunch about them: it feels like the Romans tried out designs and structures in brick first to see whether they would work, then built better versions of them in North Africa out of cut stone. I have several Indian architect friends who love bricks. They cite their cost and mutability—how you can quickly improvise with them and change design in mid-construction. Maybe my brick complex comes from the fact that I don't like the look of Montreal, my hometown, which is full of bricks. The only really good houses there are made of granite. So, right away, when I arrived in London to shoot the Tate Modern, I had problems with it.

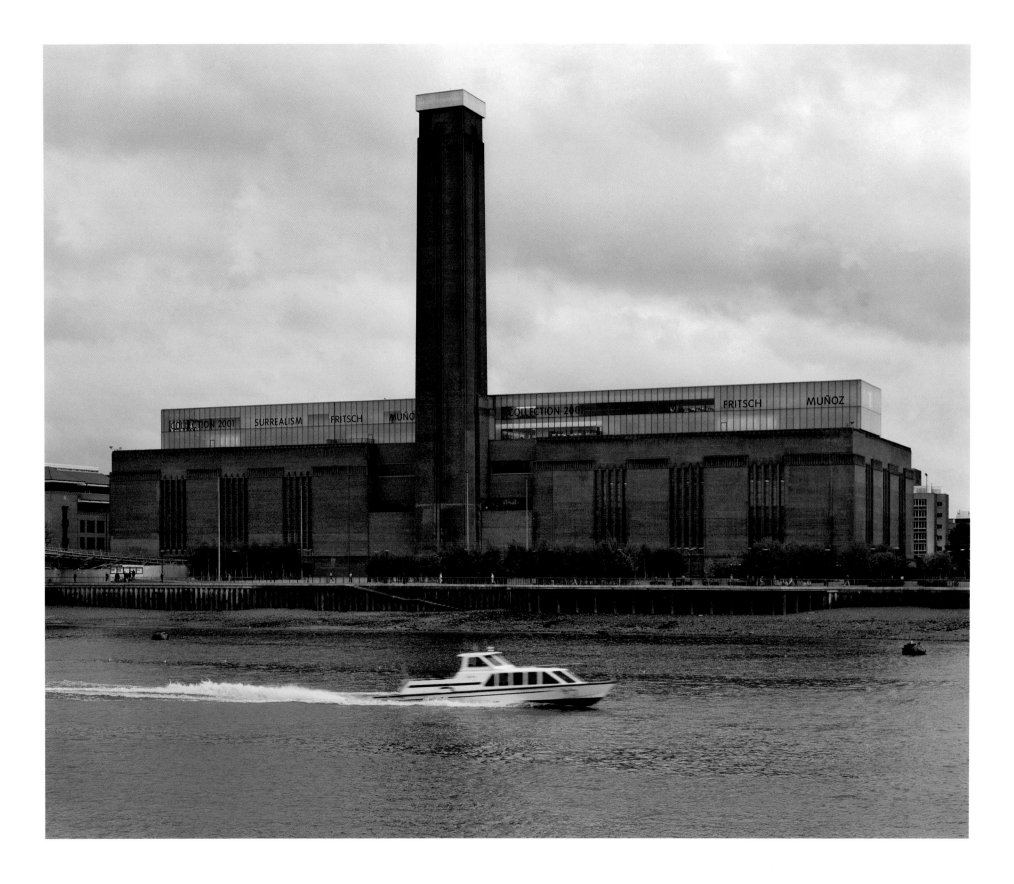

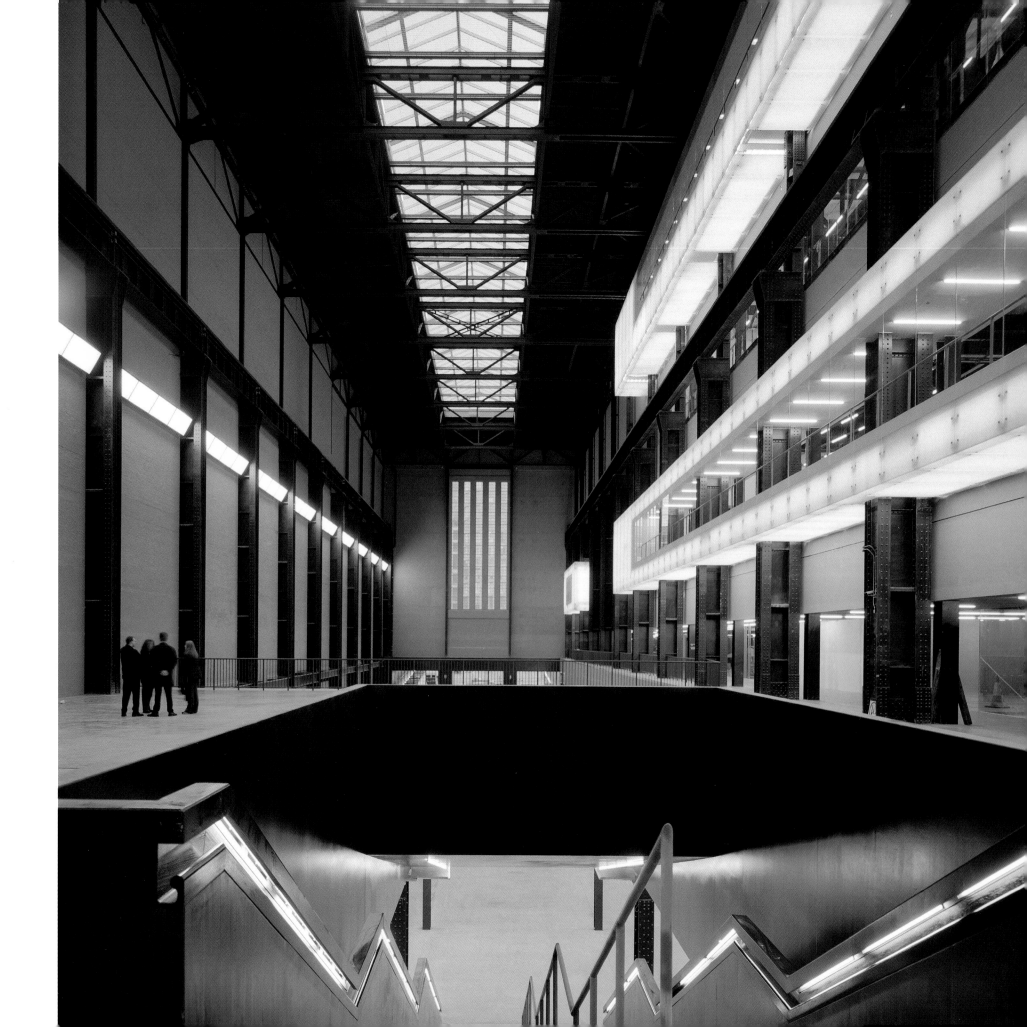

I didn't much like the Tate Modern inside, either. So, how do you shoot a building you don't like? Basically by looking at the extremes. I look for some great "wraparound" wide-angle shot or a "meaningfully evocative" detail to frame. This is where the fictional element of architectural photography comes into play. Remember, product shots are essentially commercials, and commercials lie—or at least they feature the positive elements and edit out or deemphasize the negative ones. That stairwell is nicely done, but it can only be seen from the immediate top of the stairs. If you're looking at it without the benefit of a large-format wide-angle lens, I don't think the naked eye's field of vision can also include the glowing light-boxes seen on the top right. To see them together, you have to step back twenty feet, but then you won't see down the stairs as you do in this picture. I shot it both ways, and believe me, it's a whole lot more interesting with that stairway in the lower third. I once had an agent in Paris who used to say that I was best at photographing what I didn't love. I was never sure whether that was praise or insult. But maybe the payoff for me in these cases is being able to edit and revise reality by visually transforming it. To the naked eye, the Tate has no vantage points that are as interesting as what I achieved in this image. 121

ON TADAO ANDO

Ando is what I would call a sublimely schizophrenic architect. There's such a contrast between the inside and outside of his buildings that it's almost as if two architects worked on them. The real magic for me is on the inside, because Ando thinks about the experience of moving from one room to another. There's a conscious progression as you work your way through the Modern Art Museum of Fort Worth. Using light and spatial volume, Ando leads you on a journey with a beginning, middle, and end. Most architects are not aware of the fragile, temporal quality of being in a building. They're so consumed with fulfilling their physical obligations that they forget about this subjective experience, that moving through space is cinematic. Instead they approach a series of rooms as if they're a sequence of still shots for a catalogue. People call Ando's work "spiritual," but what they're really responding to is the journey: the art of getting there.

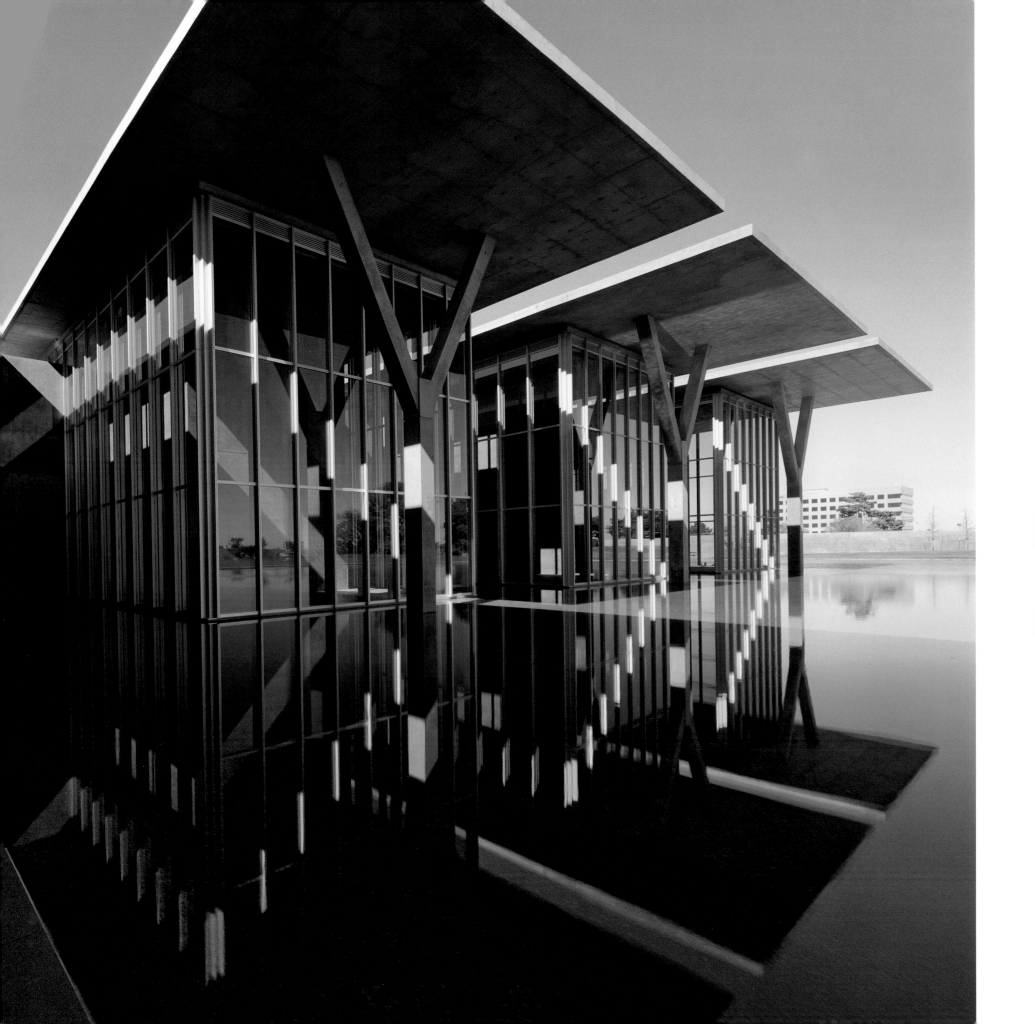

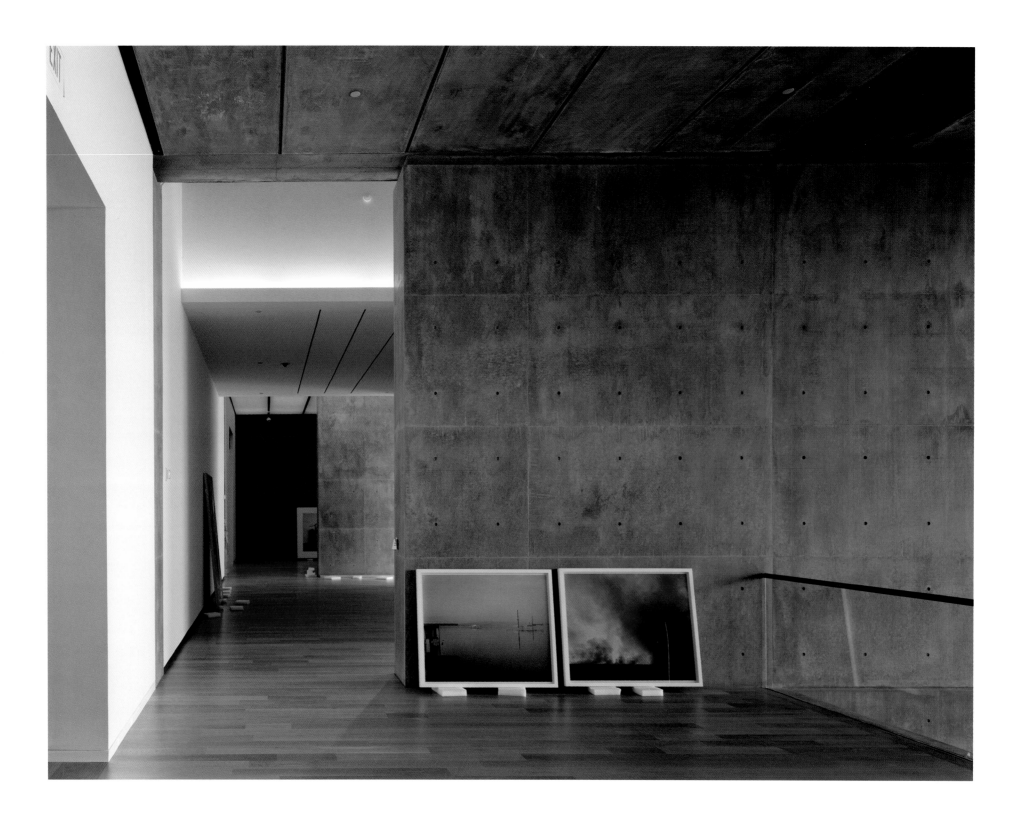

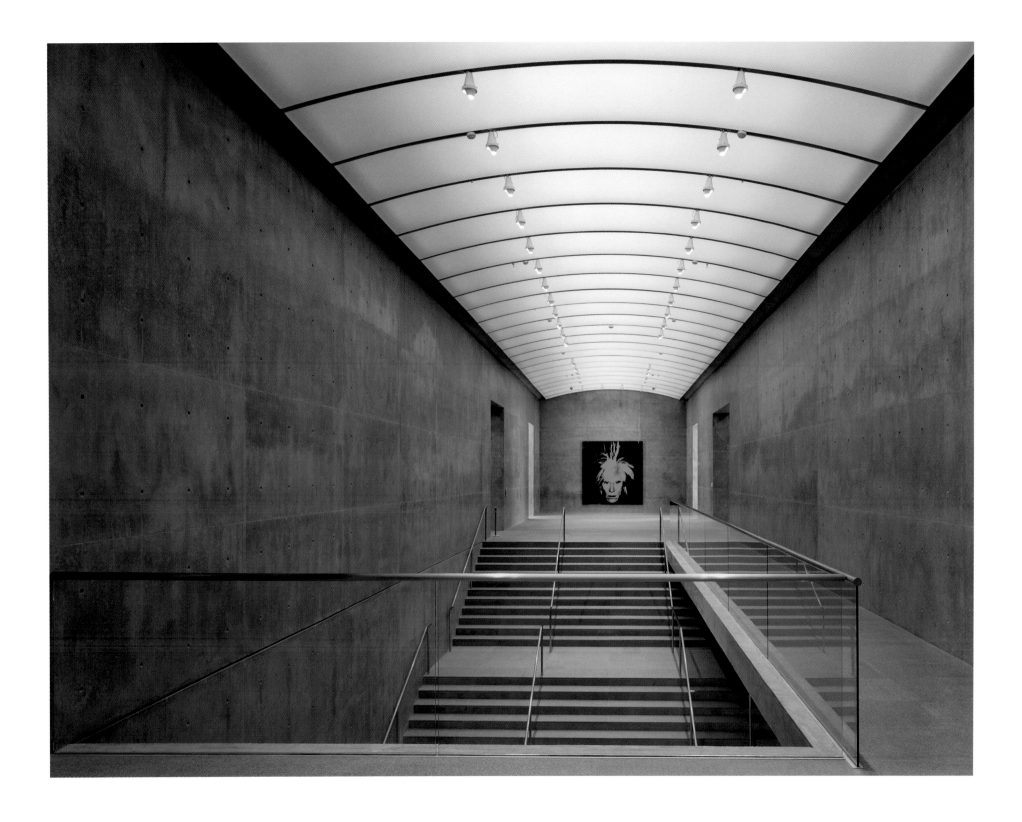

ON THE BRITISH MUSEUM

When I first got to the Great Court, I knew I had to find a spot that was high and central because I wanted to emphasize Norman Foster's streamlined symmetrical beauty. He's a modern classicist. But shooting round buildings close up never works because there aren't any dramatic angles to capitalize on. If you photograph them too close, the shapes distort to a displeasing oval. Round buildings—round shapes, in general—look great and best from above. So creating the emblematic shot here was about finding the one place in the building where my camera and the viewer could take it all in, in one enveloping glance. We're lucky that Foster integrated a central opening on the third floor that makes it possible for all of us.

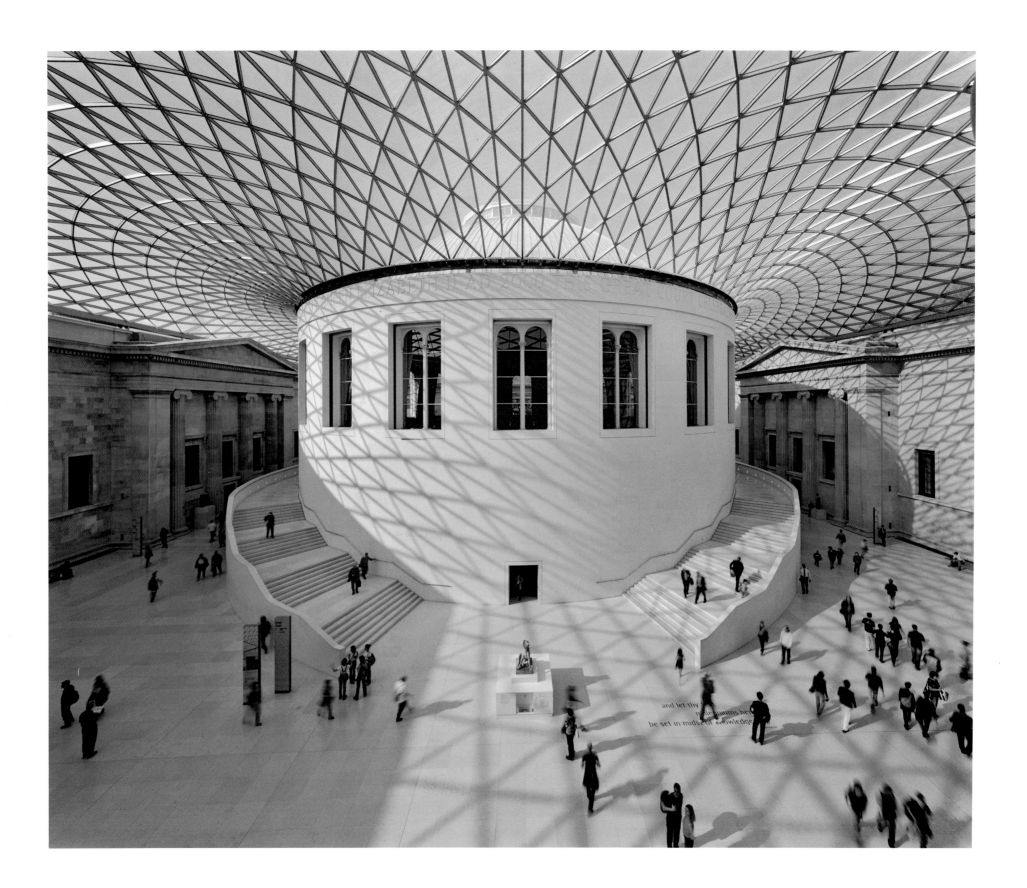

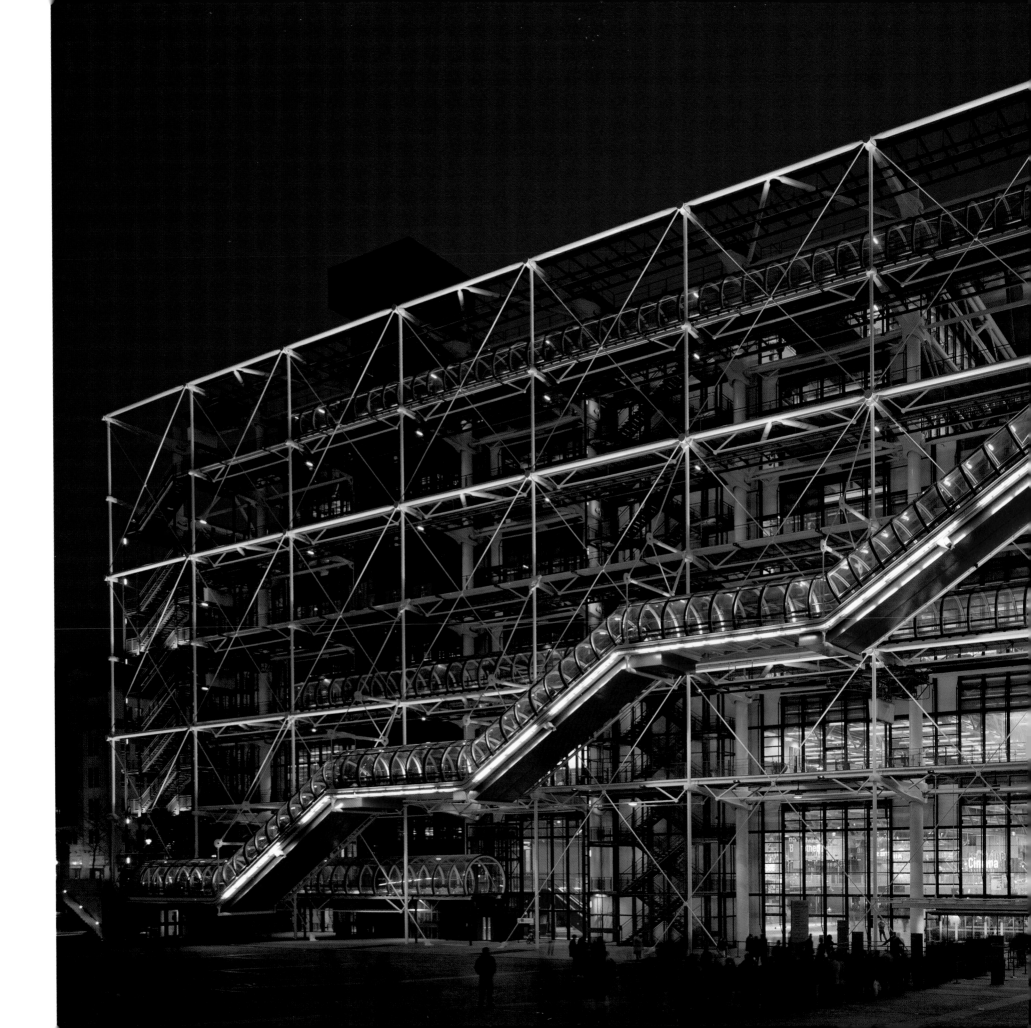

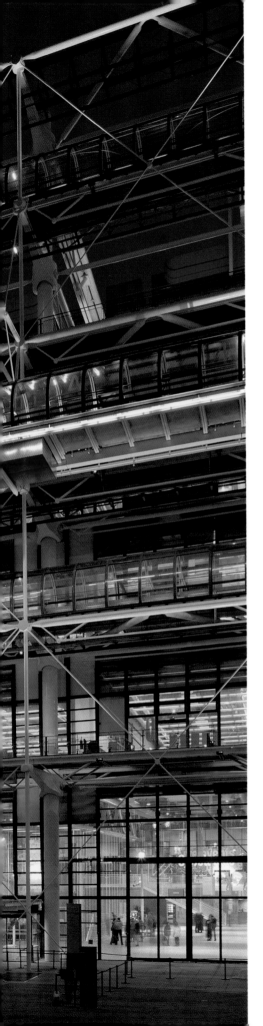

ON THE POMPIDOU CENTER

The Parisians love this building. Not so much conceptually or architecturally, because it's not really a French expression, but they love to use and play with it, and they have come to accept it as theirs. It's like a great urban toy, a giant Erector set. At night when it's all lit up it reminds me of those models of the human body where you can see all the organs inside. I lived in Paris not so far from it for about fourteen years, and I saw the building pass through a lot of phases, including the last restoration. It has a complex color scheme where different sets of pipes have different colors. The cleaning and paint job took over a year, I think, but it only looked fresh for about five months. Then it looked grimy again like it always did. The process cost many millions of francs, and I remember thinking that it would have been cheaper to sheet it with transparent plate glass and maintain it with a normal window-cleaning contract. But you know, that's probably irrelevant. Dirty or clean, the people will love it and use it just the same. Buildings have fates and personal karma like people. Some are loved and successful in spite of their shortcomings, and others are shunned and never make it, no matter how good the original intentions were, no matter what subsequent corrections are made.

ON THE LVMH TOWER

I took this shot from the middle of a sidewalk on 57th Street. It's an example of how reality reduces your choices for you. Because I wanted to draw your eye toward the summit and capture the long, thin elegance of the tower, I needed to shoot it closer to mid-height. But the windows of the building across the street don't open and the roof is too high. So when I photographed it at 5:30 in the morning, I was suspended forty feet in the air in a cherry picker. For New York, this tower is a unique aesthetic statement, a rare touch of architectural femininity. Even though it was designed by a French architect for a French company, it is quite reverent toward its American neighbors. When I examine the building closely I find that she is not really dressed in Chanel. She's dressed in Calvin Klein. She strikes a French pose, but does so in American clothes.

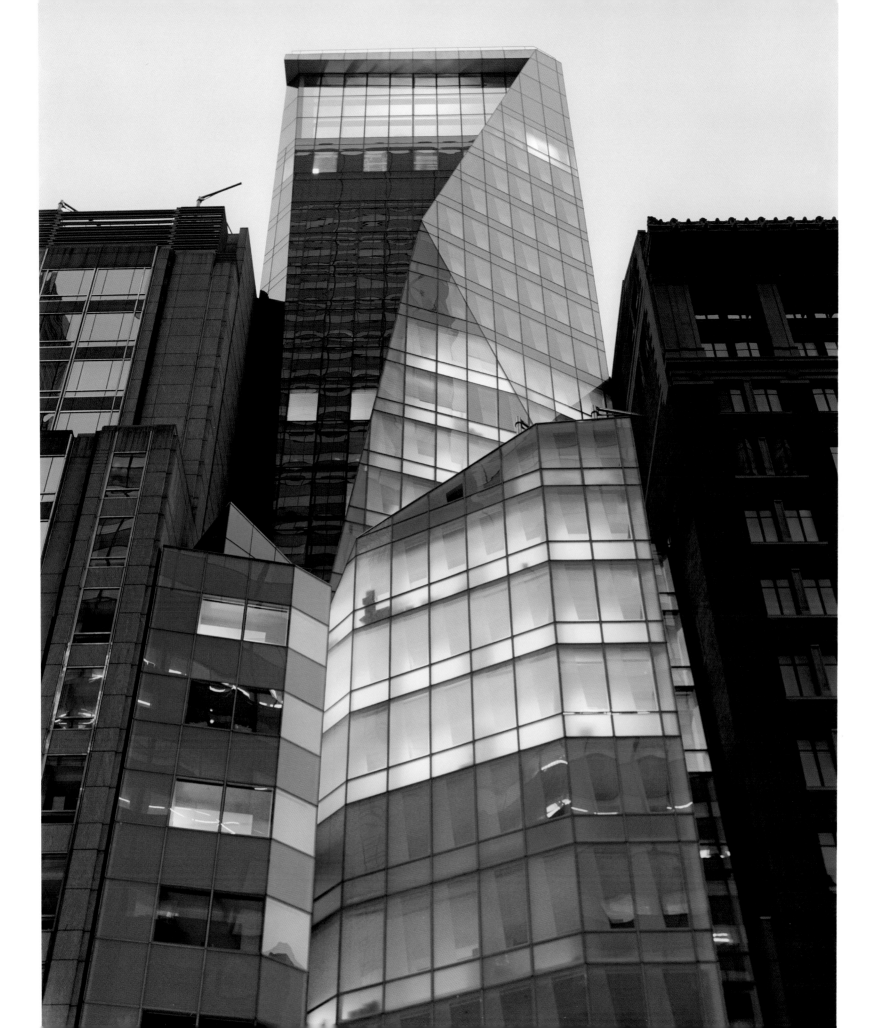

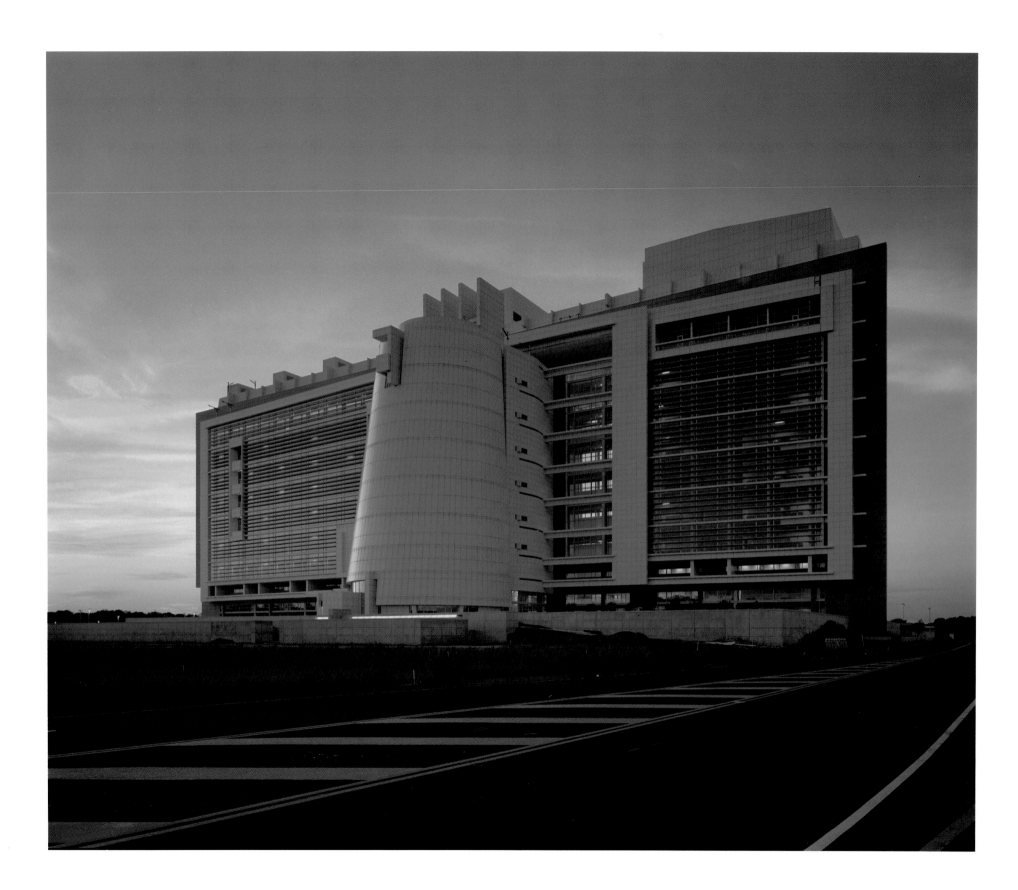

ON THE ISLIP COURTHOUSE

It took me five hours to get this shot. When I looked at the courthouse, it seemed compositionally imbalanced. There's a rectangle, a square, and a cylinder, but I couldn't find the center for the one emblematic shot. When I don't immediately see it, I always circle a building on foot and zigzag, searching for angles. If that doesn't work, I look for details, but that's never as satisfying. Adding to my problem here was that my authorization to photograph began the following day and the forecast said rain. We were getting close to dusk, and I could tell the sunset was going to be fabulous. Just in time, I found a place where I liked the composition—but the security guys chased me off. Feeling pressured and knowing the light wouldn't last much longer, I glanced to my right across the street, just off federal property. Let's try it—no time to waste. As it turns out, this shot was even better, maybe perfect. At that angle, the perspective radically fore-shortens the pavilion on the left side while elongating the one on the right side. In reality the left wing is two to three times longer, but I find that compositionally displeasing. Here they look roughly equiv-alent. Sometimes I have to distort things to make them look better on a page. And this time, having corrected and improved upon the building's shape, I didn't mind.

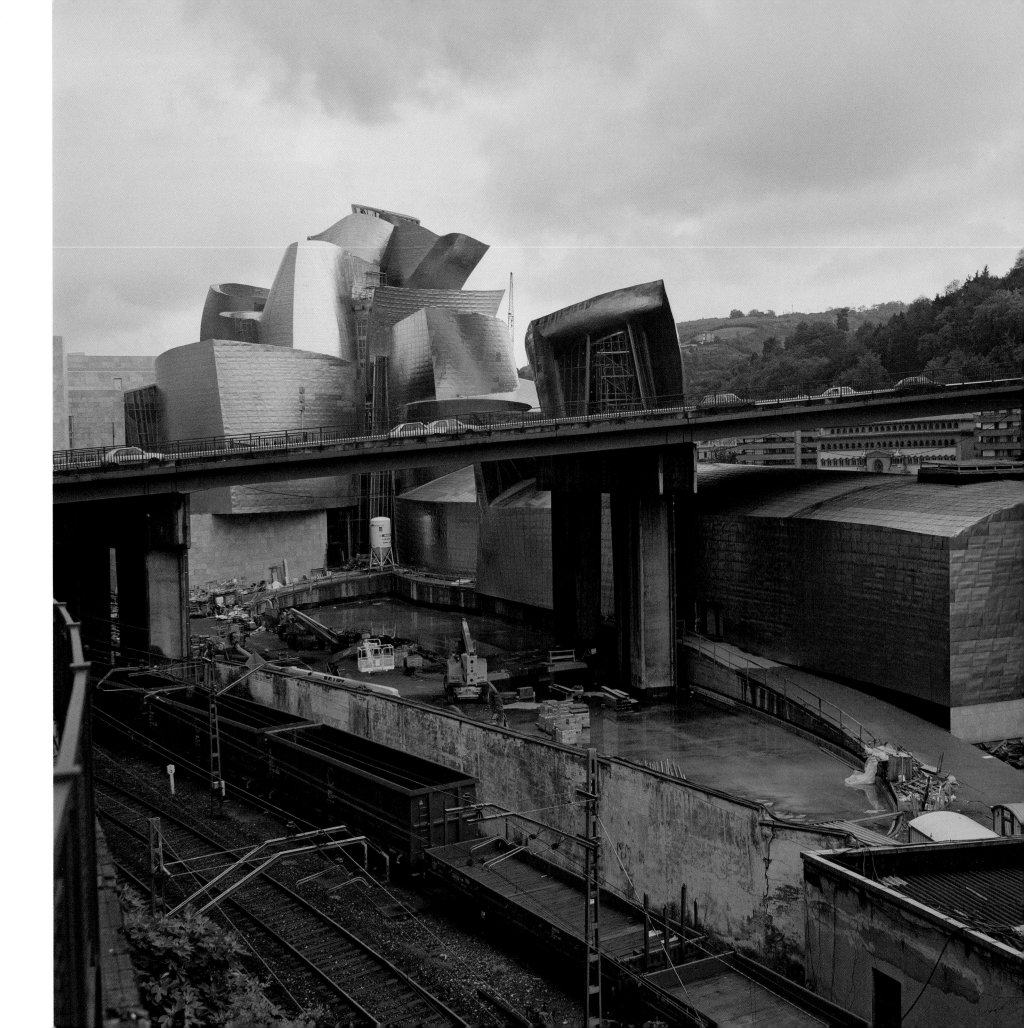

ON BILBAO

One of my biggest problems with shooting architecture for magazines is their fetishistic mania for exclusives—always trying to beat everyone to the punch. The designers of the building want just the opposite—as much exposure as possible by everyone at the same time. So timing and scheduling are a major ordeal, and to finally get to shoot is a relief. But the result is that I often end up photographing buildings before they're actually completed. This preempts a whole lot of good compositions because the shots are populated by equipment, workers, and debris, much to the displeasure of most editors. It's a bit like taking a portrait while the subject is still in surgery—not always so photogenic.

This was the case when I was sent to photograph the Guggenheim Bilbao. No doubt about it: the building was nowhere near finished. I walked all around it and couldn't find one clear, clean shot that communicated. To make things worse, the weather was lousy. Nothing about this rang "commercial money shot." In a situation like this there's only one thing to do: forget about pleasing editors, please yourself. So I took a sociological shot from what I thought was the most interesting perspective—where part of the building continues under the existing bridge. It's rare to see a new structure reach under an older one. When I took this picture I knew it would never be published, and I was almost right.

ON REM KOOLHAAS

As a kid I learned a lot about geography and cultures from collecting stamps. Of all the European countries, the one I could never quite get a handle on was Holland. I could tell that it had a specific and unique color palette, but it seemed awkward to me (and by the way I can't stand Rembrandt). Even the geographical links between its former colonies seemed bizarre and noncontiguous to me. Ultimately, I was just perplexed.

I feel exactly the same about Rem Koolhaas's work. The color schemes are acidic but uncommon. The spaces are awkward but unique. Unlike the work of most architects, there is hardly anything cliché about Rem's buildings. There is an element of surprise from one space to another—it's not monotone or boring, but it's not sensual either. Perhaps that's what puts me off: a Protestant ethic where the body must conform to the mind. But I have to say that he's pretty much an original. His spaces are more than just the current fad for theatrical facades. What you see is what you get, and what is holding it up. Rem's architecture is probably something great that is simply not to my taste.

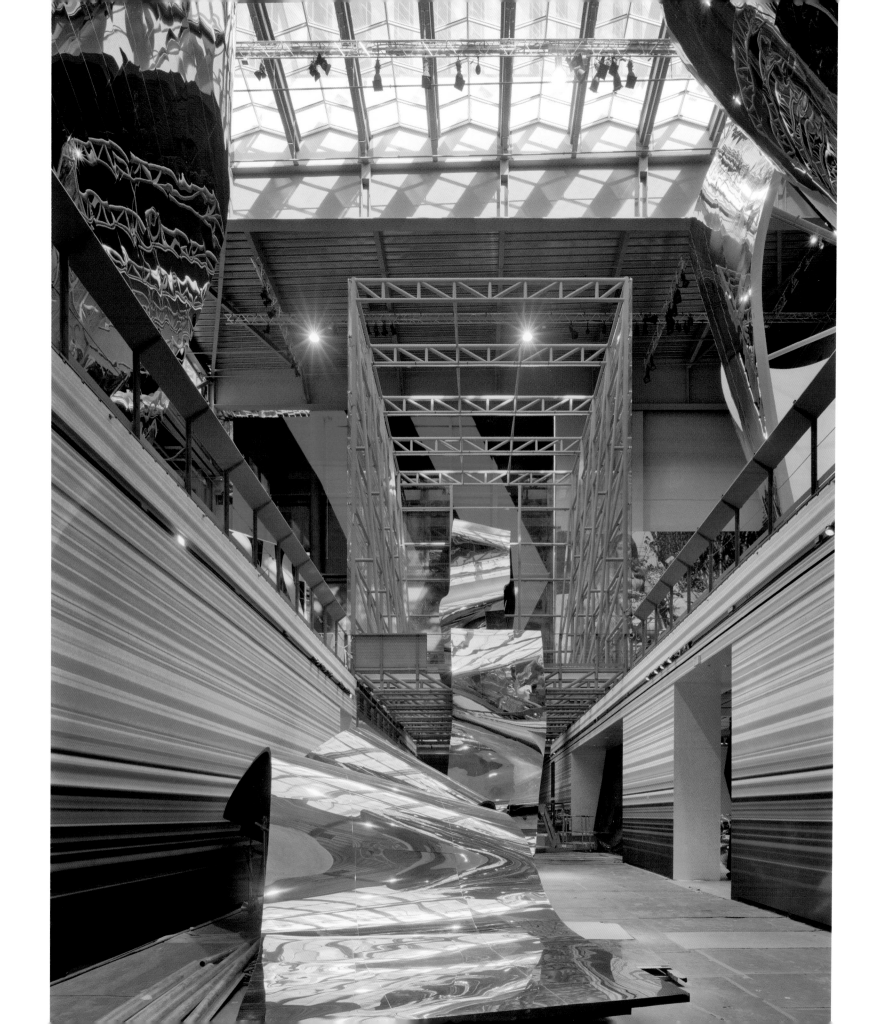

ON A FORGOTTEN MASTERPIECE

As soon as you walk inside the Ford Foundation Building, the air pressure changes and your mood is transformed. Paradiso! I just love it. There's a whole new world of smells, humidity, and muffled sounds of life. The building breathes and creates its own atmosphere. Looking out from inside the offices, you see a lush garden below, a kind of miniature urban forest, with the neighboring buildings of Manhattan visible just beyond a massive curtain wall. It's a contemporary reworking of classic Persian architectural themes, executed in the mold of Mies van der Rohe. The way the building brings the outside world into the corporate environment was ahead of its time. It's an under-appreciated masterpiece.

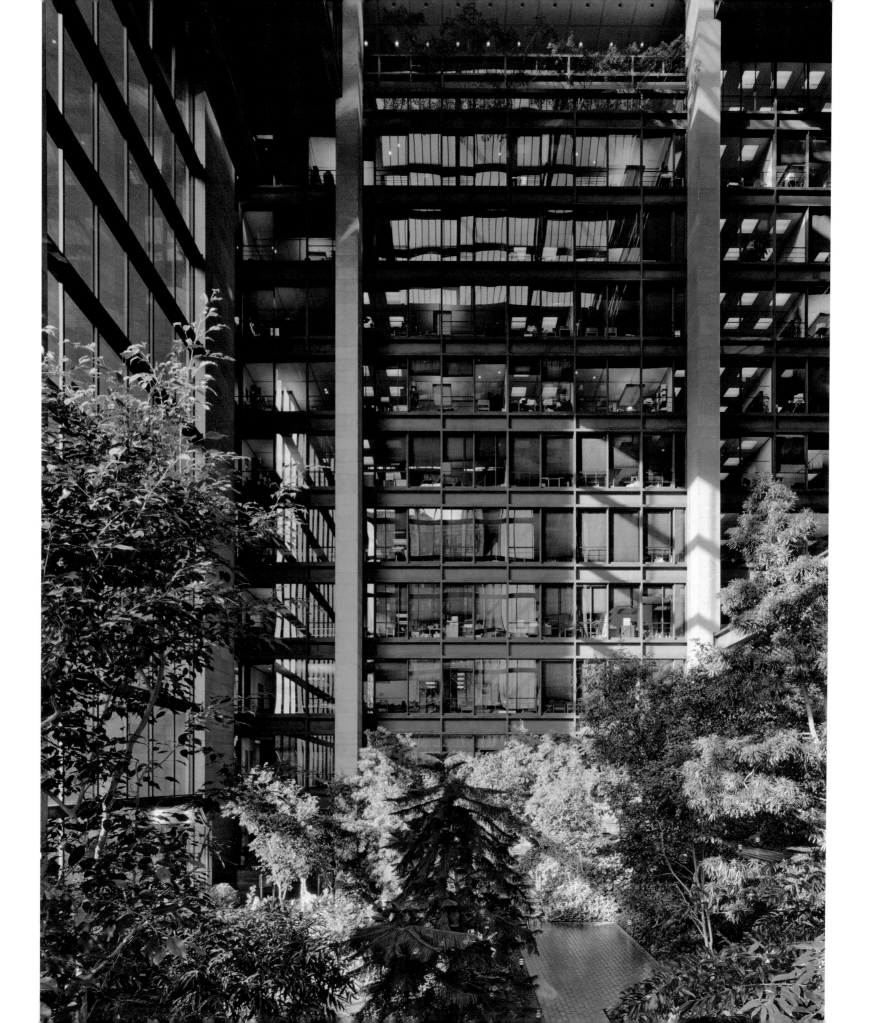

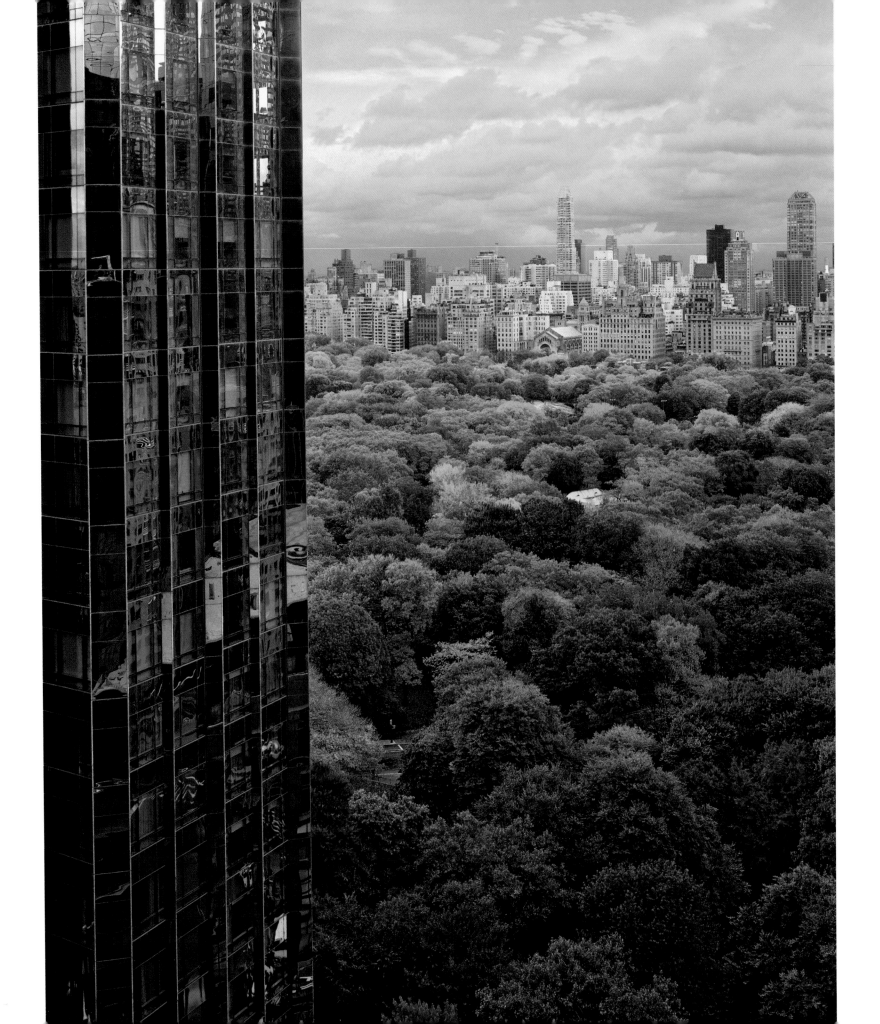

ON NEW YORK

I've come to realize that I have shamefully few photos of the cities where I've actually lived, and archives full of images of places where I've spent just a few days. Why is that? Is it impossible to participate in and observe the same phenomena at the same time? I don't know. But New York has always worked on me at an even deeper level. I first became aware of its unique identity when I was nine or ten years old and living in Seattle. It was during the World Series in 1960 or '61, and the kids in school were talking about it. Even though my English wasn't fluent then, I got the intended meaning of our teacher's story about visiting Manhattan one day and stopping a man on the sidewalk to ask him directions to Fifth Avenue. "The man looked at me with the strangest look," she said, "and then he said to me, 'Lady, you're standing on it.'" She went on a diatribe about how the people of the Pacific Northwest were much friendlier and then ricocheted on from this to implore the class to give their support to whoever opposed the Yankees. I was shocked. What's wrong with this teacher? I thought. She must be stupid. The guy on the street had a perfectly normal reaction, and now she wants me to cheer for an inferior and less inspiring team?

The New York seed was planted, and by the time I was in high school I was already scheming how to move there. My initial attraction was psychological, not visual. I was drawn to the collection and variety of people, the energy that I felt pulsating here. On my first night in New York, in June 1969, a cab ride brought me down Park Avenue. I remember sitting totally transfixed while driving through what I think of as the Pan Am Building, realizing how visually rich and potent this city was. I loved the density and the gridness of it all; I felt its gravitational pull as being psychic. And let's be honest here, I'm not talking about the other boroughs. When I say New York, I am referring to Manhattan.

So, let's get to the point: Just what is the defining and emblematic shot of New York? For me it's a view of Central Park from its perimeter. The illusion is that the buildings surrounding the park are some sort of natural crystal growths, and that sometime in the past, visionary planners cut out a rectangle of buildings and planted a garden in their place to give the city some lungs. Of course, the opposite is true: the city grew up around it. I try to remain optimistic and hopeful that over time the skyscraper crystals will grow all the way to JFK, which will be a transition zone so grand that when you fly across it, you'll land at LAX and take a cab ride to Santa Monica, also known as TriBeCa West.

141

APOLOGIES AND THANK YOUS

If this were a music CD it would be considered a compilation of collected singles, jingles, and other covers. Since nearly all the photographs in this book were taken on assignment for one publication or another, this volume could be looked at as an abridged survey of my commercial or editorial photography. I came out of an art background—avant-garde film, specifically—and this milieu simply did not tolerate the notion of realizing any work for *any* client. Because of this I once hid a shame about even doing this kind of work. Obviously, my thinking has evolved and I now feel differently about it. It's like taking a rock band on the road. You don't always do your best work there, but the proficiency of your base level rises because you tone up working under adversity. I've also realized that in accepting these assignments I've met so many incredible people that I never would have encountered while staying at home in a normal state of unchallenged psychological passivity. For this I am grateful, and my life has been made richer and more interesting because of it. Perhaps it's the middle-age-crisis-thing about giving up on the person you always wanted to be and accepting the person you are. But looking back on it I'm mostly happy I did these assignments and I am a different person for it.

So when Martin Pedersen of *Metropolis* magazine asked me to do a book based on my editorial photographs of cities and architecture, and my commentaries on them, a flash of fright went through me. I knew I would get nailed for it but I knew I was going to do it anyway. What I didn't realize was what a long and winding road this was going to be. Specifically, the process entailed the audio recording of my reflections on a predetermined selection of sites and images. These were transcribed and rewritten by Martin and resubmitted to me. I then rewrote them

based on what I wanted to say or what I thought I meant—or simply to make them sound as if I were speaking. Martin and Elizabeth Culbert then reworked them once again to make them less idiosyncratic and digressive, and more understandable. Criswell Lappin responded patiently and creatively to my many interventions in his image selection, sequencing, and layout.

Words, however, are slippery and approximate. They're like the representation of images, where the thing and the image of the thing are not the same—because saying the words, hearing the words, writing the words, and then reading the words do not produce exactly the same meaning as what was originally intended. Unfortunately for me, composing with words is not like Ravel's "Bolero," where meaning is built up by adding transparent layers of sound. Words are opaque, discrete bits, and meaning has to be cut out of a block all at once. There's no discovery or improvisation: you have to know where you're going before you even begin. That's what words are like, that's their nature—deterministic. It's not like in Photoshop, where I can say to my computer, let's take that verb and desaturate it by 15 percent. There's a preexisting word that already covers that meaning or there isn't, but I can't mix one up. So I'm not on my normal terrain here and I've had a lot of help handling it. This volume is the accumulation of many labors performed by an oligarchy of participants engaged in various tasks at different times. So it is with sincerity that I thank the many individuals who have made this project possible. If I've omitted or offended anyone, please forgive me, let me know, and I'll try to make it up to you next time.

Dr. Ousmane Aidi
Hossein Mahmoud Ali
Giuma Anag
Tadao Ando
Dr. Camille Asmar
Catherine Balet
Sara Barrett
John Battista
Maylis Bellocq
Olivier Binst
Elisabeth Biondi
Ricardo Bloch
Amal Bouchenaki
Jean-Luc Bouvret
Alexandra Brez
Bill Charles
Jonathan Chick
David Childs
Randy Colgate
Béatrice Comte
Phil Davies
Eric Delpont
Winnie Denker
Marie Depalle
Béatrice de Durfort
Roland Eckl
Egyptian State Information Service
Carl van Eiszner
Enaam Eltantwy
Ehab Fahmy
Norman Foster
Albert Fung
Sharon Helgason Gallagher
Yishay Garbasz
Frank Gehry
Lucy Gilmour
Esin Ili Goknar
Paul Goldberger
Gilles Guey
Scott Hagendorf
Suzy Hakimian
Horace Havemeyer III
Moussa Al Houchi
Amal Hrawi
I.F.A.P.O.
IMA
Clive Irving
Madan Jee
Jordanian Ministry of Tourism and Antiquities
Walid Jumblatt
Jean-Jacques Karatchian
Dr. Ali Khadouri

Mona Khazindar
Kathleen Klech
Rem Koolhaas
Philippe Laumont
Didier Lecouanet
David Leventi
Marco Liviadotti
Natasha Lunn
Lybian Ministry of Antiquities
Maria MacDonald
Peter MacGill
Marco Marchesi
Richard Meier
Angelica Mistro
Rafael Moneo
Andrew Moore
Jamil Muhaisen
Diana Murphy
Lisa Naftolin
Lauren Nelson
Karla Osorio Neto
Tom Oxley
Suryakant Patel
John Pelosi
Pat Pesce
Renzo Piano
Christian de Portzamparc
Marc Pottier
Tushar Rao
Sylvie Rebbot
Olivier Renaud-Clément
Sonia Rendigs
Bertrand Rigot-Muller
Kevin Roche
Richard Rogers
Colonel Ronde
Hemant Sagar
Evandro Sales
Andrea Schwan
Matthew Spiegelman
Gerhard Steidl
Joel Sternfeld
Susan Szenasy
Eric Taubman
Muriel Tohme
Dr. Ali Abdussalem Treki
Charles Tufenkji
James Turrell
UNESCO
Claudia Vicent
Martin Weinstein
Ned Witogen
Kylie Wright
Harf Zimmerman

INDEX OF PHOTOGRAPHS

This work is a collaboration by Robert Polidori, Martin C. Pedersen,
Criswell Lappin, and Elizabeth Culbert.

Editor: Diana Murphy
Managing editor: Lori Waxman
Production manager: Prem Krishnamurthy
Separations and printing: Steidl, Göttingen, Germany

This book is set in Gotham and printed on Profisilk

Library of Congress
Cataloging-in-Publication Data

Polidori, Robert.
 Robert Polidori's metropolis/With Martin C. Pedersen
and Criswell Lappin.
 p. cm.
 ISBN 1-891024-98-1
1. Architectural photography. 2. Polidori, Robert.
I. Title: Metropolis. II. Pedersen, Martin C.
III. Lappin, Criswell. IV. Title.
 TR659.P65 2004
 778.9'4—dc22

 2004011650

Metropolis Books is a joint
publishing program of:

D.A.P./Distributed Art Publishers, Inc.
155 Sixth Avenue, 2nd floor
New York NY 10013
Tel 212 627 1999
Fax 212 627 9484
www.artbook.com

and

Metropolis Magazine
61 West 23rd Street, 4th floor
New York NY 10010
Tel 212 627 9977
Fax 212 627 9988
www.metropolismag.com

Available through D.A.P./Distributed Art
Publishers, Inc., New York

METROPOLIS
BOOKS